ANATOMY
PERSPECTIVE
AND
COMPOSITION
FOR THE ARTIST

ANATOMY
PERSPECTIVE
AND
COMPOSITION
FOR THE ARTIST

STAN SMITH

Deputy Ruskin Master and Head of Fine Art at the
Ruskin School of Drawing and Fine Art, Oxford University,
and Visiting Tutor at the Royal College of Art, London.

WATSON-GUPTILL PUBLICATIONS/NEW YORK

A QED BOOK

Copyright © 1984 by QED

First published 1984 in the United States by
Watson-Guptill Publications, a division of Billboard
Publications, Inc., 1515 Broadway, New York,
N.Y. 10036.

ISBN 0-8230-0219-5

This book was designed and produced by
QED Publishing Limited, 32 Kingly Court,
London W1

Macdonald & Co (Publishers) Ltd
Maxwell House
74 Worship Street
London EC2A 2EN

Typeset in Great Britain by
Leaper & Gard Limited
Origination by Rainbow Graphics, Hong Kong
Printed and Bound by Poligrafici Calderara S.p.a.,
Bologna, Italy

Editorial Director: Christopher Fagg
Art Director: Alastair Campbell
Senior Editor: Jim Miles
Editor: Tish Seligman
Designers: Nick Clark and Moira Clinch
Editorial Assistance: Deirdre McGarry, Emma Foa
Special thanks to Kate Smith

CONTENTS

1. ANATOMY

2. PERSPECTIVE

3. COMPOSITION

FOREWORD

An artist can transpose a burst of mental energy into an image of wonder and delight, creating illusion and bringing beauty into the world. This quality of original and personal creation is the essence of art — the common factor in all good, not to say great, works of art. But, how is it acquired? Some will say it evades but a few. Yet, it can be encouraged, enticed and even provoked. By providing a solid foundation from which it can spring, the creative impulse will more readily seek its freedom. Through the knowledge of a basic artistic vocabulary, including anatomy, perspective and composition, that foundation can be provided.

At face value, a work of art exists within its own unique terms of reference, bounded only by the outer edges and containing all the energy, sensitivity and personality of the artist. He or she will create the wonderful magical imagery according to the demands of the heart and mind, bringing to us a statement in color, form, line and rhythm, which encapsulates — whether the artist likes it or not — personal experience, prejudice and stress. The emotions and intellect will filter through a mass of acquired knowledge and experience before emerging in the form of the work of art and, as often as not, will be both dependent and conditioned by them. No matter how strong and personal the commitment, how passionate the determination, without the incorporation of this historically established visual grammar, the essential disciplines are very hard to find.

This visual grammar is evident in the work of the Great Masters. It is from looking at these works that the artist can witness the theory in practice. The ingenious ways these theories have been used will also demonstrate how there is no one solution from any one source, but a fresh discovery within the strictures imposed. It is essential to experiment, risk and search for originality aided by such study.

Knowledge and understanding of anatomy, perspective and composition will provide the basic tenets of visual representation. Assimilation of such knowledge and the practice of their principles will emerge spontaneously as we draw. 'Seeing' for an artist is very different from the everyday seeing which enables us to recognize and move about in our surroundings. In our lives we are presented with a chaotic assortment of impressions from which, as artists, we must select the visual shorthand — expressed through the relationships between points, lines, spaces, tones and colors — which adequately conveys our observations and emotions. Only practice and understanding will help us choose and judge correctly.

Knowledge of anatomy will help the artist to look at a seated figure and sum up the basic tensions and emphasis within that figure. It is common to be versed only in the map of the human figure but this tends towards a two-dimensional interpretation. In the section on anatomy, an attempt has been made to create a three-dimensional view of the bones of the skeleton and the musculature of the human form. The full richness of the complex human machine is demonstrated in action.

A study of perspective will show the artist how to create an illusion of space beyond the picture surface. Theories concerning the relationship of objects and figures within a three-dimensional space and how these can be represented on a two-dimensional surface will be explained. Much successful representative art is achieved through the discovery of the difference between what we know and what we see — it reveals the discrepancy between the appearance of an object and our preconceived ideas of what it looks like.

Finally, the study of compositional theory throws new light on the history of art. It explains the seeming inevitability of so many great masterpieces. It can be used to spark off the artist's imagination whilst creating a solid base for the work. It also can solve a universal artistic problem: where and how to start.

This book aims to make available the mechanics by which the magic of picture-making is achieved. It elucidates the complexities of human anatomy, perspective and composition and creates a sound reference book which can be retained for consultation long after the initial lessons have been learned.

1 ANA

TOMY

INTRODUCTION

*Knowledge of the bones and muscles of the body helps the artist to read the form
and balance of a pose, giving authority to a figure drawing.*

Most anatomical text books are researched and written by medical men, where the stress is on function. These works can be very useful to the artist as knowledge of the workings of the human body can be an aid to figure-drawing. Some artists, however, feel that detailed anatomical knowledge is not necessary and that those concerned with figure-drawing should limit their acquisition of knowledge to the fundamental structure of the human form.

The answer must fall somewhere between these two extremes. Certainly, too much concern with study of a scientific nature can be distracting, at best, and seductive, at worst. There is a need to tread warily so as to avoid becoming so involved in physiology and detailed anatomy that the inspiration of a drawing or painting is lost. Then, rather than the study being an aid to the intended composition, it becomes an end in itself.

The artist must, on the other hand, have some knowledge of what lies underneath the human skin, to lend credibility to his figure-drawing. He will have difficulty, for example, in producing a convincing drawing of an upholstered chair, if all he knows about is the material that covers it; some knowledge of the basic structure and stuffing is essential. It is not necessary, though, to learn the name of every bone and muscle, but an appreciation of function, with relation to movement and balance, and the effect on the body form is a great aid to figure-drawing.

The maxim that shape is dependent upon function is generally true of the human body. In instances where leverage or hingeing is necessary, there is a simple visual explanation, just as there is where counter-rhythms are employed to retain balance in a biped. In some complicated movements, however, it can be very difficult to understand what is happening to the muscles and bones. For example, the turn of the forearm from pronation to supination — from palm facing upwards to palm facing downwards — involves a beautiful series of interrelated movements of the two bones of the forearm, the ulna and radius, both surface and buried muscle, and the movement of major and minor blood vessels. This sounds over-complicated, but, in general, the artist making a figure study needs only to know the basic configurations — knowledge of the appearance of the body when movement is completed and an understanding of the muscles and bones involved in the completed action are sufficient.

The series of diagrams in this section set out to suit the needs of the artist in a unique fashion. They are not intended to be read as an orthodox anatomical chart, but as an indication of how surface form is affected by stresses and stretchings, movement and balance. To this end, four views of each pose are represented, with the major musculature exposed in relation to the pose. It is hoped that such a series of figures in action will prove of value to the artist, both by demonstrating structure and by illustrating the depth of knowledge likely to prove useful.

Historical Background

Until the introduction of the camera in 1839, any study or analysis of the human body and its complex machinery relied upon the drawings and annotations of artists and men of medical science. Indeed, early medical books were illustrated with anatomical drawings researched by artists and, although artists concentrated on the external manifestation of the workings of skeleton, muscles and fat, rather than the specific functioning of the body's parts, there has always been a close link between artists and the medical profession in their search for knowledge and understanding of the human body.

Records of early dissections are rare. The first accounts of any authority describe dissections performed by Erasistratus and Herophilus of the Ptolemaic medical school of Alexandria in the second century BC. Evidence of study after this is thin; the religious association between body and soul fuelled early fears and superstitions and made it difficult for the examination of corpses to be carried out. Those who did so were threatened with excommunication, hell and damnation. In the thirteenth century, however, records of post-mortems and autopsies were made for the University of Bologna, where, for the most part, the hapless cadavers were those of condemned criminals and vagrants. In addition, there are accounts of grave-robbing, not for gold but for bodies to dissect to quench the thirst for anatomical knowledge.

It was during the Renaissance, however, that the greatest achievements were made. This was the dawn of experimental science and research, when there was a new consciousness of man's dignity and of his powers to create a new environment for himself. No longer was the body of man regarded as an insignificant shell housing his immortal soul; it became the object of intense research and excitement. Artists and medical men now had the incentive to fight taboo and superstition.

Accounts of anatomical study by Renaissance artists exist and the most illuminating of these have come down to us in the secret *Notebooks* of Leonardo da Vinci (1452-1519). In them he describes, in his cramped mirror-writing, accompanied by breathtaking illustrations, how on one occasion he examined more than ten human bodies and that 'as one single body did not suffice for so long a time, it was necessary to proceed by stages with so many bodies as would render my knowledge complete'.

Another aspect of the human body which has fascinated artists since classical times is its proportion. The earliest known canons of proportion are Egyptian. They used them to construct effigies to contain the spirits of the dead. The Greeks felt that, if the rules of proportion were followed, then an artistic representation would be naturally imbued with beauty. The celebrated Greek sculptor, Polyclitus, in the fifth century BC, defined through a mathematical formula the type of athlete so admired by the Greeks. This was the strong healthy male, excellent at gymnastics and skilled in handling weapons of war. His head fitted into the overall height of his body seven and a half times. Leonardo, on the other hand, made his man eight heads tall.

This leap from classical times to the Renaissance, was bridged by Renaissance artists' discovery of the writings of the Roman architect, Vitruvius. *De Architectura*, written at the end of the first century BC, was particularly important to these artists as it was the only manual of its kind to have survived from antiquity. In it, Vitruvius outlined the rules applied to architecture by the Greeks and suggested that man, being 'the measure of all things', should and could be used as a yardstick for proportion in the design of buildings, be they temples, theaters or villas. The reacceptance of the philosophy that lay behind the expression of such ideas was a turning point in Renaissance thinking.

The revival of the classical link between art and mathematics led to the assertion that man, with his arms and legs extended, could be contained within both a circle and a square — the symbols of perfection and aesthetic beauty. This was the basis for the analysis of the human figure by Leonardo: 'The span of a man's outstretched arms is equal to his height. If a circle (with navel as center) be described of a man lying with his face upward and his hands and feet extended, it will touch his fingers and toes.' The German artist, Albrecht Dürer (1471-1528) worked along the same lines trying to evolve canons of proportion. His two volumes on human proportion, originally conceived as a treatise of four volumes, contain carefully described formulae for the depiction of man.

Artists pursued a double purpose in attempting to determine these rules of proportion. First, they tried to define the symmetry of the body, in the Greek sense of balancing diverse parts within the whole, in the search for perfect beauty and, second, they tried to evolve rules to make their art more simple. In neither objective were they successful.

Notwithstanding the magnitude of these works, man's attitude to himself and his idea of beauty has changed greatly. Although we may presume the human body to have changed little over the centuries, artists have sought to portray it in various guises, emphasizing and seeking out the characteristics which they thought most appealing to their audience. Regardless of the manner in which the figure is portrayed, however, certain proportions remain constant. The center of the body falls just above the crotch, at a point called the pubis. In general the human figure is usually from six and a half to seven head-lengths tall. Yet, examination of existing painting will show that in practice, where the artist is concerned, this may vary from four to twelve head-lengths, according to fashion.

THE SKELETON

Knowledge of the skeleton is fundamental to the study of anatomy. Without it, there can be no understanding of the body's balance, movement, twists or turns. It can be well defined as the structure underlying the upholstery. A common mistake made by artists is to bypass an appreciation of the skeleton in favor of a superficial knowledge of muscles and fat; the one without the other makes little sense, just as foam cushions and fine covers without their underlying structure would collapse as soon as someone sits on them. By taking the trouble to learn this basic structure, any figure drawing will be more authoritative.

At the same time as researching the shape and position of the bones, it is necessary to understand how one affects another and why any movement of the body involves so many adjustments of the skeleton. When a figure is balanced on both feet, it appears very different from when the total body weight is shifted on to one leg. If the figure is standing on a level surface and takes the body weight on the left leg, then the pelvis will dip to the right so that the center of gravity passes through the relevant points in the body to achieve stable balance. To compensate for this imbalance in the lower part of the body, the upper part of the body, or thorax, tips in the opposite direction; thus, the left shoulder dips and a beautiful snake of consummate balance emerges. This balancing of parts of the body is evidenced in all standing poses when there is no additional support, so that when a model

lifts a leg, raises an arm or arches the back, there will be a compensating angle. Knowledge of the skeleton enables the artist to establish a point at which to begin; an anchor from which to cast off into the poetry of the pose, no matter how complicated.

Let us examine the different characters of the various bones: the vertebral column, or back-bone, has the same function as a column supporting a building; the pelvis is bucket-like to protect vital organs. The rib cage is a strong, yet delicate, enclosure, protecting the lungs, heart and liver; the skull, enormously strong packaging for the brain. The bones of the arms and legs work on the same principles of leverage applied in engineering. Although we each have approximately the same number of bones, we can be born with extra or absent ones and a few fuse together with age. Bones, however, can vary greatly from person to person — a rib cage can be long and narrow, short and wide, rounded or flattened. The skeleton contributes to the build of the person, regardless of fat and muscles. You have your own body to look at, to examine closely and to move as an aid to teaching you alongside diagrams, books and models, so let us begin with a detailed look at the skeleton.

Bones of the upper limb
Shoulder The shoulder joint comprises surfaces of several bones in the region. The scapula, or shoulder blade, is a thin plate-like bone of triangular form. It is placed high in the back and is capable of a great range of movement as can easily be seen in any reasonably thin model. There is a shallow socket at the upper part of its outer edge — the external angle — which furnishes seating for the head of the humerus in the upper arm. Long bones in the body are described as having a shaft with extremities. Usually the top extremity, as in the case of the humerus, is called the head. Also part of the shoulder joint is the clavicle, or collar bone — a thin curved bone running from the top of the sternum to the shoulder joint. The movement of the clavicle is very important in determining many of the poses adopted by the figure as its angle very often counters that of the pelvis. Attached to the clavicle and the scapula are the major muscles which control the movement of the arms and torso.

The shoulder joint, like the hip joint, is an example of a ball and socket joint which permits a very wide range of movement.

The arm The bones of the arm comprise, in the upper arm, the humerus, which is the main bone of the arm, and the radius and the ulna, both of which are in the forearm. The bones of the arm do not have to perform the same function as the leg bones — they have no need to support the weight of the upper body, for instance. Consequently, they are smaller and less thick although they bear considerable likeness to the bones in the leg. The extremities of the humerus have articular surfaces while the shaft allows, through grooves and prominences, for the attachment of the various muscles of arm, shoulder and back. At its lower extremity the humerus is complicated in form, designed to link with the bones of the forearm.

Of the two forearm bones, the radius is the outer and the ulna the inner. In saying 'outer' and 'inner', however, some confusion can arise because these two bones are not united and are free to move over one another in certain directions. We can examine them in relation to each other in different positions of the forearm. If we hold the arm with the palm of the hand held upwards, the bones will be lying side by side — more or less parallel to each other. Now, by turning the hand so that the palm faces downwards, the outer bone, the radius, lies obliquely across the ulna. In the former position the arm is described as being supine, in the latter prone. The movement itself is called pronation and the reverse action — that which rotates the arm from prone to supine — is called supination. The long bones of the forearm interrelate in a unique way for it can be seen that the upper extremity of the ulna is large but its lower end relatively small. The radius, on the other hand, has a large extremity at its lower end but a small one at the top. It is important to understand why such is the case and to associate function with form. The inner of the two bones, the ulna plays a large part in the formation of the joint at the elbow, whereas the radius (the outer bone) is an important part of the wrist joint.

Elbow The junction of the bones of the upper and forearm, the elbow, is a typical hinge joint. The movements made possible by such a joint are called flexion and extension. In flexion, the forearm is bent forwards on to the upper arm, in extension it is straightened so as to be in line with the upper arm. The joint is formed by the ulna, which is more significant in the joint than the radius, and the humerus whose lower extremity is round in form to receive the large process matching it in the ulna. At the elbow the general movement downwards is slightly outwards, giving the appearance that the forearm is splayed out in relation to the upper arm.

Wrist The wrist consists of eight bones called phalanges. They are tightly related adjoin the lower extremities of the ulna and radius and, below, they meet the finger bones, called metacarpals. They are tightly related and form a mass of bony structure between the arm and the hand.

The eight bones comprising the joint are arranged as two sets of four — the anterior, or back ones, can be felt in the wrist where they

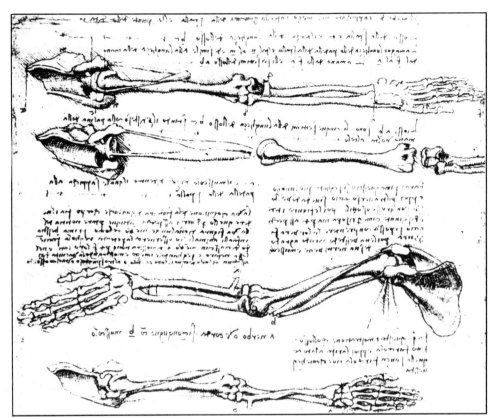

This is a detail page from the *Notebooks* of Leonardo da Vinci (1452-1519) showing an example of his minutely observed drawings of the human anatomy. Here, he is looking at the structure of the upper limb. The lower two drawings illustrate how when the palm is turned down, the bones of the lower arm, the radius and ulna, cross over each other.

are overlaid with the tendons of the muscles travelling down to the fingers. The movements of the wrist are limited: when it is bent forward, it is said to be flexed; when bent back it is called extended. There is greater flexibility in the flexing than in the extending movement. The wrist is also capable of movement from side to side: when turned to the inner side, it is called adduction; when turned to the radial side, it is called abduction. **Hand** The skeleton of the hand, connected to the wrist, comprises the bones of the palm and fingers. The palm bones, the five metacarpals, are long bones which at their top extremities meet the wrist and, at the bottom, four of them meet the bones of the fingers (phalanges). The remaining one (the outermost one) meets the thumb. The phalanges total fourteen in all — three in each finger and two in the thumb. The bones of the first row are the longest and the length diminishes towards the tip of the digit. The bones at the end of the fingers have a surface which allows the nail to be attached. By forming a fist and examining the rows of knuckles, the junction of all these bones can be easily seen.

The range of movement rendered possible by these bones is wide: the fingers can be separated and closed again and they can be bent at each of the joints along their length. The thumb possesses a greater range of movement than the fingers — it can be brought into opposition to each of them. As a means of harnessing the skills needed to pick up objects, the thumb is a unique digit. It has a musculature which gives it both its range of movement and great strength and enables the hand to perform delicate tasks.

Bones of the trunk

The spine, or vertebral column, is the main support for the head and the rib cage: it also makes the chief anchorage for the legs and the arms. The length of the spine is, on average, shorter in the female than the male.

The spine is composed of a related series of bones, twenty-six in all — seven cervical, twelve thoracic, five lumbar and one each sacral and coccygeal. The sacrum and the coccyx are fixed to the pelvis and form a solid foundation only capable of movement in conjunction with the other parts of the pelvis. Each of the moveable vertebrae has spines — strong bonal appendages which seat part of the muscular system supporting the thorax and allowing major movements of the upper body, the shoulders and arms. The spines of the vertebrae are subcutaneous and some affect the surface appearance more than others. When a person bends forward, for instance, the thoracic vertebrae rise to the surface and resemble a string of pearls lying beneath the skin.

If we now move from the spinal column at the back of the figure form, to the front, the rib cage appears as the most significant feature of the upper part of the skeleton. We should first examine the central support system of the ribs, the sternum or breast bone. This is a flat, sword-like bone situated centrally in the thorax, supplying the point of origin for the ribs and the collar bones. The sternum rises to

the surface and therefore becomes subcutaneous in its middle region.

Pelvic girdle The pelvis is an association of several parts which fuse at the hip to form a stable and protective mass of bone. It forms the major difference between the male and female skeleton both externally and internally. The female pelvis is wider and not so high as the male pelvis. At the same time it is of greater volume due to the differing function it must perform — the pubic arch is wider to facilitate child birth. The pelvis itself is formed by the sacrum, the hip bones and the coccyx. The two halves of the pelvis are visually separated by a marked ridge, well visible on both the sacrum and the ilium. The sacrum is lodged between the two iliac bones with the weight of the body resting on it. Under the weight of the pelvis it acts like a two-armed lever, it dampens the force of sudden jolts from above and below. The hip bones themselves are formed by deep excavations on the lateral surface of the iliac bone and the head of the femur of the thigh. Here, the lower limb can move rather freely depending on the agility and fitness of the individual. Ballet dancers, for example, can perform wonderful feats envied by most of us. The movement of the femur is dictated by the depth of the articular fossa. The femur can also describe circular movements, like the humerus in the arm, because of the ball and socket joint at the hip.

The bucket of the pelvis has an important function protecting essential organs but, from the point of view of the artist, it also performs an important function in balancing the body as it forms the base from which the spine springs. When observing the figure, particularly the female form, it can be very difficult to locate — all but impossible from the back view. By finding the ilium (or top ridge of the major bone in the pelvis) at the front, the pelvis will be more easily traced. The significance then of the position and angle of the pelvis becomes apparent and, together with the direction taken by the shoulders and the position of the feet, an accurate reading of any pose becomes more feasible.

Bones of the lower limb

The bones of the lower limbs have features in common with those of the arms but there are also major differences. The differences are the result of the functional dimensions concerned with balance and movement. The thigh contains one large bone, a long one of great strength, which allows for the attachment of many important muscles along its length. It is called the femur and consists of, in descending order, a head, a neck, a shaft, and the lower process, which forms a major part of the knee joint. Such a summary of its parts does less than justice to the extraordinary shapes

and twists which constitute the overall rhythm of this major bone.

There are two bones in the lower leg, the tibia and the fibula. The tibia, the shin bone, comes very close to the surface along the greater part of its length. It can be seen on the inside of the leg and travels from the knee joint to the ankle. At its upper end it has a wide process which makes up the knee joint with the lower end of the femur. The fibula, together with the tibia, forms part of the ankle joint. The fibula is long and slender and lies on the outer side of the leg and its main importance is in furnishing attachment for several muscles of the leg.

Ankle and foot The ankle joint is between the lower leg and the foot and is formed by a meeting of the lower ends of tibia and fibula and the tarsals of the foot. The tarsals of the foot are in direct correspondence with the carpals of the wrist — the tarsals, however, number only seven as against eight carpals in the upper limb. They contrast in other ways too, being larger, broader and occupying more of the foot than carpals occupy of the hand. At their lower ends they abut the long bones which constitute the remainder of the foot and the five toes. The bones of the toes, like those of the fingers, are called phalanges.

The skull The importance of the skull in underlying the forms of the face and in its relationship with the trunk cannot be overstated. The bones comprising this feature are divided into two groups, those which form the brain box and those which underlie the face. The bones forming the cavity which houses the brain are called calvaria and they comprise the following: the frontal bone — which has two frontal prominences and two eyebrow arches; the parietal bones, which are anotriangular bones which together form the upper and lateral part of the calvaria; the occipitus is a shell-shaped bone which lies to the base of the cranium; the temporal bone is complicated in form and is always significant in drawing and in painting portraits. It is a bone with many parts and processes into which muscles are attached to contribute to the expressions of the face.

Now, let us look at the bones constituting the skeleton of the face. The maxilla, or upper jaw, constitutes the lower part of the structure that also includes the nasal cavity and the orbit of the eye. It also furnishes sixteen cavities for the teeth. The cheek bone, the zygomatic arch, connects the frontal, and temporal bones of the cranium and the maxilla. Strongly marked features of the side of the face are often attributable to this bone.

The mandible, the bone of the lower jaw, is the only moveable bone of the skull. Looked at from below, it is of horseshoe form and it

has seating for sixteen teeth. The point at which it meets the upper skull is called the articular process.

The bones of the skull need to be studied in two ways, first, to discover how they affect the appearance of the head and face as the underlying structure and bony prominences by pushing against the surface skin; and, second, viewed as an anchorage for the muscles which affect the changes of expression in the face. All bones should be studied in these ways but, because the bones of the skull are compact, their effects are easier to see and it is easy to see both the point of origin and of insertion of the muscles.

MUSCULATURE SYSTEM

It is the muscles which determine the appearance of the form of the body. Without muscles, the skeleton would be merely an inert mass of bones: they provide the power necessary for action. Muscles of various kinds — differing in character and shape according to their intended function — cover the whole of the superficial area of the body. Many muscular processes, however, lie beneath these superficial muscles and yet deeper ones below that.

The functions of the muscles vary. Some are there to hold series of bones erect — as in the case of the vertebral muscles — others to activate two parts joined by a hinge — a good example is the arm. Some are massive, others small; there are muscles which carry great strength and power, and muscles which control a range of fine movements. In spite of the differences, it is the characteristics they have in common which are of greatest interest to the artist learning anatomy and which will help him analyze the appearance of the life model.

Nature of muscles

All muscles have an origin and an insertion — that is to say they begin in one place and end at another. Sometimes, this is on the same bone, but often muscles have their origin in one bone and insertion in another. When a muscle contracts, it becomes shorter and harder, as can be felt by flexing the muscles of the upper arm until they bulge and stand out. A further illustration of the way in which muscles work can be made by examining how the upper arm and forearm, meeting at a hinge joint, are articulated by the relevant muscles. Here, the muscle travels from one bone across a hinge joint to be inserted into the other and when it is contracted it effects the movement of the arm. If the muscle passes over the joint, it will flex the limb, if it travels behind, it will extend it. It can go further and, from the upper bone, travel not only across the joint but beyond the lower bone to be

inserted finally in another related bone below. In such a case, several articulations of bones will be effected but, if the muscle is deep-seated, it may not have a direct action — in such circumstances it is described as having indirect action.

Symmetry is an important aspect of the musculature of the human body; major muscles come in pairs on either side of the figure and smaller muscles, like those in the forearm or leg, are paired in the opposite limb.

Let us examine those muscles which concern the artist — those which can be seen on the surface, giving the body its shape, and those which change in form through action.

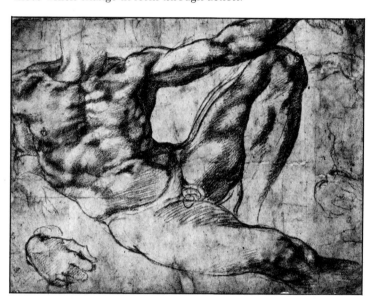

For ease of understanding, the muscles of the front of the body will be described first, followed by the back. Finally, the musculature of the head and neck will be dealt with. It is, of course, impossible to separate the muscles of the front, back and sides of the body, because so many muscles travel across and around, as well as up and down, the form; it is merely for the convenience of identification that we adopt the following method.

Front view of the body's musculature

Thorax The shape of the thorax, as we can see, is influenced by the rib cage, protecting major life-supporting organs. Of the muscles in the area, the deltoid muscle is shaped like the Greek letter *delta*, from which it takes its name. It has its origin in the front and back of the shoulder girdle and is inserted into the humerus. Its function is to raise the arm from the side and it is also active in pulling the arm backwards and forwards.

The pectoralis major, the chest muscle, is attached to the outer edge of the sternum, to the clavicle and to the sixth and seventh rib. Virtually all its mass is visible on the body's surface. Its action is to draw down the uplifted arm and it combines with other muscles to

Michelangelo (1475-1564) completed this *Study for the Torso of Adam* in preparation for his work on the Sistine Chapel in Rome. The well-developed muscles are depicted with great care and with the authority of a certain knowledge of human anatomy. Michelangelo does not let his expertise in anatomy override his art: in the final painting the musculature is simplified so as not to detract from the highly charged emotional moment depicted.

rotate the limb. In the fat which covers the pectoralis major the mammary gland is located and, in the female, this becomes the breast. Because the breasts lie on the individual muscles, they are placed well apart from each other. Both male and female have nipples, but, in the male, it is only the indication of the breast.

The external oblique is the muscle of the outer part of the abdominal wall. Its name describes it well — the fibers of the muscle lie in an oblique direction from its upper end, where it is attached to the eight lower ribs, down to its lower end, where it enters the pubis and inserts in to the top of the pelvis. Its function is to pull the rib cage to its own side and it also works in pulling the pelvis upwards. The serratus magnus muscle is shaped like a fan and has extensive origins from the side of the rib cage. Not much of it is seen on the surface, but it affects the appearance of the trunk because it is familiar in poses in which the arm is raised. It has eight strips of fiber, which spring from the eight upper ribs and, when seen in action, it appears as a row of radiating ridges under the arm and down the wall of the trunk.

The next muscle, which has a significant effect on the appearance of the upper part of the body, is called rectus abdominis. It is placed to the front of the trunk and covers the abdomen. It is attached above to the cartilages of the fifth, sixth and seventh ribs and to the sternum; at the lower end, it inserts into the pubis. An interesting muscle visually, it is divided by three transverse furrows, forming lines on the surface. The top two sections of the muscle are approximately equal in length and the lower section is the longest of the three. The furrows visible are the points at which the muscle most readily bends and its main function is to bend the trunk forward.

The muscular structures of the front of the thorax do not of course work in isolation; they are interrelated with the back muscles and those of the thigh and, through those, the lower leg. Similarly, they have connections with, and interdependence upon, the muscles of the arm. It is well to remember this basic fact that all muscles are related, and that even the most subtle of movements will not only involve those muscles directly concerned with the action, but it will also activate other apparently unconnected muscles.

Leg muscles The muscles of the thigh, as seen from the front, comprise the exteriors which are four in number — rectus femoris, vastus medialis and lateralis and the crurens. The latter is deep seated and is therefore not seen in the superficial forms of the thigh. All of them are inserted into the patella — or knee-cap — and together they form a fleshy mass. The outer muscles of the front of the thigh are sartorius, tensor fasciae femoris

and the iliotibial band. In addition, there are four which form the inner part — from top to bottom, psoas and iliacus, pectineus, adductor longus, and gracilis. Sartorius is a strap-like muscle which travels obliquely from the anterior superior iliac spine of the pelvis at the outer front of the top of the thigh, to the lower inner thigh and then behind the knee joint. It is the longest muscle in the body and links the thigh with the lower leg. Its function is to flex both the knee and the hip joint — it plays a part in everting the whole leg.

Before examining the muscles of the lower leg it is well to look closely at the structure of the knee joint and its musculature. The surface forms of the knee are difficult to describe, indeed, it takes practice to read them in the model. But, it is important to understand the various parts which come together to constitute the knee joint and, with the benefit of a little experience, it is easy to see what is going on. A problem encountered in figure-drawing is found in the areas of soft fatty tissue which lie over most of the knee. The flowing line, between the thigh, with its angle inwards from hip, to the knee, must continue to the lower leg via the knee without that feature being seen as a weakness — a point of potential breakage. The angles across the bony joints at the top of the knee, the bottom of the knee and the ankle joint complement each other. They all have rhythmic structures evolved to support the body weight and a determined range of movements. (The leg, like the thigh, is covered with a sheath of fascia which fits like a stocking.)

The knee has a bony cap — the patella — covering the front of the joint made by the femur in the thigh, and the tibia and fibula in the lower leg. It is connected above with the muscles of the front of the thigh, and below it is linked by a ligament to the top of the tibia. On the lower part of the patella are two pads of fatty tissue, seen better when the knee joint is in repose rather than action, when the bony structure can be more clearly distinguished. It is easier to see in the average male model because, in the female, there is more subcutaneous fat in the region. At its outer side, the appearance of the knee joint is affected by the iliotibial band which runs down from the thigh to insert in the outer panel of the head of the tibia. Sartorius continues downwards to below the knee on the inner side and inserts into the upper part of the shaft of the tibia. This muscle forms a curved prominence on the inward side of the knee.

The muscles of the front of the lower leg are divided into those that lie to the outer side of the tibia, which itself travels superficially down most of the surface, and those which lie to the inner side. Because there is a great mass of muscle at the back of the leg, some evidence

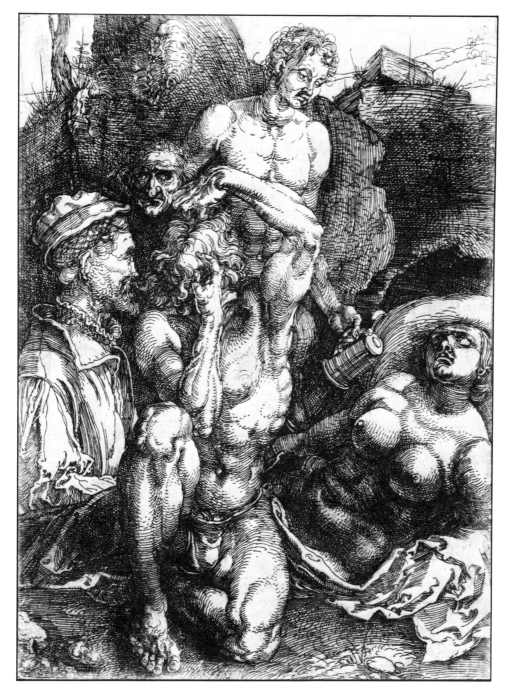

The German artist, Albrecht Dürer (1471-1528) made studies similar to Leonardo's. This engraving shows evidence of his anatomical knowledge in its depiction of muscular form. Such engravings by Dürer came to be used by artists throughout Europe because of their detailed anatomical observation.

of its presence is visible at the outer parts of the front. The tibialis anterior arises from the tibia and partly from the fibula and finds insertion in the metatarsal bone of the great toe. It lies on the outer side of the front of the leg and travels along the line of the tibia for most of its length. The extended tendon travels across the ankle bone and eventually is seen to be inserted into the base of the metatarsal bone. In its higher parts this muscle, being full and fleshy, conceals something of the harshness of line of the tibia and gives a fullness of form to the outer part of the front of the lower leg. In action, this muscle is used to flex the ankle.

On the outer side of tibialis anterior is the long extensor of the toes, whose action is well described in the name. It arises from several points high on both tibia and fibula and inserts, after separating into four ligaments, into the upper parts of the four outer toes. The tibialis anterior and the long extensor lie very close together at their origin but, when in the foot the tendons of each appear, another muscle, the extensor of the great toe, can be seen between them. This has its origin in the middle part of the fibula and only becomes apparent on the surface at that point. As the name suggests it is inserted into the great toe, having passed the ankle and travelled along the inner part of the instep.

(continued on page 30)

17

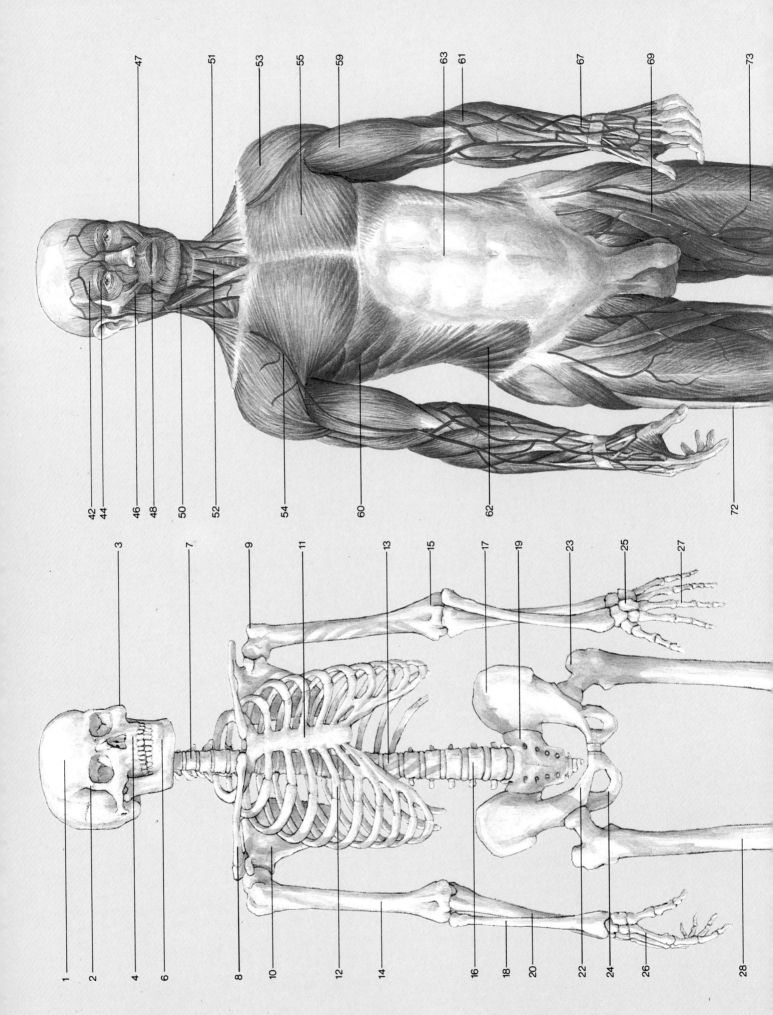

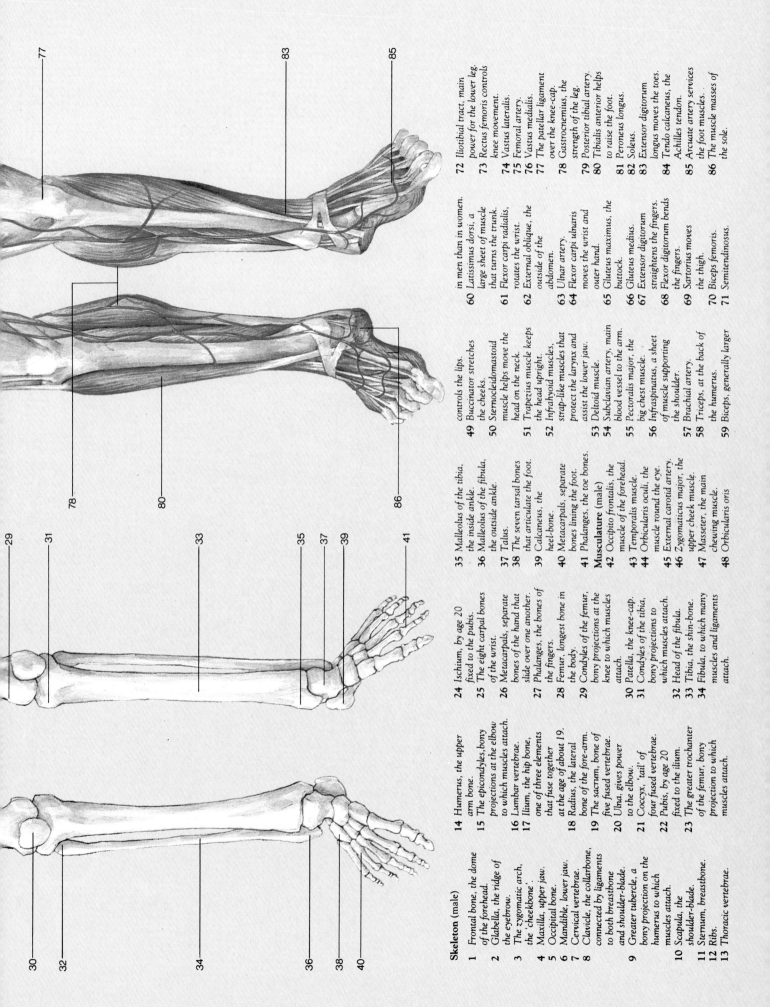

Skeleton (male)

1 Frontal bone, the dome of the forehead.
2 Glabella, the ridge of the eyebrow.
3 The zygomatic arch, the 'cheekbone'.
4 Maxilla, upper jaw.
5 Occipital bone.
6 Mandible, lower jaw.
7 Cervical vertebrae.
8 Clavicle, the collarbone, connected by ligaments to both breastbone and shoulder-blade.
9 Greater tubercle, a bony projection on the humerus to which muscles attach.
10 Scapula, the shoulder-blade.
11 Sternum, breastbone.
12 Ribs.
13 Thoracic vertebrae.

14 Humerus, the upper arm bone.
15 The epicondyles, bony projections at the elbow to which muscles attach.
16 Lumbar vertebrae.
17 Ilium, the hip bone.
18 Radius, the lateral bone of the fore-arm.
19 The sacrum, bone of five fused vertebrae.
20 Ulna, gives power to the elbow.
21 Coccyx, 'tail' of four fused vertebrae.
22 Pubis, by age 20 fixed to the ilium.
23 The greater trochanter of the femur, bony projection to which muscles attach.

24 Ischium, by age 20 fixed to the pubis.
25 The eight carpal bones of the wrist.
26 Metacarpals, separate bones of the hand that slide over one another.
27 Phalanges, the bones of the fingers.
28 Femur, longest bone in the body.
29 Condyles of the femur, bony projections at the knee to which muscles attach.
30 Patella, the knee-cap.
31 Condyles of the tibia, bony projections to which muscles attach.
32 Head of the fibula.
33 Tibia, the shin-bone.
34 Fibula, to which many muscles and ligaments attach.

35 Malleolus of the tibia, the inside ankle.
36 Malleolus of the fibula, the outside ankle.
37 Talus.
38 The seven tarsal bones that articulate the foot.
39 Calcaneus, the heel-bone.
40 Metacarpals, separate bones lining the foot.
41 Phalanges, the toe bones.

Musculature (male)

42 Occipito frontalis, the muscle of the forehead.
43 Temporalis muscle.
44 Orbicularis oculi, the muscle round the eye.
45 External carotid artery.
46 Zygomaticus major, the upper cheek muscle.
47 Masseter, the main chewing muscle.
48 Orbicularis oris

controls the lips.
49 Buccinator stretches the cheeks.
50 Sternocleidomastoid muscle helps move the head on the neck.
51 Trapezius muscle keeps the head upright.
52 Infrahyoid muscles, strap-like muscles that protect the larynx and assist the lower jaw.
53 Deltoid muscle.
54 Subclavian artery, main blood vessel to the arm.
55 Pectoralis major, the big chest muscle.
56 Infraspinatus, a sheet of muscle supporting the shoulder.
57 Brachial artery.
58 Triceps, at the back of the humerus.
59 Biceps, generally larger

in men than in women.
60 Latissimus dorsi, a large sheet of muscle that turns the trunk.
61 Flexor carpi radialis, rotates the wrist.
62 External oblique, the outside of the abdomen.
63 Ulnar artery.
64 Flexor carpi ulnaris moves the wrist and outer hand.
65 Gluteus maximus, the buttock.
66 Gluteus medius.
67 Extensor digitorum straightens the fingers.
68 Flexor digitorum bends the fingers.
69 Sartorius moves the thigh.
70 Biceps femoris.
71 Semitendinosus.

72 Iliotibial tract, main power for the lower leg.
73 Rectus femoris controls knee movement.
74 Vastus lateralis.
75 Femoral artery.
76 Vastus medialis.
77 The patellar ligament over the knee-cap.
78 Gastrocnemius, the strength of the leg.
79 Posterior tibial artery.
80 Tibialis anterior helps to raise the foot.
81 Peroneus longus.
82 Soleus.
83 Extensor digitorum longus moves the toes.
84 Tendo calcaneus, the Achilles tendon.
85 Arcuate artery services the foot muscles.
86 The muscle masses of the sole.

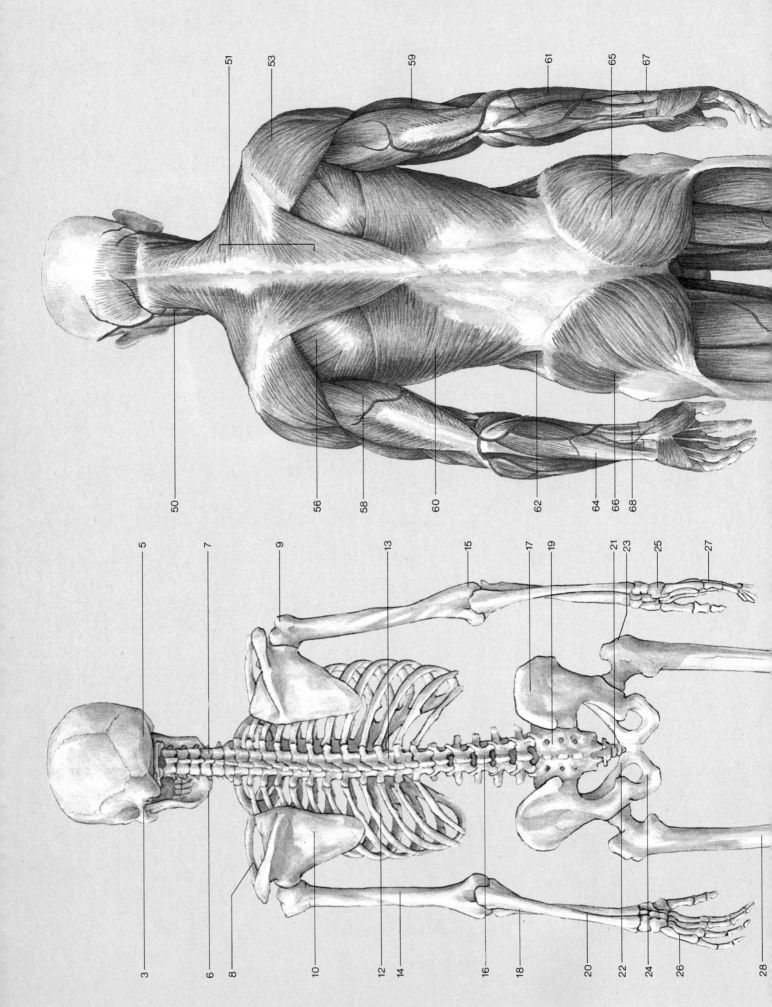

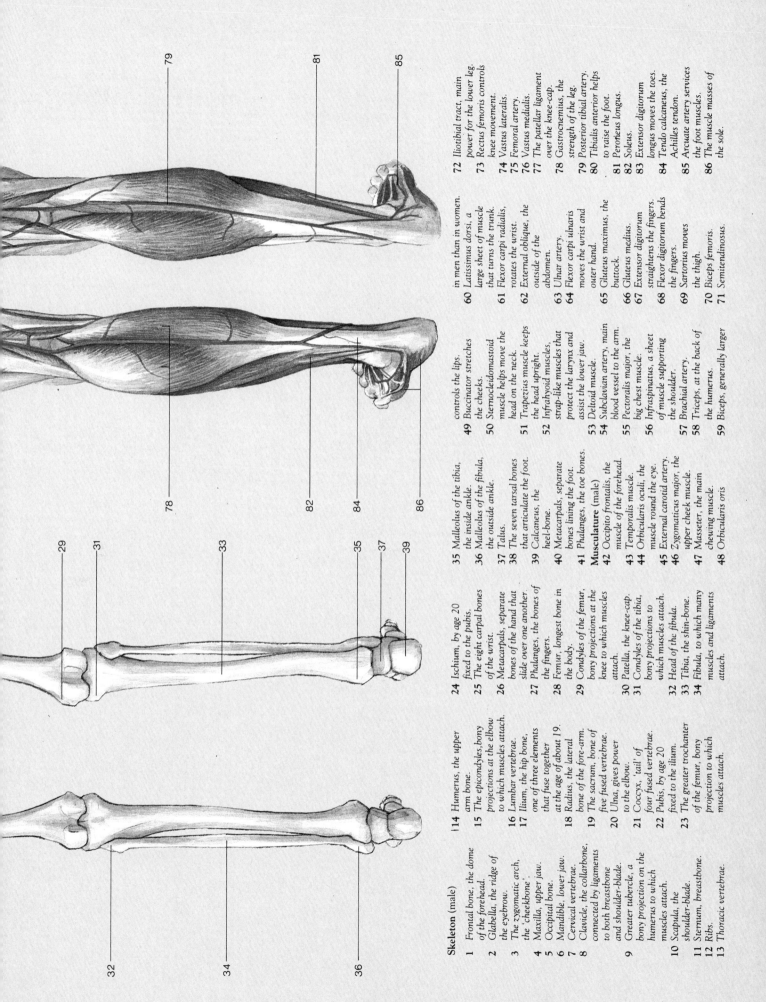

Skeleton (male)

1 Frontal bone, the dome of the forehead.
2 Glabella, the ridge of the eyebrow.
3 The zygomatic arch, the 'cheekbone'.
4 Maxilla, upper jaw.
5 Occipital bone.
6 Mandible, lower jaw.
7 Cervical vertebrae.
8 Clavicle, the collarbone, connected by ligaments to both breastbone and shoulder-blade.
9 Greater tubercle, a bony projection on the humerus to which muscles attach.
10 Scapula, the shoulder-blade.
11 Sternum, breastbone.
12 Ribs.
13 Thoracic vertebrae.
14 Humerus, the upper arm bone.
15 The epicondyles, bony projections at the elbow to which muscles attach.
16 Lumbar vertebrae.
17 Ilium, the hip bone, one of three elements that fuse together at the age of about 19.
18 Radius, the lateral bone of the fore-arm.
19 The sacrum, bone of five fused vertebrae.
20 Ulna, gives power to the elbow.
21 Coccyx, 'tail' of four fused vertebrae.
22 Pubis, by age 20 fixed to the ilium.
23 The greater trochanter of the femur, bony projection to which muscles attach.
24 Ischium, by age 20 fixed to the pubis.
25 The eight carpal bones of the wrist.
26 Metacarpals, separate bones of the hand that slide over one another.
27 Phalanges, the bones of the fingers.
28 Femur, longest bone in the body.
29 Condyles of the femur, bony projections at the knee to which muscles attach.
30 Patella, the knee-cap.
31 Condyles of the tibia, bony projections to which muscles attach.
32 Head of the fibula.
33 Tibia, the shin-bone.
34 Fibula, to which many muscles and ligaments attach.
35 Malleolus of the tibia, the inside ankle.
36 Malleolus of the fibula, the outside ankle.
37 Talus.
38 The seven tarsal bones that articulate the foot.
39 Calcaneus, the heel-bone.
40 Metacarpals, separate bones lining the foot.
41 Phalanges, the toe bones.

Musculature (male)

42 Occipito frontalis, the muscle of the forehead.
43 Temporalis muscle.
44 Orbicularis oculi, the muscle round the eye.
45 External carotid artery.
46 Zygomaticus major, the upper cheek muscle.
47 Masseter, the main chewing muscle.
48 Orbicularis oris controls the lips.
49 Buccinator stretches the cheeks.
50 Sternocleidomastoid muscle helps move the head on the neck.
51 Trapezius muscle keeps the head upright.
52 Infrahyoid muscles, strap-like muscles that protect the larynx and assist the lower jaw.
53 Deltoid muscle.
54 Subclavian artery, main blood vessel to the arm.
55 Pectoralis major, the big chest muscle.
56 Infraspinatus, a sheet of muscle supporting the shoulder.
57 Brachial artery.
58 Triceps, at the back of the humerus.
59 Biceps, generally larger in men than in women.
60 Latissimus dorsi, a large sheet of muscle that turns the trunk.
61 Flexor carpi radialis, rotates the wrist.
62 External oblique, the outside of the abdomen.
63 Ulnar artery.
64 Flexor carpi ulnaris moves the wrist and outer hand.
65 Gluteus maximus, the buttock.
66 Gluteus medius.
67 Extensor digitorum straightens the fingers.
68 Flexor digitorum bends the fingers.
69 Sartorius moves the thigh.
70 Biceps femoris.
71 Semitendinosus.
72 Iliotibial tract, main power for the lower leg.
73 Rectus femoris controls knee movement.
74 Vastus lateralis.
75 Femoral artery.
76 Vastus medialis.
77 The patellar ligament over the knee-cap.
78 Gastrocnemius, the strength of the leg.
79 Posterior tibial artery.
80 Tibialis anterior helps to raise the foot.
81 Peroneus longus.
82 Soleus.
83 Extensor digitorum longus moves the toes.
84 Tendo calcaneus, the Achilles tendon.
85 Arcuate artery services the foot muscles.
86 The muscle masses of the sole.

21

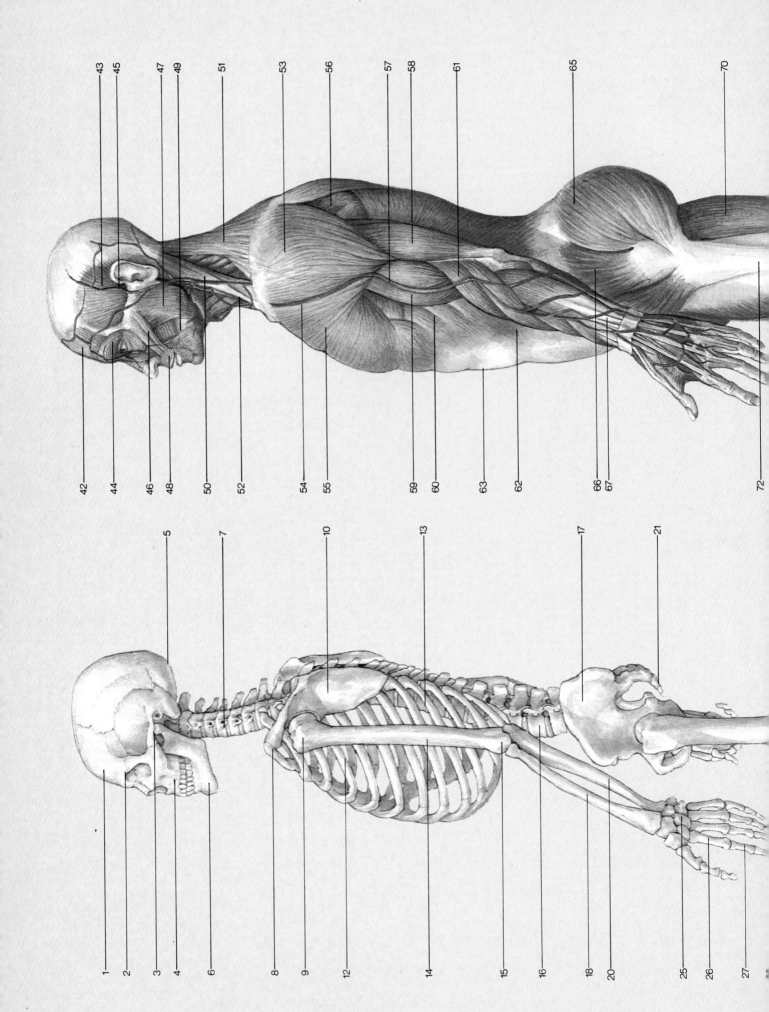

43 45 47 49 51 53 56 57 58 61 65 70

42 44 46 48 50 52 54 55 59 60 63 62 66 67 72

5 7 10 13 17 21

1 2 3 4 6 8 9 12 14 15 16 18 20 25 26 27

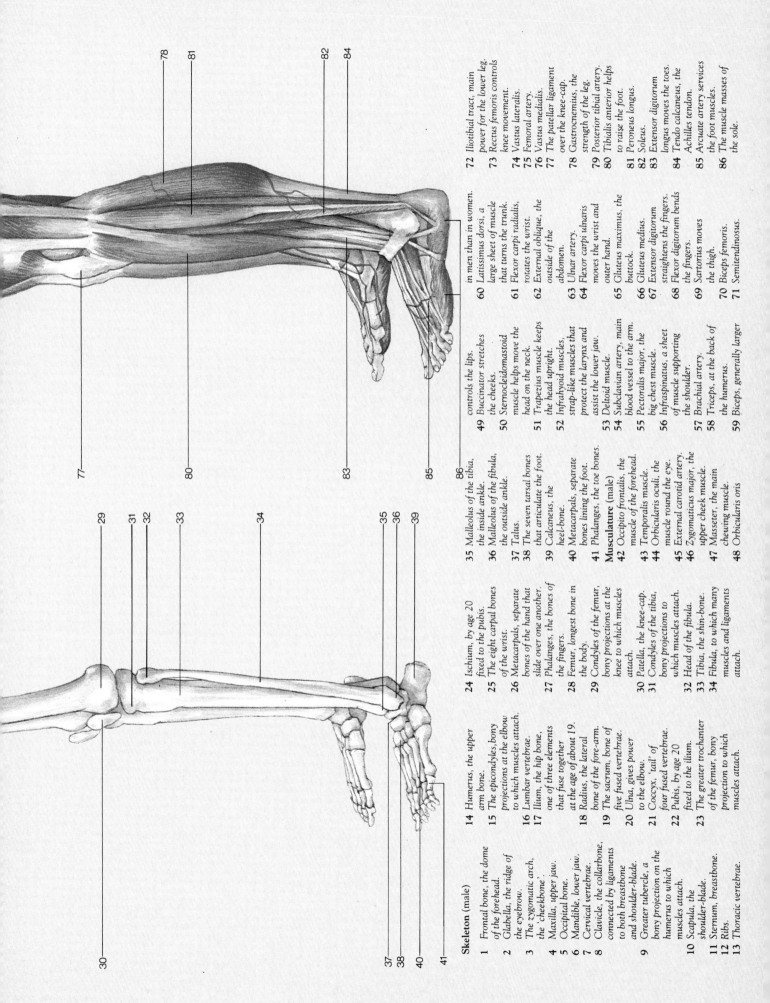

Skeleton (male)

1 Frontal bone, the dome of the forehead.
2 Glabella, the ridge of the eyebrow.
3 The zygomatic arch, the 'cheekbone'.
4 Maxilla, upper jaw.
5 Occipital bone.
6 Mandible, lower jaw.
7 Cervical vertebrae.
8 Clavicle, the collarbone, connected by ligaments to both breastbone and shoulder-blade.
9 Greater tubercle, a bony projection on the humerus to which muscles attach.
10 Scapula, the shoulder-blade.
11 Sternum, breastbone.
12 Ribs.
13 Thoracic vertebrae.

14 Humerus, the upper arm bone.
15 The epicondyles, bony projections at the elbow to which muscles attach.
16 Lumbar vertebrae.
17 Ilium, the hip bone, one of three elements that fuse together at the age of about 19.
18 Radius, the lateral bone of the fore-arm.
19 The sacrum, bone of five fused vertebrae.
20 Ulna, gives power to the elbow.
21 Coccyx, 'tail' of four fused vertebrae.
22 Pubis, by age 20 fixed to the ilium.
23 The greater trochanter of the femur, bony projection to which muscles attach.
24 Ischium, by age 20 fixed to the pubis.
25 The eight carpal bones of the wrist.
26 Metacarpals, separate bones of the hand that slide over one another.
27 Phalanges, the bones of the fingers.
28 Femur, longest bone in the body.
29 Condyles of the femur, bony projections at the knee to which muscles attach.
30 Patella, the knee-cap.
31 Condyles of the tibia, bony projections to which muscles attach.
32 Head of the fibula.
33 Tibia, the shin-bone.
34 Fibula, to which many muscles and ligaments attach.

35 Malleolus of the tibia, the inside ankle.
36 Malleolus of the fibula, the outside ankle.
37 Talus.
38 The seven tarsal bones that articulate the foot.
39 Calcaneus, the heel-bone.
40 Metacarpals, separate bones lining the foot.
41 Phalanges, the toe bones.

Musculature (male)

42 Occipito frontalis, the muscle of the forehead.
43 Temporalis muscle.
44 Orbicularis oculi, the muscle round the eye.
45 External carotid artery.
46 Zygomaticus major, the upper cheek muscle.
47 Masseter, the main chewing muscle.
48 Orbicularis oris controls the lips.
49 Buccinator stretches the cheeks.
50 Sternocleidomastoid muscle helps move the head on the neck.
51 Trapezius muscle keeps the head upright.
52 Infrahyoid muscles, strap-like muscles that protect the larynx and assist the lower jaw.
53 Deltoid muscle.
54 Subclavian artery, main blood vessel to the arm.
55 Pectoralis major, the big chest muscle.
56 Infraspinatus, a sheet of muscle supporting the shoulder.
57 Brachial artery.
58 Triceps, at the back of the humerus.
59 Biceps, generally larger in men than in women.
60 Latissimus dorsi, a large sheet of muscle that turns the trunk.
61 Flexor carpi radialis, rotates the wrist.
62 External oblique, the outside of the abdomen.
63 Ulnar artery.
64 Flexor carpi ulnaris moves the wrist and outer hand.
65 Gluteus maximus, the buttock.
66 Gluteus medius.
67 Extensor digitorum straightens the fingers.
68 Flexor digitorum bends the fingers.
69 Sartorius moves the thigh.
70 Biceps femoris.
71 Semitendinosus.

72 Iliotibial tract, main power for the lower leg.
73 Rectus femoris controls knee movement.
74 Vastus lateralis.
75 Femoral artery.
76 Vastus medialis.
77 The patellar ligament over the knee-cap.
78 Gastrocnemius, the strength of the leg.
79 Posterior tibial artery.
80 Tibialis anterior helps to raise the foot.
81 Peroneus longus.
82 Soleus.
83 Extensor digitorum longus moves the toes.
84 Tendo calcaneus, the Achilles tendon.
85 Arcuate artery services the foot muscles.
86 The muscle masses of the sole.

23

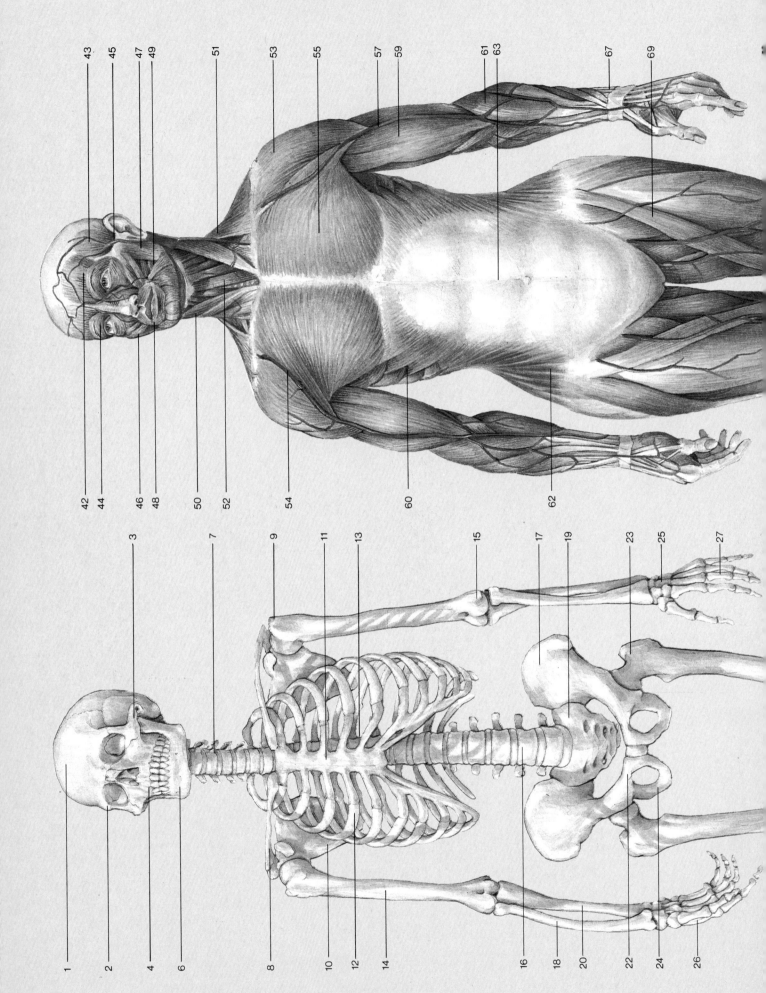

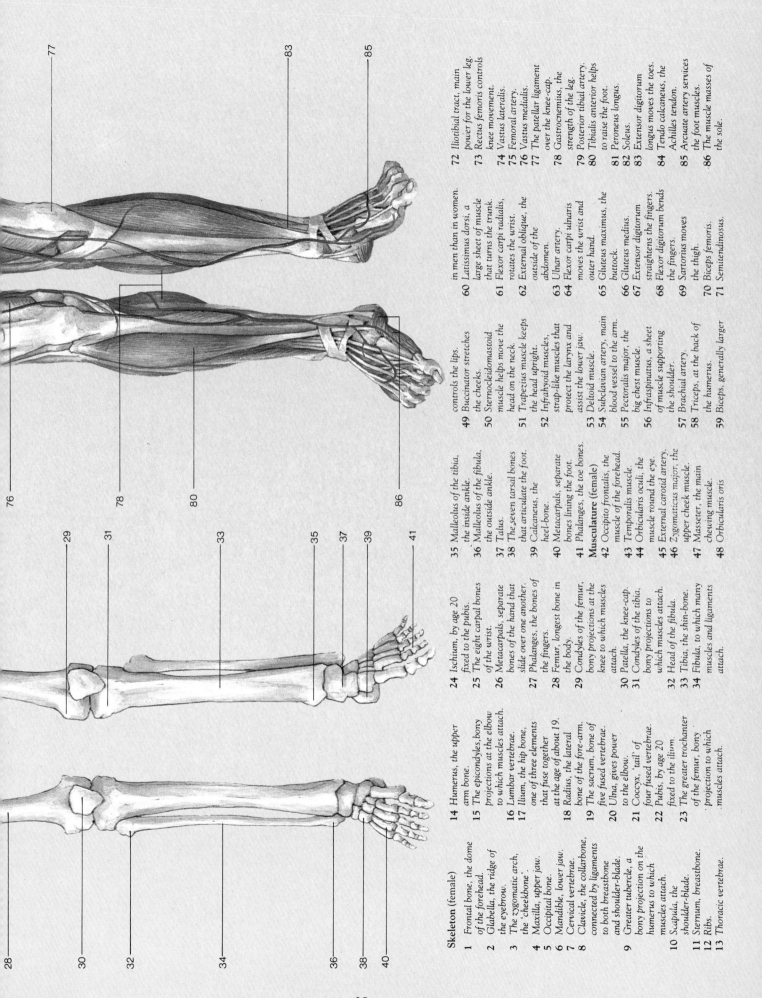

Skeleton (female)

1 Frontal bone, the dome of the forehead.
2 Glabella, the ridge of the eyebrow.
3 The zygomatic arch, the 'cheekbone'.
4 Maxilla, upper jaw.
5 Occipital bone.
6 Mandible, lower jaw.
7 Cervical vertebrae.
8 Clavicle, the collarbone, connected by ligaments to both breastbone and shoulder-blade.
9 Greater tubercle, a bony projection on the humerus to which muscles attach.
10 Scapula, the shoulder-blade.
11 Sternum, breastbone.
12 Ribs.
13 Thoracic vertebrae.
14 Humerus, the upper arm bone.
15 The epicondyles, bony projections at the elbow to which muscles attach.
16 Lumbar vertebrae.
17 Ilium, the hip bone.
18 Radius, the lateral bone of the fore-arm.
19 The sacrum, bone of five fused vertebrae.
20 Ulna, gives power to the elbow.
21 Coccyx, 'tail' of four fused vertebrae.
22 Pubis, by age 20 fixed to the ilium.
23 The greater trochanter of the femur, bony projection to which muscles attach.
24 Ischium, by age 20 fixed to the pubis.
25 The eight carpal bones of the wrist.
26 Metacarpals, separate bones of the hand that slide over one another.
27 Phalanges, the bones of the fingers.
28 Femur, longest bone in the body.
29 Condyles of the femur, bony projections at the knee to which muscles attach.
30 Patella, the knee-cap.
31 Condyles of the tibia, bony projections to which muscles attach.
32 Head of the fibula.
33 Tibia, the shin-bone.
34 Fibula, to which many muscles and ligaments attach.
35 Malleolus of the tibia, the inside ankle.
36 Malleolus of the fibula, the outside ankle.
37 Talus.
38 The seven tarsal bones that articulate the foot.
39 Calcaneus, the heel-bone.
40 Metacarpals, separate bones lining the foot.
41 Phalanges, the toe bones.

Musculature (female)

42 Occipito frontalis, the muscle of the forehead.
43 Temporalis muscle.
44 Orbicularis oculi, the muscle round the eye.
45 External carotid artery.
46 Zygomaticus major, the upper cheek muscle.
47 Masseter, the main chewing muscle.
48 Orbicularis oris controls the lips.
49 Buccinator stretches the cheeks.
50 Sternocleidomastoid muscle helps move the head on the neck.
51 Trapezius muscle keeps the head upright.
52 Infrahyoid muscles, strap-like muscles that protect the larynx and assist the lower jaw.
53 Deltoid muscle.
54 Subclavian artery, main blood vessel to the arm.
55 Pectoralis major, the big chest muscle.
56 Infraspinatus, a sheet of muscle supporting the shoulder.
57 Brachial artery.
58 Triceps, at the back of the humerus.
59 Biceps, generally larger in men than in women.
60 Latissimus dorsi, a large sheet of muscle that turns the trunk.
61 Flexor carpi radialis, rotates the wrist.
62 External oblique, the outside of the abdomen.
63 Ulnar artery.
64 Flexor carpi ulnaris moves the wrist and outer hand.
65 Gluteus maximus, the buttock.
66 Gluteus medius.
67 Extensor digitorum straightens the fingers.
68 Flexor digitorum bends the fingers.
69 Sartorius moves the thigh.
70 Biceps femoris.
71 Semitendinosus.
72 Iliotibial tract, main power for the lower leg.
73 Rectus femoris controls knee movement.
74 Vastus lateralis.
75 Femoral artery.
76 Vastus medialis.
77 The patellar ligament over the knee-cap.
78 Gastrocnemius, the strength of the leg.
79 Posterior tibial artery.
80 Tibialis anterior helps to raise the foot.
81 Peroneus longus.
82 Soleus.
83 Extensor digitorum longus moves the toes.
84 Tendo calcaneus, the Achilles tendon.
85 Arcuate artery services the foot muscles.
86 The muscle masses of the sole.

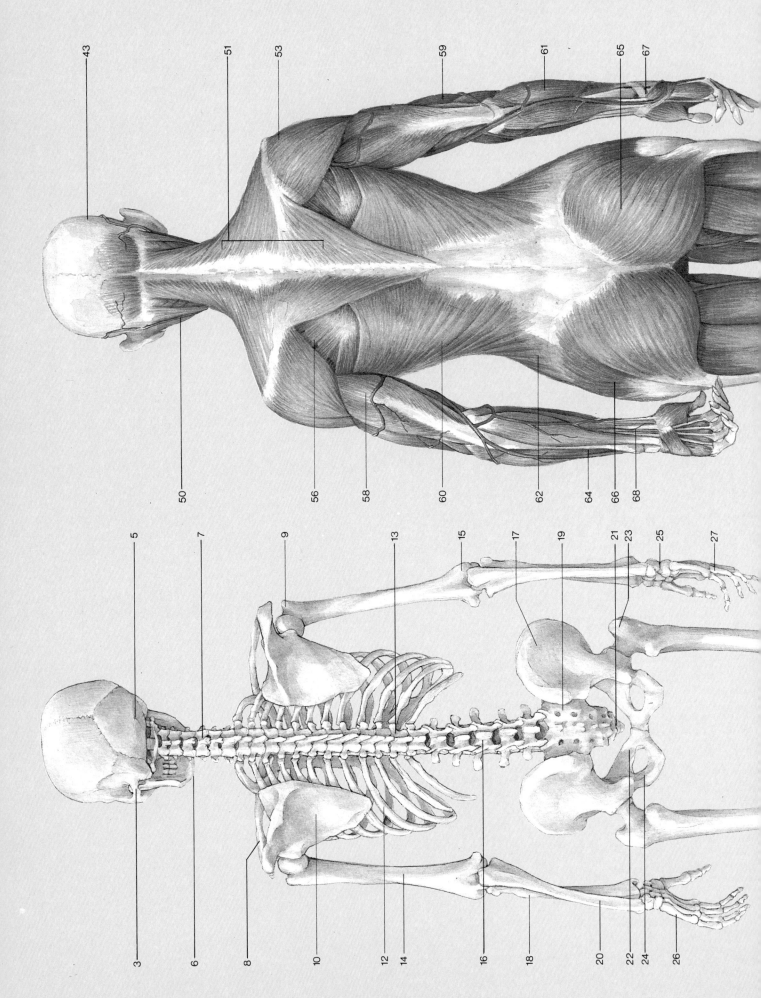

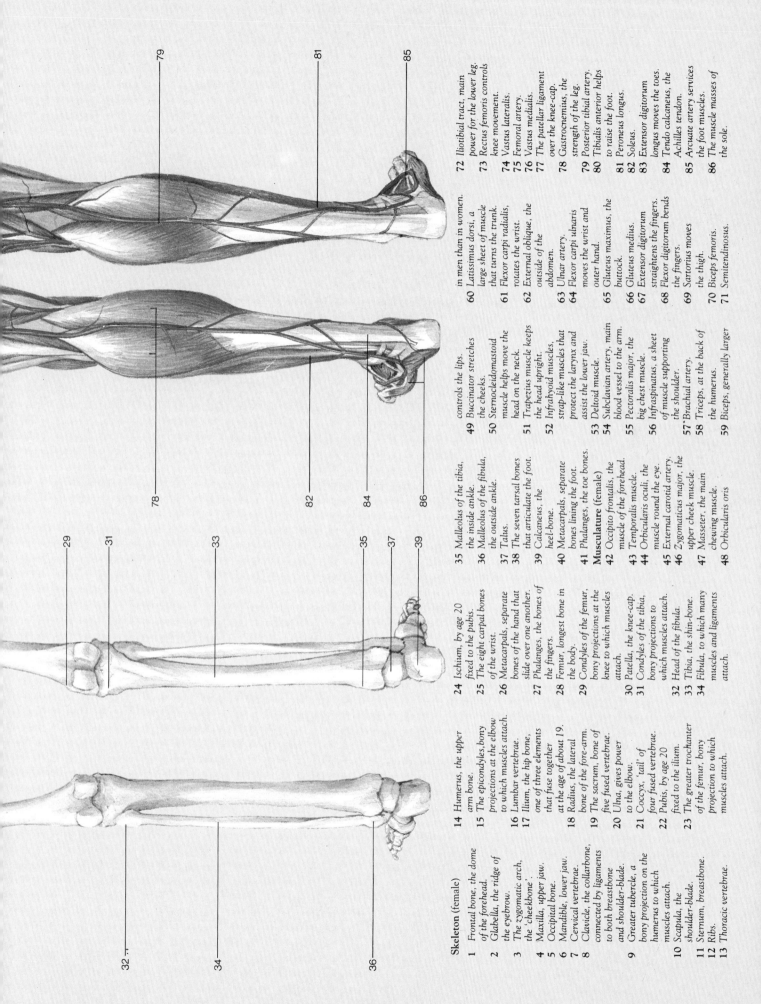

Skeleton (female)

1 Frontal bone, the dome of the forehead.
2 Glabella, the ridge of the eyebrow.
3 The zygomatic arch, the 'cheekbone'.
4 Maxilla, upper jaw.
5 Occipital bone.
6 Mandible, lower jaw.
7 Cervical vertebrae.
8 Clavicle, the collarbone, connected by ligaments to both breastbone and shoulder-blade.
9 Greater tubercle, a bony projection on the humerus to which muscles attach.
10 Scapula, the shoulder-blade.
11 Sternum, breastbone.
12 Ribs.
13 Thoracic vertebrae.

14 Humerus, the upper arm bone.
15 The epicondyles, bony projections at the elbow to which muscles attach.
16 Lumbar vertebrae.
17 Ilium, the hip bone.
18 Radius, the lateral bone of the fore-arm.
19 The sacrum, bone of five fused vertebrae.
20 Ulna, gives power to the elbow.
21 Coccyx, 'tail' of four fused vertebrae.
22 Pubis, by age 20 fixed to the ilium.
23 The greater trochanter of the femur, bony projection to which muscles attach.

24 Ischium, by age 20 fixed to the pubis.
25 The eight carpal bones of the wrist.
26 Metacarpals, separate bones of the hand that slide over one another.
27 Phalanges, the bones of the fingers.
28 Femur, longest bone in the body.
29 Condyles of the femur, bony projections at the knee to which muscles attach.
30 Patella, the knee-cap.
31 Condyles of the tibia, bony projections to which muscles attach.
32 Head of the fibula.
33 Tibia, the shin-bone.
34 Fibula, to which many muscles and ligaments attach.

35 Malleolus of the tibia, the inside ankle.
36 Malleolus of the fibula, the outside ankle.
37 Talus.
38 The seven tarsal bones that articulate the foot.
39 Calcaneus, the heel-bone.
40 Metacarpals, separate bones lining the foot.
41 Phalanges, the toe bones.

Musculature (female)

42 Occipito frontalis, the muscle of the forehead.
43 Temporalis muscle.
44 Orbicularis oculi, the muscle round the eye.
45 External carotid artery.
46 Zygomaticus major, the upper cheek muscle.
47 Masseter, the main chewing muscle.
48 Orbicularis oris

controls the lips.
49 Buccinator stretches the cheeks.
50 Sternocleidomastoid muscle helps move the head on the neck.
51 Trapezius muscle keeps the head upright.
52 Infrahyoid muscles, strap-like muscles that protect the larynx and assist the lower jaw.
53 Deltoid muscle.
54 Subclavian artery, main blood vessel to the arm.
55 Pectoralis major, the big chest muscle.
56 Infraspinatus, a sheet of muscle supporting the shoulder.
57 Brachial artery.
58 Triceps, at the back of the humerus.
59 Biceps, generally larger

in men than in women.
60 Latissimus dorsi, a large sheet of muscle that turns the trunk.
61 Flexor carpi radialis, rotates the wrist.
62 External oblique, the outside of the abdomen.
63 Ulnar artery.
64 Flexor carpi ulnaris moves the wrist and outer hand.
65 Gluteus maximus, the buttock.
66 Gluteus medius.
67 Extensor digitorum straightens the fingers.
68 Flexor digitorum bends the fingers.
69 Sartorius moves the thigh.
70 Biceps femoris.
71 Semitendinosus.

72 Iliotibial tract, main power for the lower leg.
73 Rectus femoris controls knee movement.
74 Vastus lateralis.
75 Femoral artery.
76 Vastus medialis.
77 The patellar ligament over the knee-cap.
78 Gastrocnemius, the strength of the leg.
79 Posterior tibial artery.
80 Tibialis anterior helps to raise the foot.
81 Peroneus longus.
82 Soleus.
83 Extensor digitorum longus moves the toes.
84 Tendo calcaneus, the Achilles tendon.
85 Arcuate artery services the foot muscles.
86 The muscle masses of the sole.

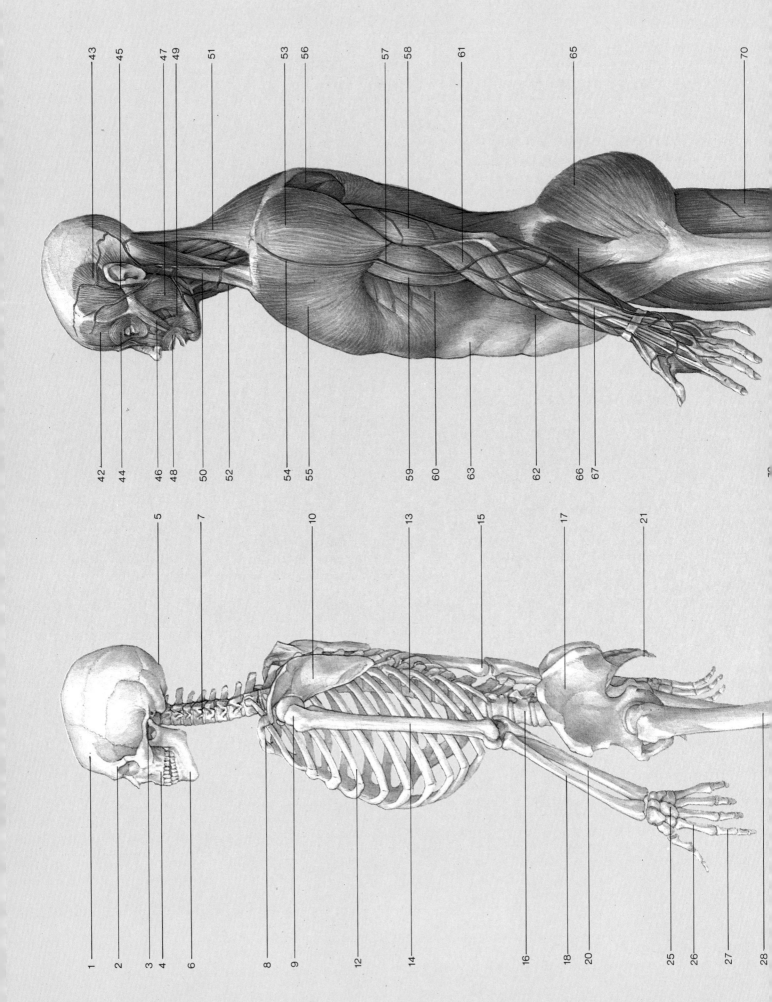

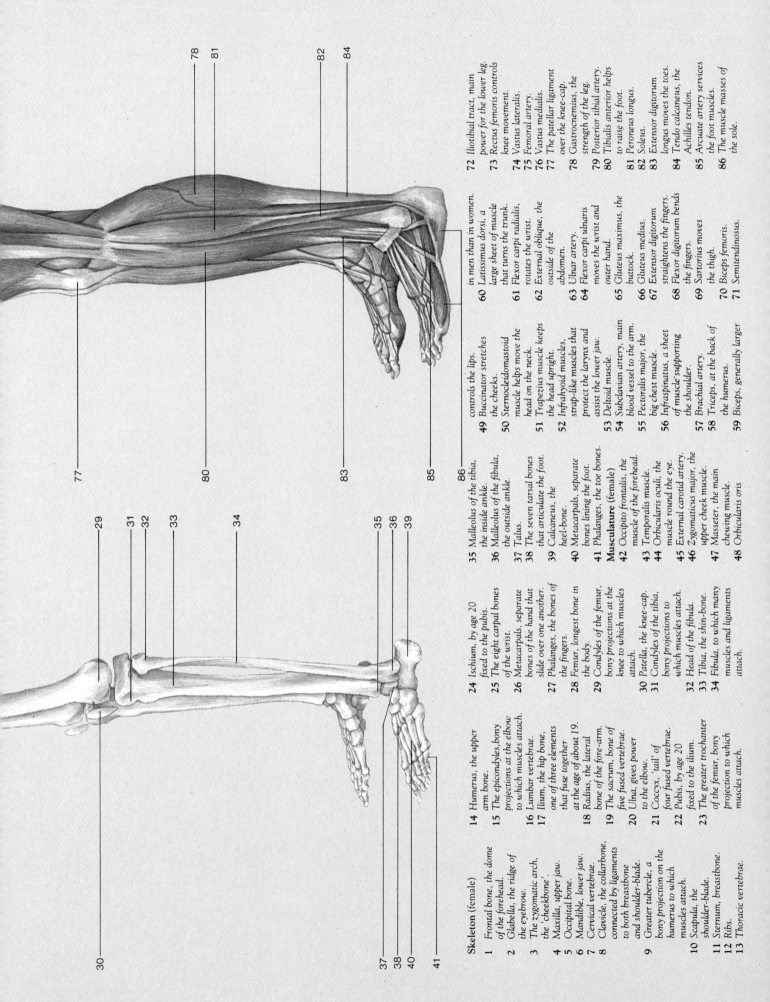

Skeleton (female)

1 Frontal bone, the dome of the forehead.
2 Glabella, the ridge of the eyebrow.
3 The zygomatic arch, the 'cheekbone'.
4 Maxilla, upper jaw.
5 Occipital bone.
6 Mandible, lower jaw.
7 Cervical vertebrae.
8 Clavicle, the collarbone, connected by ligaments to both breastbone and shoulder-blade.
9 Greater tubercle, a bony projection on the humerus to which muscles attach.
10 Scapula, the shoulder-blade.
11 Sternum, breastbone.
12 Ribs.
13 Thoracic vertebrae.

14 Humerus, the upper arm bone.
15 The epicondyles, bony projections at the elbow to which muscles attach.
16 Lumbar vertebrae.
17 Ilium, the hip bone.
18 Radius, the lateral bone of the fore-arm.
19 The sacrum, bone of five fused vertebrae.
20 Ulna, gives power to the elbow.
21 Coccyx, 'tail' of four fused vertebrae.
22 Pubis, by age 20 fixed to the ilium.
23 The greater trochanter of the femur, bony projection to which muscles attach.

24 Ischium, by age 20 fixed to the pubis.
25 The eight carpal bones of the wrist.
26 Metacarpals, separate bones of the hand that slide over one another.
27 Phalanges, the bones of the fingers.
28 Femur, longest bone in the body.
29 Condyles of the femur, bony projections at the knee to which muscles attach.
30 Patella, the knee-cap.
31 Condyles of the tibia, bony projections to which muscles attach.
32 Head of the fibula.
33 Tibia, the shin-bone.
34 Fibula, to which many muscles and ligaments attach.

35 Malleolus of the tibia, the inside ankle.
36 Malleolus of the fibula, the outside ankle.
37 Talus.
38 The seven tarsal bones that articulate the foot.
39 Calcaneus, the heel-bone.
40 Metacarpals, separate bones lining the foot.
41 Phalanges, the toe bones.

Musculature (female)
42 Occipito frontalis, the muscle of the forehead.
43 Temporalis muscle.
44 Orbicularis oculi, the muscle round the eye.
45 External carotid artery.
46 Zygomaticus major, the upper cheek muscle.
47 Masseter, the main chewing muscle.
48 Orbicularis oris controls the lips.
49 Buccinator stretches the cheeks.
50 Sternocleidomastoid muscle helps move the head on the neck.
51 Trapezius muscle keeps the head upright.
52 Infrahyoid muscles, strap-like muscles that protect the larynx and assist the lower jaw.
53 Deltoid muscle.
54 Subclavian artery, main blood vessel to the arm.
55 Pectoralis major, the big chest muscle.
56 Infraspinatus, a sheet of muscle supporting the shoulder.
57 Brachial artery.
58 Triceps, at the back of the humerus.
59 Biceps, generally larger in men than in women.
60 Latissimus dorsi, a large sheet of muscle that turns the trunk.
61 Flexor carpi radialis, rotates the wrist.
62 External oblique, the outside of the abdomen.
63 Ulnar artery.
64 Flexor carpi ulnaris moves the wrist and outer hand.
65 Gluteus maximus, the buttock.
66 Gluteus medius.
67 Extensor digitorum straightens the fingers.
68 Flexor digitorum bends the fingers.
69 Sartorius moves the thigh.
70 Biceps femoris.
71 Semitendinosus.

72 Iliotibial tract, main power for the lower leg.
73 Rectus femoris controls knee movement.
74 Vastus lateralis.
75 Femoral artery.
76 Vastus medialis.
77 The patellar ligament over the knee-cap.
78 Gastrocnemius, the strength of the leg.
79 Posterior tibial artery.
80 Tibialis anterior helps to raise the foot.
81 Peroneus longus.
82 Soleus.
83 Extensor digitorum longus moves the toes.
84 Tendo calcaneus, the Achilles tendon.
85 Arcuate artery services the foot muscles.
86 The muscle masses of the sole.

Musculature of the back of the body

The muscles located in the back of the human body have, in common with all muscles, functions to perform.

Trunk muscles The trunk has important underlying muscles some of which rise to the surface and affect superficial form. Other deeper muscles do not, but their purpose is so central to the character of normal human form that they must be discussed in relation to the back as a whole. As we have seen, the spine comprises a series of related bones, structured to allow for a wide range of movement with maximum support in each position. Without major muscular processes, however, it would not be able to sustain the erect position, so one major function of muscles in the region is support. The erector spinae is the major muscle in this context. It runs down the side of the spine and, together with its twin, provides powerful support for the bones comprising the spine. It has its origin in the posterior and spines of the sacrum, in addition to the posterior superior iliac spinae and the upper part of that bone. Its fibers are complicated in arrangement, because the muscle separates and inserts into the ribs, but, viewed overall, it is a powerful column of muscle — and, with its partner, forms the ridges which straddle the spine. Because of the strength and depth of these muscles, the vertebrae run in a groove between the pair of them; overlaid onto the whole process, are other very powerful and more obviously visible muscles.

The trapezius is so named because of the four-sided figure which is formed with the muscles of opposite sides. Its origin is in the middle of the back, rising above to the back of the skull, and then finding its insertion down in the last thoracic vertebra. The fibers of the muscle reach into the outer part of the clavicle and are seen along the border of the acromion process of the scapula. All this muscle is superficial and can easily be seen on the surface. Its action is needed in many movements of the arm and neck; when in contraction it bunches to fully demonstrate its form.

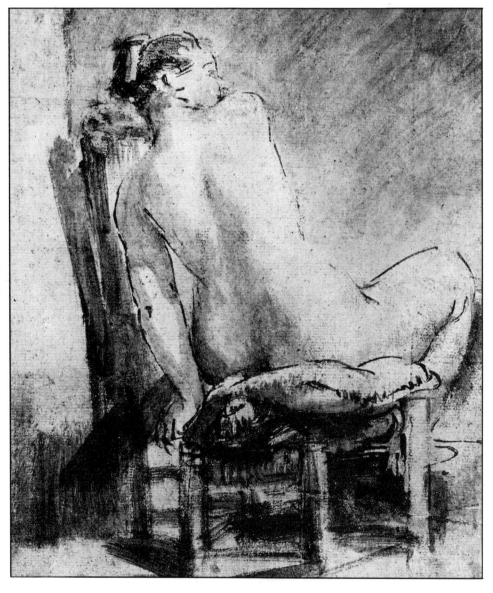

This study by Rembrandt (1606-69) shows how the Master could with a pure line and delicate modelling produce a figure study of great quality. His knowledge of anatomy is not allowed to subdue his inspiration so that the sketch demonstrates a facility and lightness of touch.

The latissimus dorsi is a great mass of muscle in the back. It arises from extensive origins on the spines of the lumbar and sacral vertebrae and travels up to attach its fibrous flesh in the fold of the armpit. It is visible over the lower half of the trunk and in its upper regions it is overlaid by the trapezius, with the erector spinae below it. At its lower end, the latissimus dorsi is attached to the iliac crest and higher up passes over the lower part of the scapula. This muscle is employed when the arm is brought down from the raised position and in the rotation of the upper arm. It is also used when the body is raised through the power of the arms, for example, in push-ups or climbing.

The study of the superficial muscles in the back would be incomplete without the examination of a group which are only seen in part but which, through their action, have influence on the body form. These are the muscles which control the movement of the scapula: teres major, infraspinatus and rhomboid which work together to pull the arm backwards. Teres major links the scapula to the upper shaft of the humerus. The infraspinatus also has attachment to the scapula but meets the humerus at its head. For most purposes, these two muscles are considered as one fleshy mass. Together with its deep-seated neighbor, teres minor, teres major acts to rotate the arm inwards and both the teres major and infraspinatus work together to pull the arm backwards.

The external oblique muscle has already been discussed in the description of the front view of the trunk but a significant portion of it is also visible on the back. As it comes down to make attachment to the iliac crest of the pelvis, it wraps around to be partly overlaid by latissimus dorsi.

Muscles of the buttocks One of the most significant visual characteristics, not only of the back, but of the whole human form, is the buttocks. So much is dependent on development and individual shapes in this region — aspects of balance, of movement and of locomotion are all involved. As a mass, as part of the overall body system, what we normally see is, of course, the result of subcutaneous fat — especially in the female. But, underlying this is a complex system of immensely powerful muscles — interrelated and interdependent — and both in form and function they are invariably of significance to the artist. The forms, as they appear to the viewer, vary a great deal according to the position of the legs. It can be readily observed that movement of the lower leg, through lifting, flexing and extending, will take the superficial look of the buttocks from a sharp definition at the base — that is at the junction of buttock and thigh — through to virtual obliteration of the change of angle.

The great flexing muscle of the buttock is the gluteus maximus. It has extensive origin from the upper part of the pelvis, from the lower parts of the same bony process, and from the coverings of the erector spinae muscle. Taken as a pair, the origins suggest that together they make a v-shaped form at the base of the back and this can be easily made out in the living model. The gluteus maximus muscle is superficial throughout and acts as a powerful extensor of the hip joint — straightening the thigh — and is employed in several other important movements, for example, when the trunk needs to be brought to the erect position from being bent forward over the thighs. It is also a powerful factor in actions such as jumping, running up stairs and other movements and is used in abduction and adduction as well as the outward rotation of the thigh. Man's erect stature is in no small part attributable to this great muscle and as we look from its location at the meeting of back and upper thigh, then the manner in which the transition takes place into the thigh is very important.

Leg muscles In its lower insertion, gluteus maximus runs into the outer fascia of the side of the thigh. This fascia is the strong fibrous substance which sheaths the thigh. From the center of the back of the thighs, there runs a pair of muscles, semitendinosus and biceps femoris. The origin of both is in the lower part of the pelvis and, after travelling side by side for the greater part of their length, they separate behind the knee — semitendinosus inserts into the head of the tibia, biceps femoris into the fibula. To the outer side of these two muscles is seen vastus lateralis and the fascia covering the outer side of the thigh. On its inner side is semimembranosus, which underlies semitendinosus and appears to either side of it. It is employed in rotating the thigh. Adductor magnus, gracilis and sartorius are seen in part of the inner edge of the thigh.

Travelling down to the lower leg, the major muscular feature is the triceps — the gastrocnemius muscle. It has two heads which unite in the middle, and the third head of the complex — the lower head — called soleus is more deeply seated. The triceps has its origin in the femur, whereas the soleus has its origin in the upper third of both bones of the lower leg. Further down, all three converge into the feature commonly known as the Achilles tendon, properly called tendo calcaneus. Below and to the sides of these major muscles, it is possible to distinguish parts of muscles and tendons located in the front and side of the leg.

Muscles of the arm The overall form of the arm should be understood by the artist before he moves on to examine the muscles in detail. The arm hinges at the elbow and has a wide range of movements both in relation to the

trunk and within itself. It can rotate, lift, and even support the weight of the entire body; it can be used to propel objects and control the movement of the fingers so finely that cotton can be passed through the eye of a needle. The arm is thickest just below the elbow and it tapers down to the wrist. Above the elbow is a power-house of muscle — strong, versatile, fibrous muscles at the front, to the side and at the back of the upper arm. There are no isolated lower or upper arm forms — each curve interrelates with another and functions are, similarly, closely related.

We have looked at the deltoid from the point of view of its association to the muscles of the front. But, as has been said, it is a muscle which appears not only on the front, but to the side and on the back of the body too. It forms a link between the chest, the back and the arm and plays an important part in the form of the arm.

The muscle which carries the responsibility for bending the arm is biceps. Its origin is in the shoulder joint and its insertion in the radius and ulna. To straighten the arm, the muscle brought into use is triceps which runs down the back of the upper arm. Both these muscles affect the appearance of the arm and are therefore important to the artist. In addition, the upper arm has on its surface the following muscles: brachialis which is covered by the biceps for much of its length and biceps brachi which lies on the humerus and is concerned in the action of pronation. Brachialis itself flexes the forearm.

Travelling from the upper arm into the forearm is a pair of muscles which looks like one, the supinator longus and extensor carpi radialis longus. The contour of the side and front of the elbow region is greatly affected by them and they are of use in rotating the radius and in moving the hand. Other visible superficial muscles of the lower arm are extensor carpi radialis brevis, extensor digitorum and extensor digiti minimi. Between them, these muscles exercise control over the movements of the fingers; in the case of extensor digitorum, it divides into four flat tendons which travel across the wrist and down to be inserted into the base of each phalanx. Extensor carpi ulnaris has as its function the movement of the hand.

There are a great many deep-seated muscles running all the way down the arm, the forearm and the fingers but, although they are interesting to the artist, it is far more important to acquire an overall appreciation of form, function and character. To study the way muscles arise, and insert is rewarding.

The main range of movements of the hand is contained in the thumb. It receives the attention of many muscles such as the opponeus pollicis, which is involved in the action of moving the thumb in opposition.

This is the term used to describe the position when the thumb is opposite the other fingers and is a major reason for the development of human dexterity and manipulative skills. Each of the fingers is served by muscles which travel down across the wrist, which itself can be described as the connection between forearm and hand. On the back of the hand are the flexor tendons and, on the front, the muscles of the palm. These muscles are divided into three groups: the thenar eminence — the thick and prominent ones of the thumb — the hypothenar eminence, and the palmar excavation — the muscles of the palm.

Front view of the muscles of the head and neck

The head is obviously of great significance in the drawing of the figure and the set of the head on the neck is also very important. Within the total head form is contained the face, which varies in size according to several factors such as sex, age and individual characteristics. The way the neck sits on the thorax and grows from the trunk is to be considered first — so often the angle, the seating and the shape of the neck in relation to both head and body are misunderstood.

The neck can be rotated from its central position in either direction by about 30° and the muscles which make this possible are mostly deep-seated and so have little immediate effect on the superficial form. There are many muscles needed to hold the neck vertebrae erect and, with the various tissues and tendons, they form a very strong column indeed. The front of the neck is not only affected by the muscles, but has an appearance greatly influenced by the alimentary canal and the respiratory system. But, from the artist's point of view, it is the superficial musculature and some aspects of these essential systems which affect the surface. The windpipe, the adam's apple and the thyroid are features whose names are in common currency and these do affect surface form although the muscles and bones do not. The functions of such features are not especially important to the artist except when the neck is thrown back or depressed into the chest when they become evident.

The muscle which is most defined on the surface of the front of the neck is sternocleidomastoid. It is attached to the clavicle and the sternum and runs upwards to be visible again in the area of the skull immediately behind the ear. The large protuberance felt behind the ear, and into which the muscle is integrated, is called the mastoid process. It is part of the temporal bone of the skull — and one significant way of showing differences between individuals in portraiture is by observing very closely the shape, form and variations of the

direction and insertions of the sternocleidomastoid. The two sternocleidomastoid muscles converge in the neck and are inserted into the upper end of the sternum. The effect of both this point of insertion and the body of muscle itself has a profound influence on the look of the neck. Between the pronounced v-shape of the sternocleidomastoid is the complicated form of larynx and adam's apple. But the importance of the contribution to surface forms made by these two muscles cannot be overstated — in almost all action and movement of the model, they are apparent and extremely significant. The deep trough between the points of insertion of these two is called the sterno-clavicular joint.

It is interesting to compare the head of man with the heads of other animals with regard to the posture. Because, in the human, the head is balanced on a vertical column, some deep-seated muscles in the neck are feeble compared with the equivalent in some other animals, for example, a dog, where very strong supporting muscles are needed to hold the head out from the body. The range of movement in a man's neck is wide and this too has led to the need for certain developments.

Back view of the muscles of the head and neck

The head and neck as seen from behind are dominated superficially by trapezius, sternocleidomastoid and smaller deeper muscles. The strength of trapezius has already been discussed, as has its participation in the movements of the head on the shoulders. The great strength and power contained in its mass contrasts well with the range of smaller facial and neck muscles nearby. These contribute to many movements, some of which are infinitely subtle.

Muscles of the face

The face is very mobile in character. It comprises large and small muscles capable together of a very wide span of activity. The cranium is seen from the front of the head at the topmost part and from it descends an important sheath of muscle called frontalis. This forehead muscle has its origin in the muscles above the eye and radiates out from the front of the skull. Orbicularis oculi is the muscle of the eye, it covers both eyelids and surrounds the orbit. Its action is to close the eyes by depressing the eyelids. The corrugator is involved in the actions of the eyebrow and brings the two eyebrows together.

Further down the face, we come across compressor nasi — a flat, triangular muscle which lies to the side of the nose. It can narrow the nostrils and pull the nose down. Orbicularis oris encircles the mouth and takes responsibility for closing the mouth, pursing the lips as, for example, in kissing. It originates in the maxilla and mandible, that is, in both the upper and lower jaws. A three-headed muscle, which associates with the side of the nose below the orbicularis oculi, is the quadratus labii superioris. Its function is to raise the upper lip. Deeper, but still significant in influencing surface form, is levator anguri oris which effects the angle of the mouth. An extremely important muscle, which, on many faces, can be traced along its total length, is the zygomaticus major. It takes its origin in the outer surface of the zygomatic bone and is inserted into the angle of the mouth. It has significance in actions such as extreme openings and vigorous movements of the mouth, for example, when a person grimaces, yawns or screams.

The mentalis is a short muscle below the mouth form. It affects the movement of the skin on the chin. Small muscles such as depressor anguli oris and depressor labii inferioris are used in actions of the mouth, but the two major muscles which control the actions of mastication are seen to the sides of the face. These are masseter and temporalis. The masseter is a short thick muscle which has its origin in the zygomatic arch and inserts into the mandible. In action, it pushes the jaw upwards and is involved with any energetic closing of the mouth. Temporalis is a large fan-like muscle which has its origin in the temporal fossa of the side of the skull. It is inserted into a point below the zygomatic arch, by which time it has become a converging tendinous bunch. This muscle is also involved in traction of the lower jaw and extreme movements of the mouth.

Because the features of the face are always of interest to artists, let us move in closer and look at the individual parts. The organ of sight is the eyeball. It has the cornea on its front surface; the iris contains the colored part of the eye. The ball sits in its socket in the skull and is wholly or partly covered by the eyelid which is a cartilaginous shell. Eyelashes and eyebrows must be carefully observed — the former being longer towards the centre than at their edges. The hairs of the eyebrow generally lie in a lateral direction. The form of the mouth is affected by the shape of the lips and the teeth. The upper lip is longer than the lower and projects out further from the overall form of the face-mask. The base of the nose is called the root and from this point the breadth increases — the tip can be double — and the sides of the nostrils are composed of cartilage. The ear is sited at the level of the zygomatic arch — roughly halfway between the top of the head and the chin. It is a complicated and variable shape, comprising several parts; the artist is interested particularly in its position and seating on the head as the variation between individuals can be quite considerable.

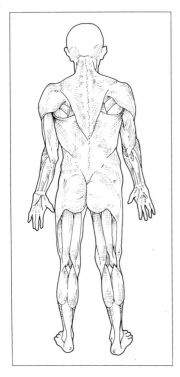

MALE FIGURE

The feet are positioned in this relaxed, standing man to take an even distribution of body weight. Note, in the arms, the outward-splaying angle from elbow to wrist and the backward-facing palm (prone) of the relaxed hand.

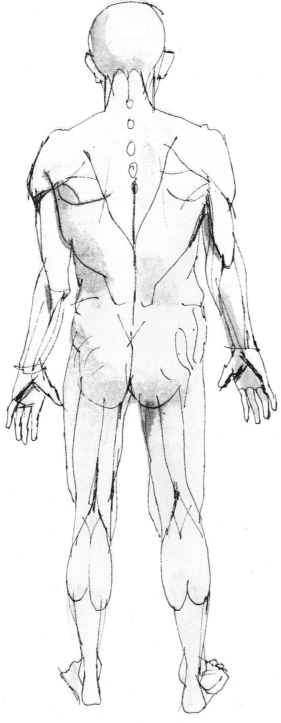

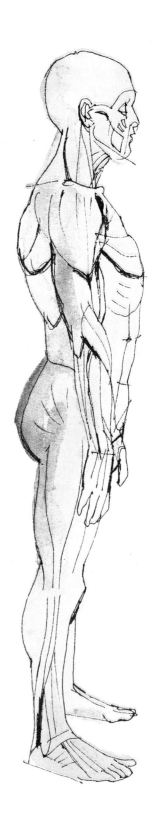

In all views, the slant of the trapezius muscle, between the neck and collar bone (clavicle), can be seen. The side-view demonstrates the curve of the relaxed spine and the angle at which the head meets the neck.

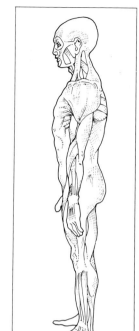

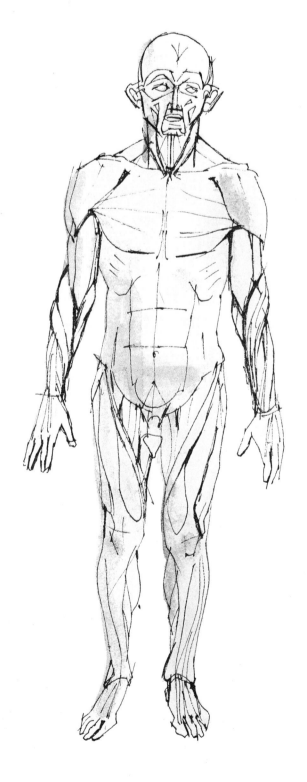

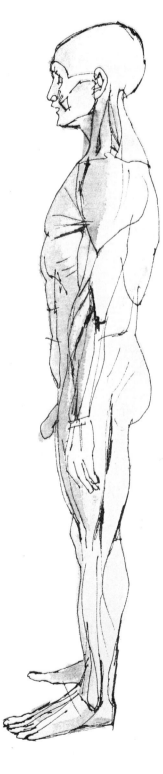

The model here has his hands on the back of his hips, resting on the upper buttock (gluteus medius). In the back-view, the trapezius muscle is flat as the shoulder girdle is raised. The shoulder blades (scapulae), rotated on their axes outwards, can be seen affecting the surface form. As some action is involved the feet are more widely set apart.

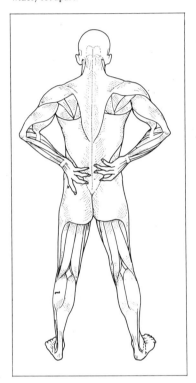

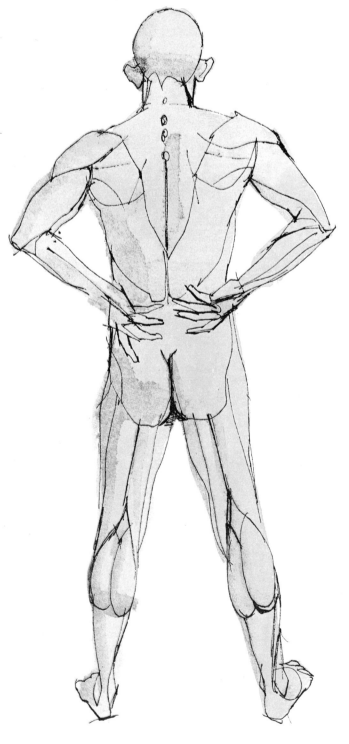

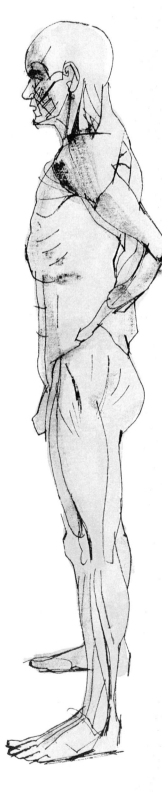

This position forces the shoulders and arms back, thereby clearly revealing the rib cage and the bunching of the upper arm muscles.

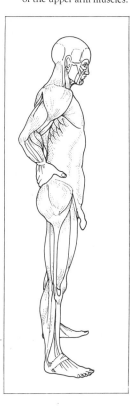

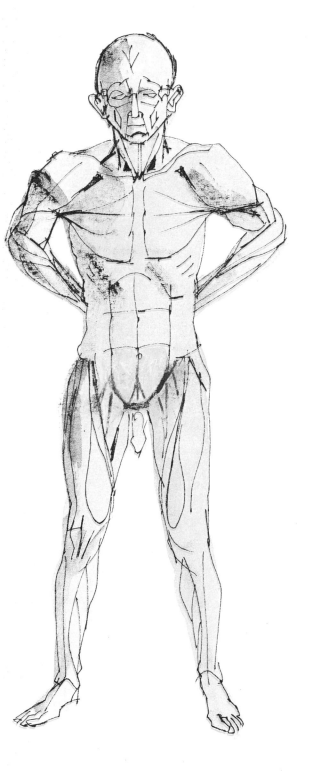

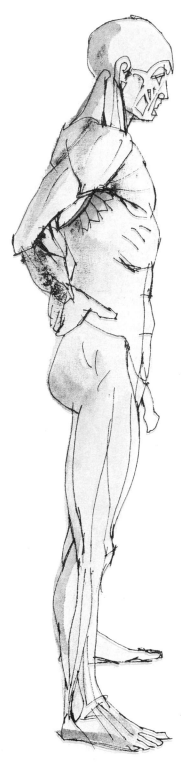

The action here, involving the raised arms and
interlaced hands, affects the attendant muscular
processes of the lower and upper arm and of the back,
particularly the deltoid, capping the shoulder joint,
and the latissimus dorsi, which can be seen originating
under the arm, and then running round to the back.

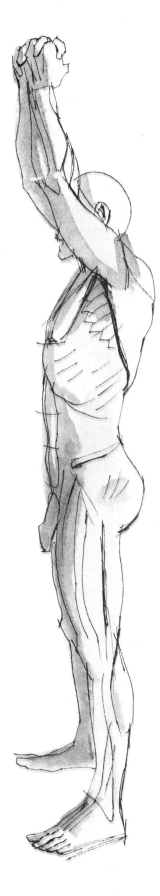

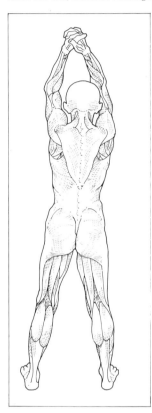

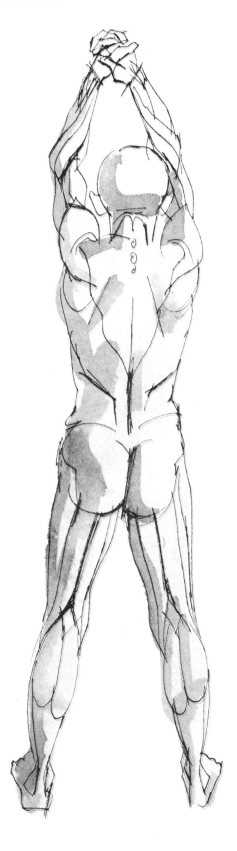

In the side-view, the ridged serratus anterior is easily distinguished under the arm and, lower down on the hip, the ridge of the iliac crest. Although the major action is contained in the upper part of the body, we can see, in the back-view, how the leg and buttock muscles are also involved.

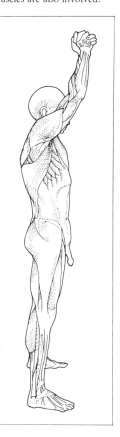

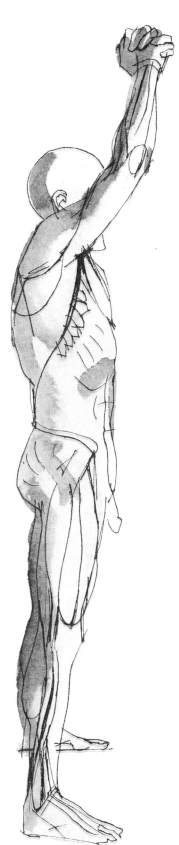

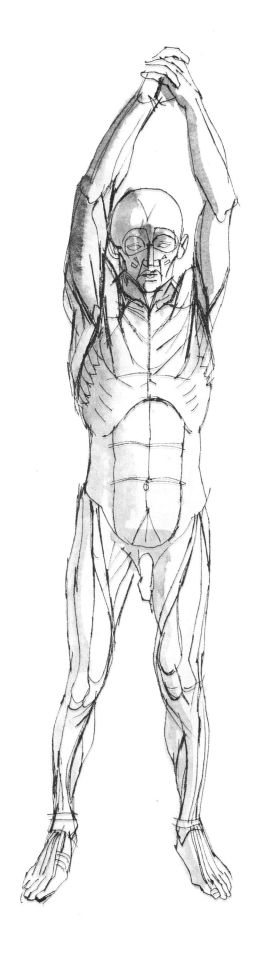

Most of the body here is involved in balance. The platform of the foot is no longer employed, only the toes and ball of the foot. Thus the arms are splayed and positioned forwards to counter the natural pull of the body backwards onto the foot.

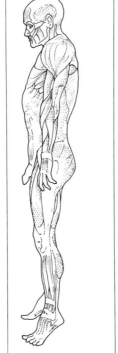

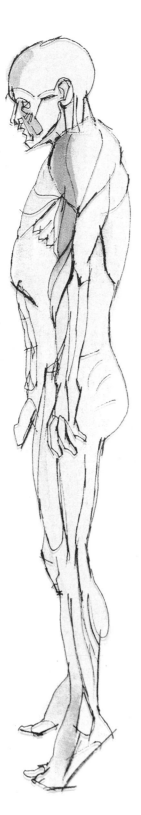

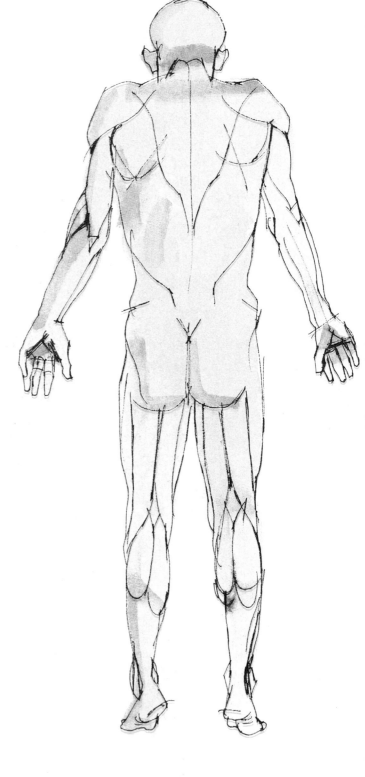

The shoulders are tensed and raised to activate the arms, pushing the neck and head forwards. Such a pose conditions movement of the neck and face muscles and can alter facial expression. Observe the interaction of muscular activity in the legs.

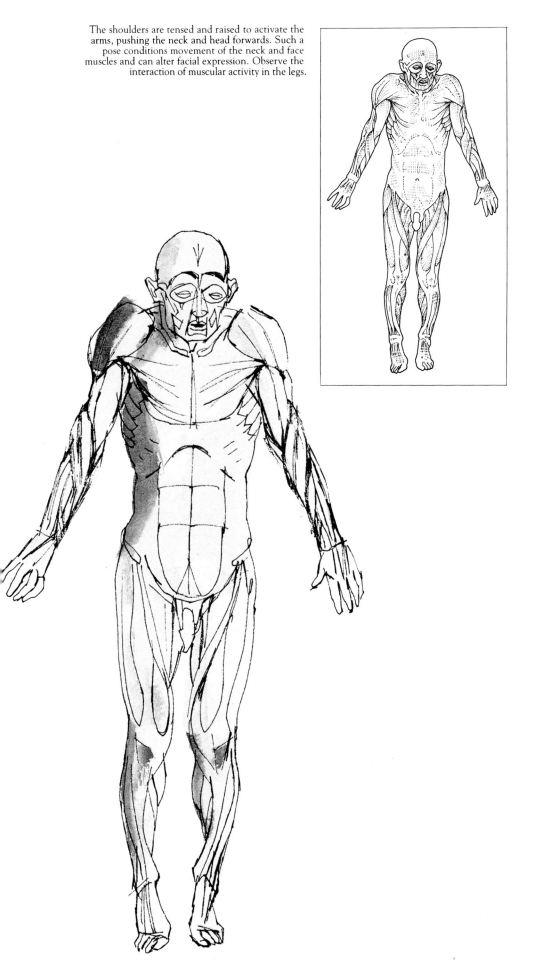

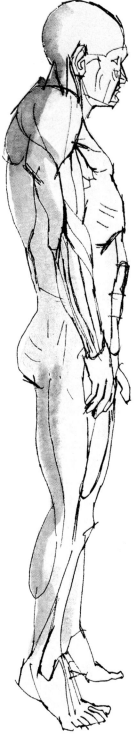

41

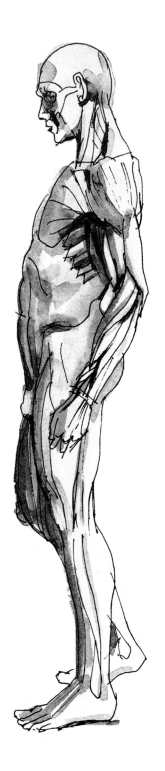

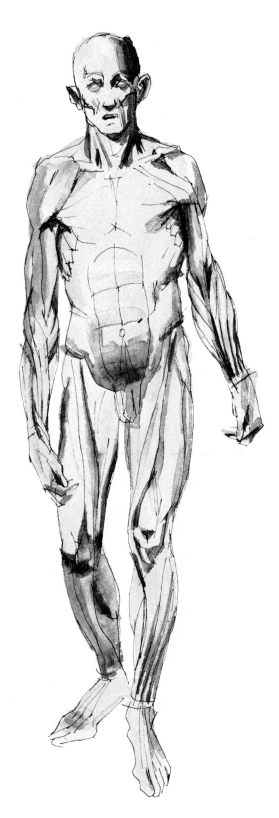

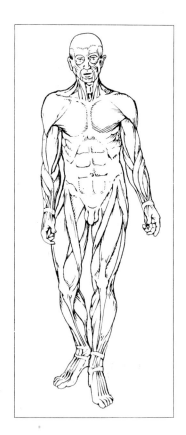

In this relaxed walking pose, the weight is in the process of being transferred from one leg to the other. Almost every muscle is involved in aiding action or balance and compensation — where one part of the body mirrors the direction of action of another.

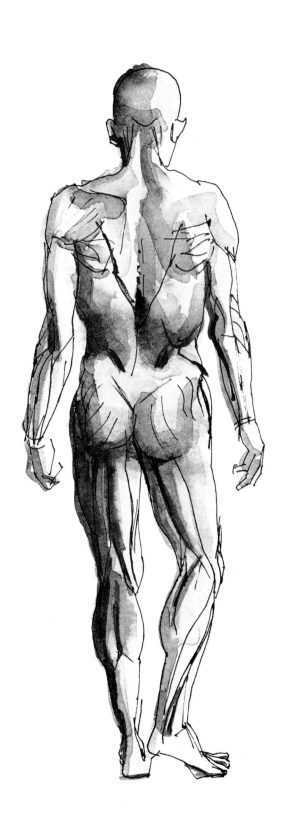

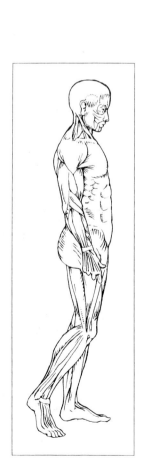

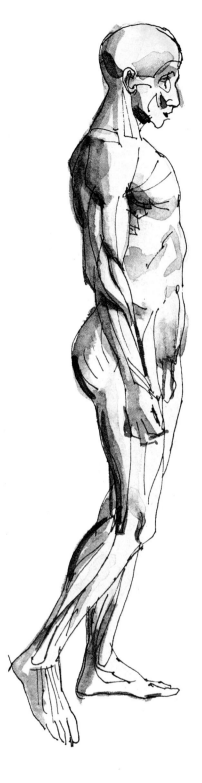

In the right side-view, the bunched muscle of the buttocks (gluteus maximus) can be seen concerned in activating the right leg. The chin is tilted forwards at the moment captured in this pose, but will rise as the right leg moves forwards.

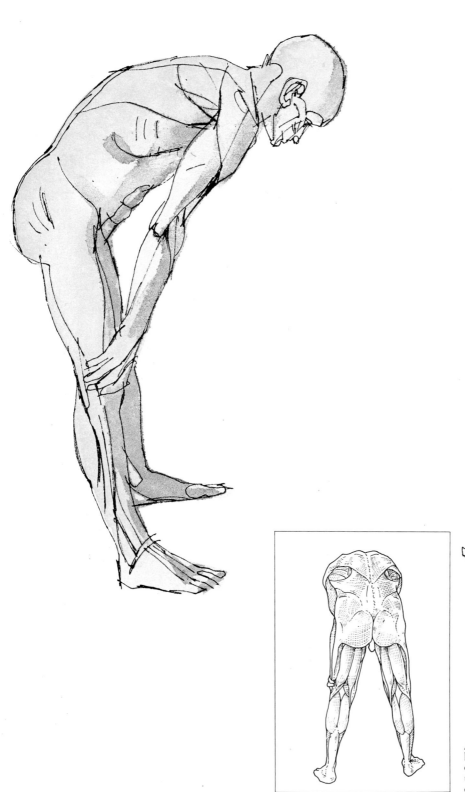

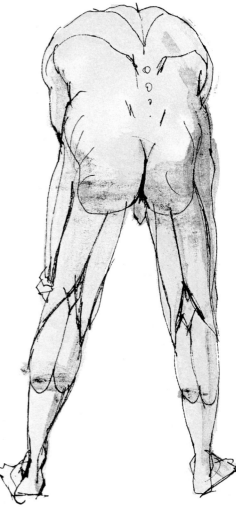

A bending man can comfortably place his hands on his knees. It is as well to know the body's range and limits of movement, otherwise blunders can ensue when uncomfortable poses are represented. Here the balance of the whole body is changed.

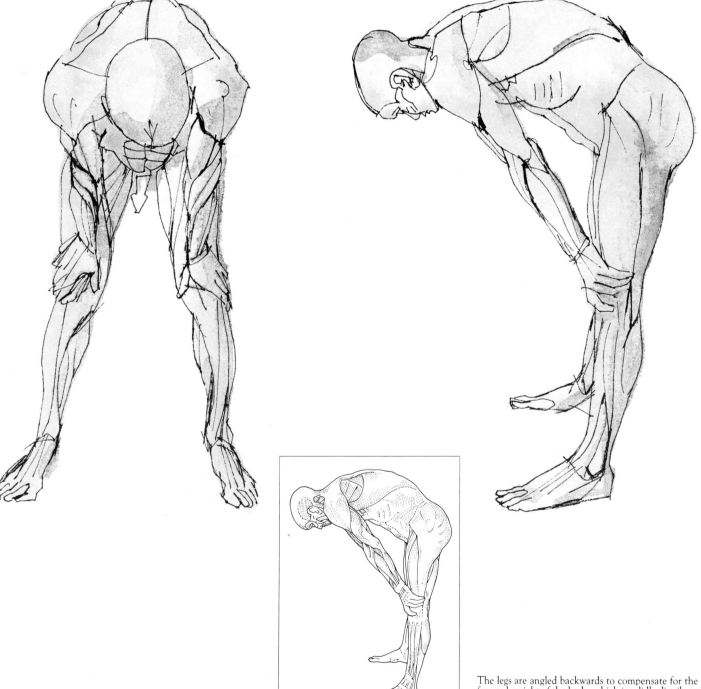

The legs are angled backwards to compensate for the forward-weight of the body, which is solidly distributed on the platform of the feet. The skin of the back is pulled taut over the vertebrae, ribs and scapulae.

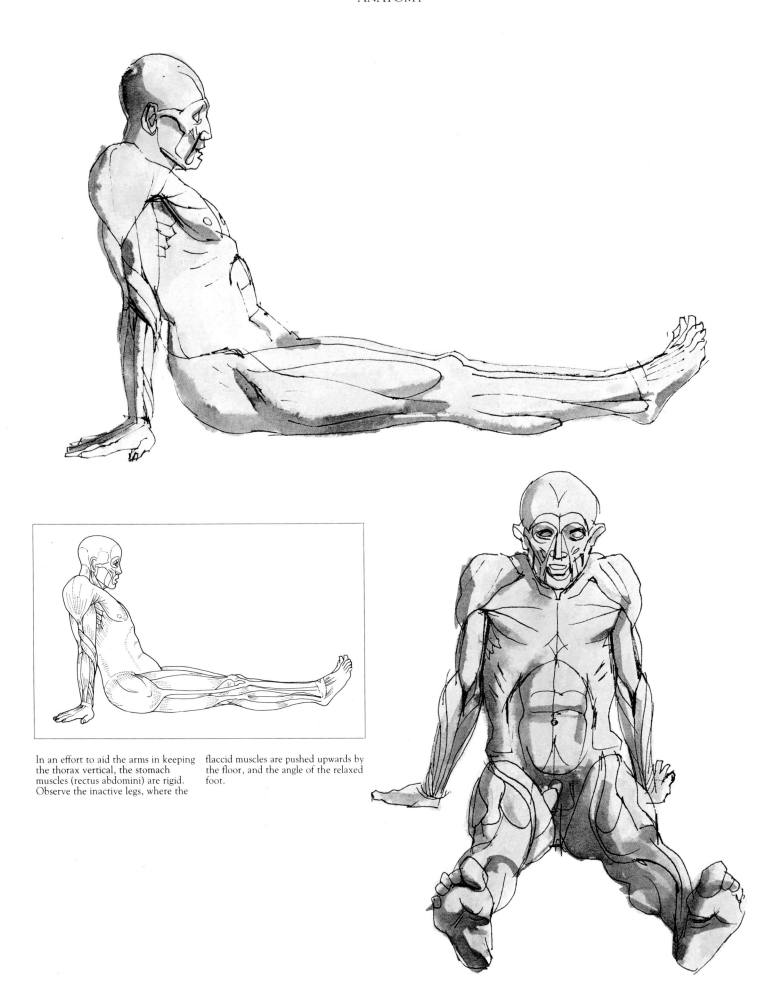

In an effort to aid the arms in keeping the thorax vertical, the stomach muscles (rectus abdomini) are rigid. Observe the inactive legs, where the flaccid muscles are pushed upwards by the floor, and the angle of the relaxed foot.

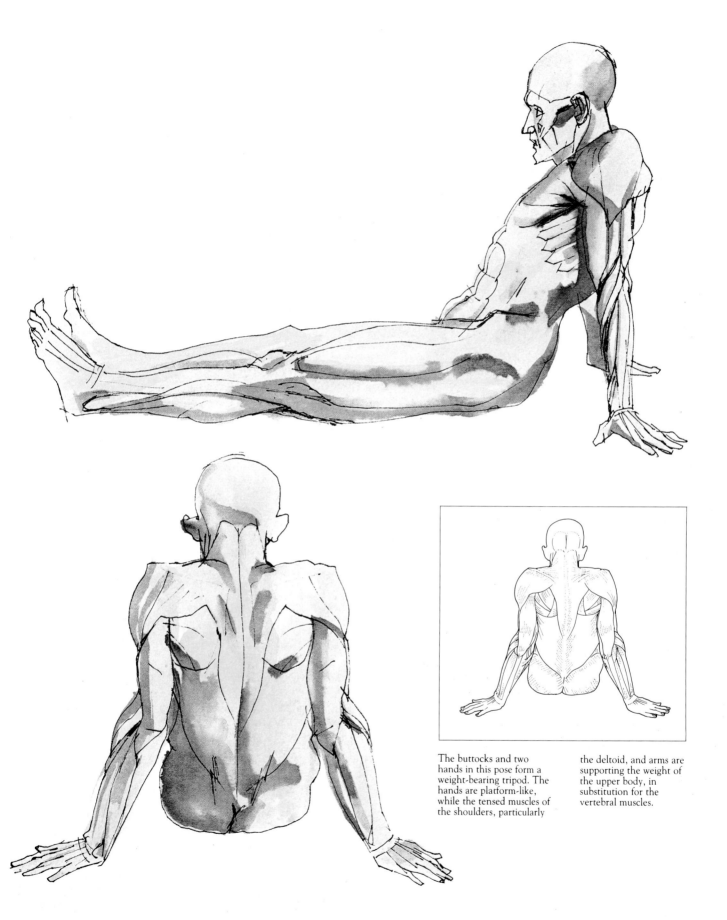

The buttocks and two hands in this pose form a weight-bearing tripod. The hands are platform-like, while the tensed muscles of the shoulders, particularly the deltoid, and arms are supporting the weight of the upper body, in substitution for the vertebral muscles.

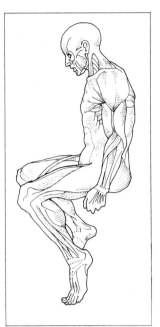

In this relaxed seated pose, the weight is being taken by the base of the spine and buttocks. The shoulders are relaxed forwards, curving the vertebral column, which can be seen, in the back-view, affecting the surface form at the base of the neck.

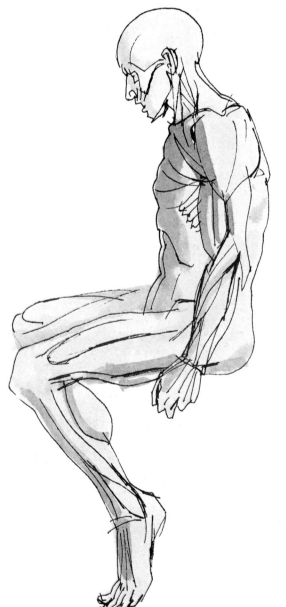

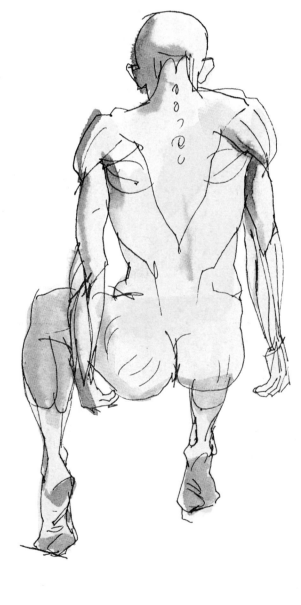

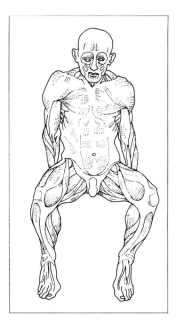

The head and neck are relaxed forwards. It is interesting to note the set of the ears in relation to the trapezius muscle in this position. The action of pushing the leg up onto the ball of the foot tightly tenses the calf muscles (gastrocnemius). The division of this muscle is clearly visible in the back-view.

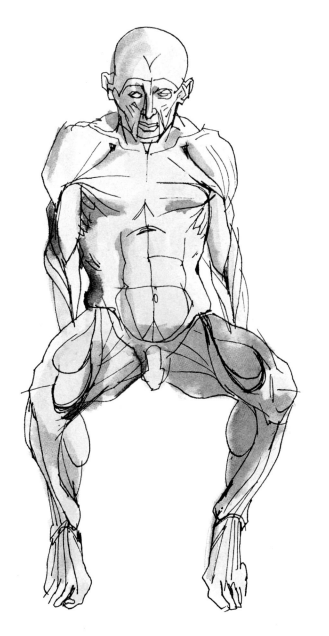

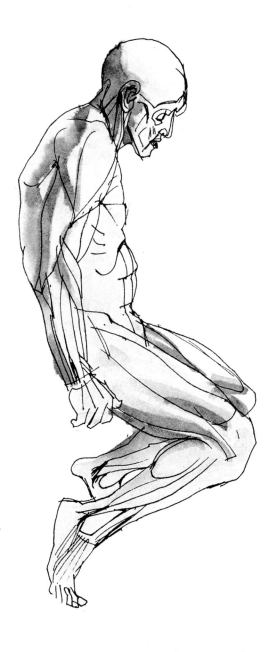

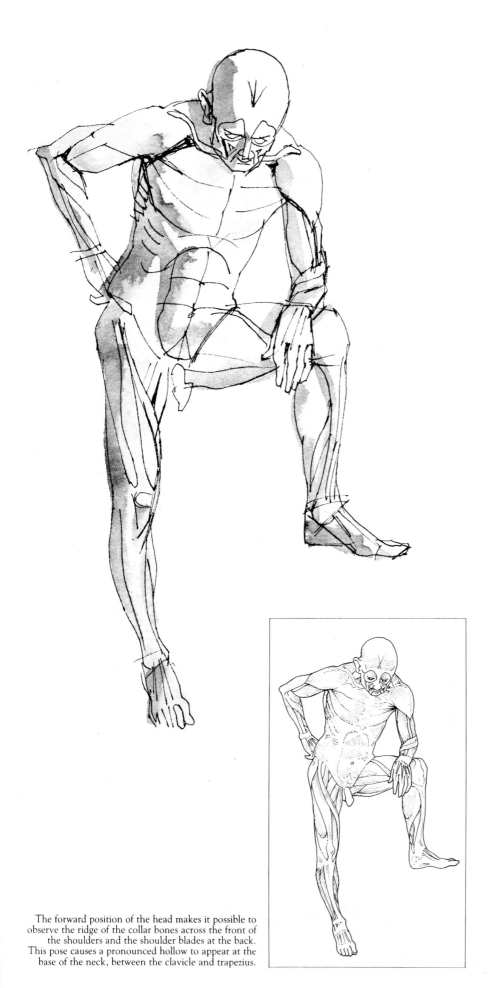

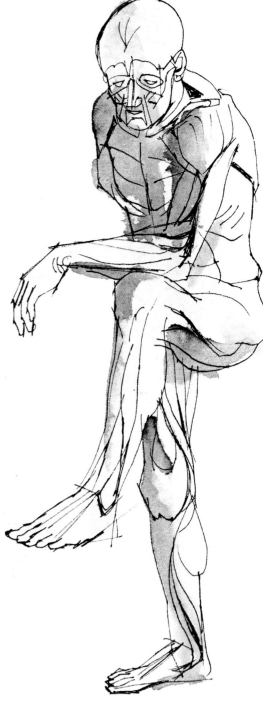

The forward position of the head makes it possible to observe the ridge of the collar bones across the front of the shoulders and the shoulder blades at the back. This pose causes a pronounced hollow to appear at the base of the neck, between the clavicle and trapezius.

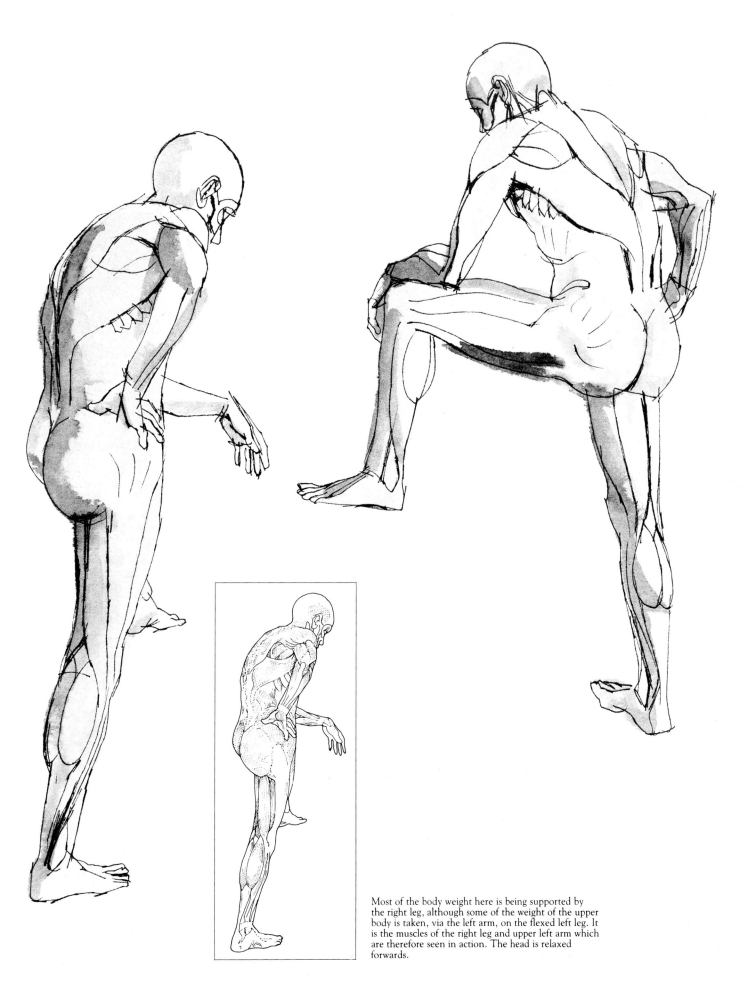

Most of the body weight here is being supported by the right leg, although some of the weight of the upper body is taken, via the left arm, on the flexed left leg. It is the muscles of the right leg and upper left arm which are therefore seen in action. The head is relaxed forwards.

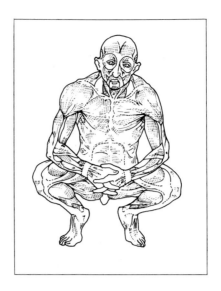

Much of the muscular activity involved in this crouching position is involved in balance. The total body weight is taken by the toes and balls of the feet. The head and upper torso strain forwards to counter-balance the lower torso and buttocks.

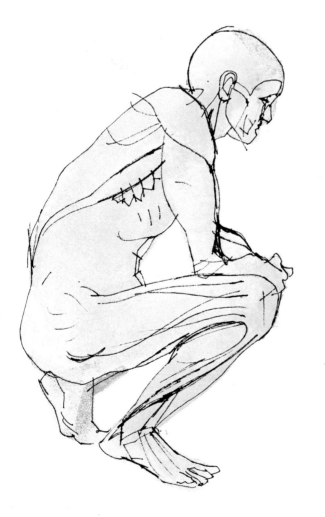

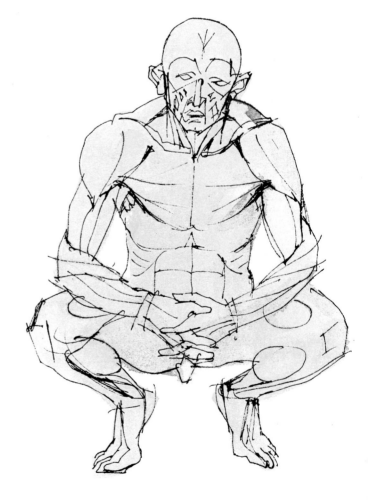

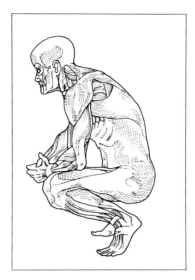

In the back-view, the upper part of the trunk is relaxed, while the lower part is tensed. As the shoulders are pulled forwards by the arms, this stretches the skin of the back over the spines of the upper vertebrae, making them visible on the surface.

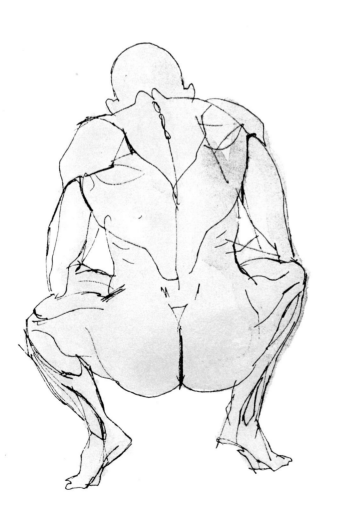

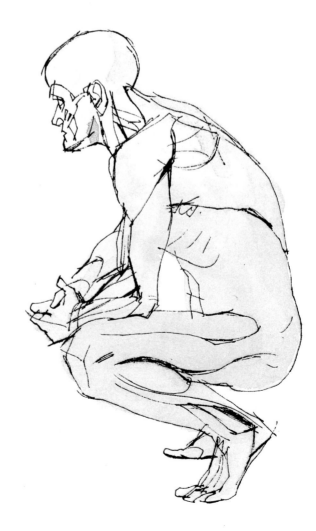

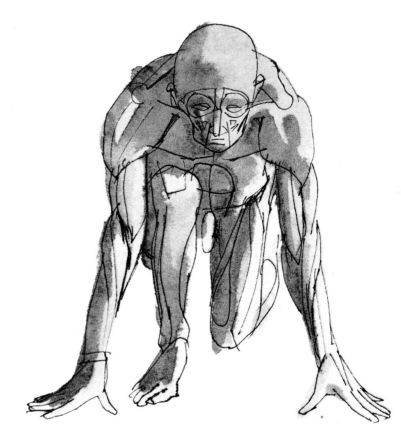

This athlete is 'on his marks' with every muscle tensed, ready for action. There is a fine balance between the outstretched fingers and thumb of the hand, the foot and the knee — almost the balance of a quadruped.

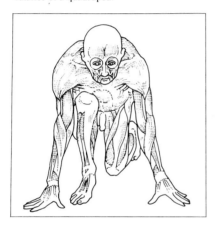

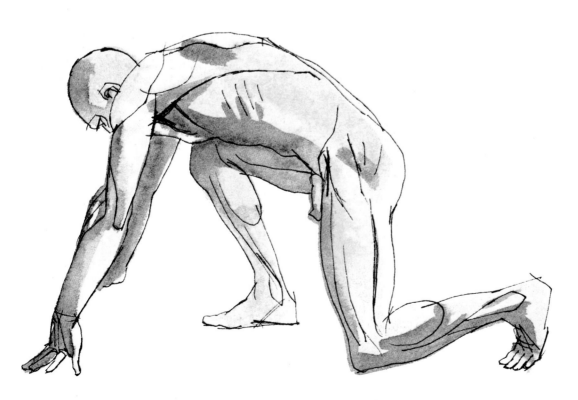

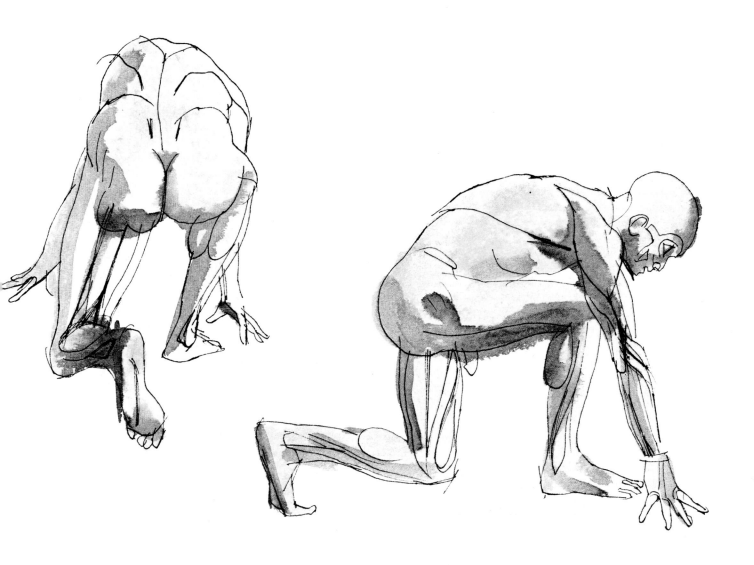

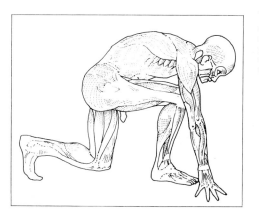

The back-view shows a good example of compensation: the right shoulder dips to counter-balance the angle of the pelvis, caused by the position of the legs. To assess these angles, it is useful to hold up a pencil at arm's length, placing it along the angle of the shoulder girdle, hips and feet.

The model here is stooping to lift a heavy weight. The body's potential for leverage is being utilized, harnessing the power of most muscles, particularly in the arms and legs, buttocks and abdomen.

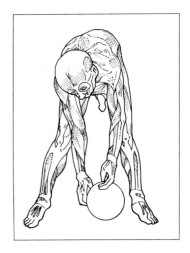

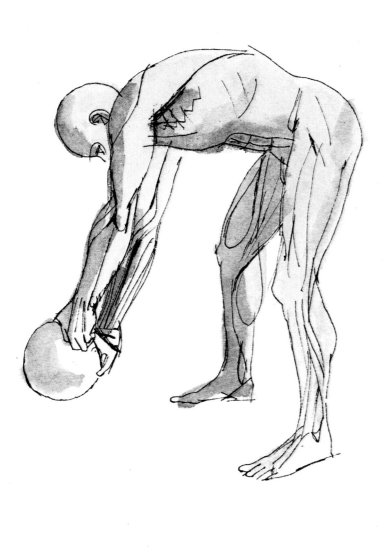

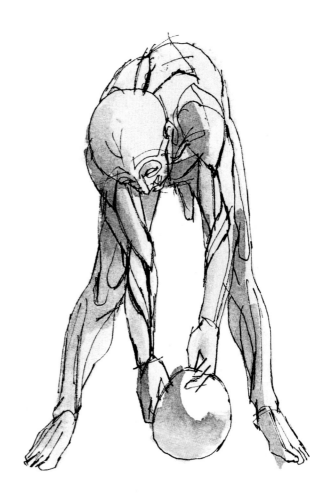

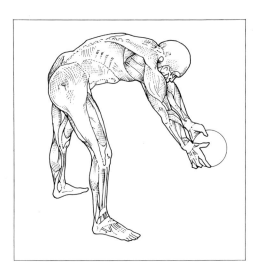

The feet are well planted on the floor and set wide apart in preparation for the extra weight. The head is positioned to concentrate on the action. In the side-view the neck and part of the head is hidden by the forward-reaching arms and shoulders.

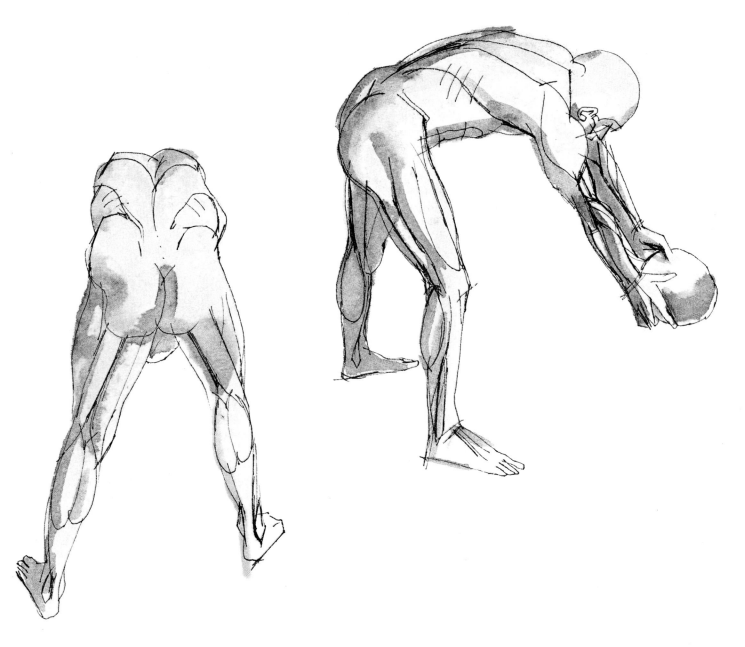

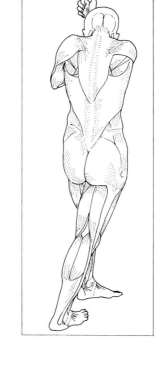

The problems faced by this man, punting in a boat, concern balance and the action of swivelling at the hips whilst putting downward pressure on the pole. The balance is precarious so the feet are set well apart. The swivel action of the upper torso allows us to view certain bones affecting the surface form.

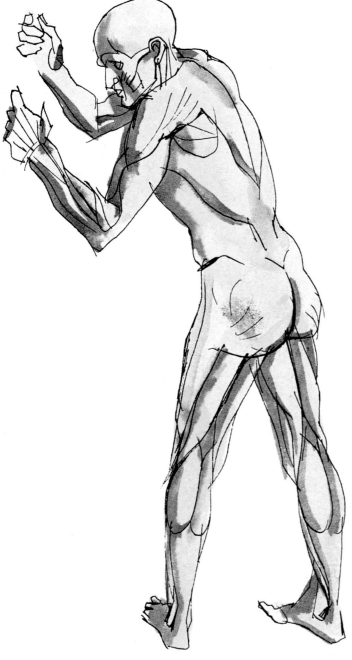

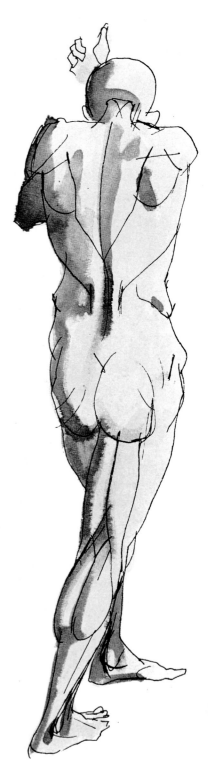

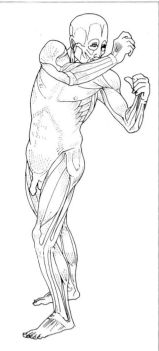

This *contraposto* pose is compositionally interesting as the twisting upper torso can grab the attention of the eye through the arms from one side and lead the eye on to the other with the forward-facing lower half of the body.

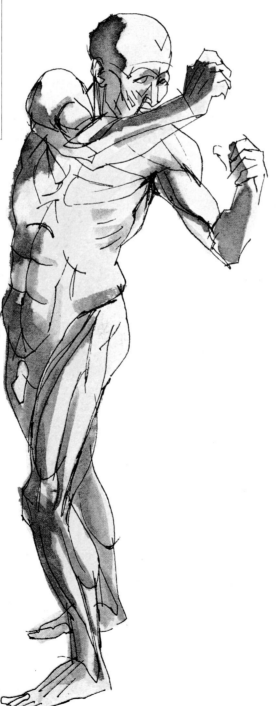

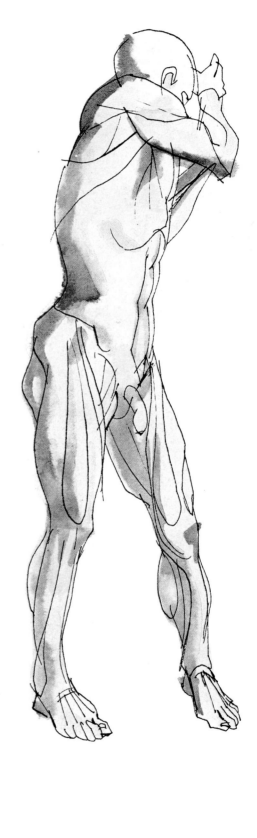

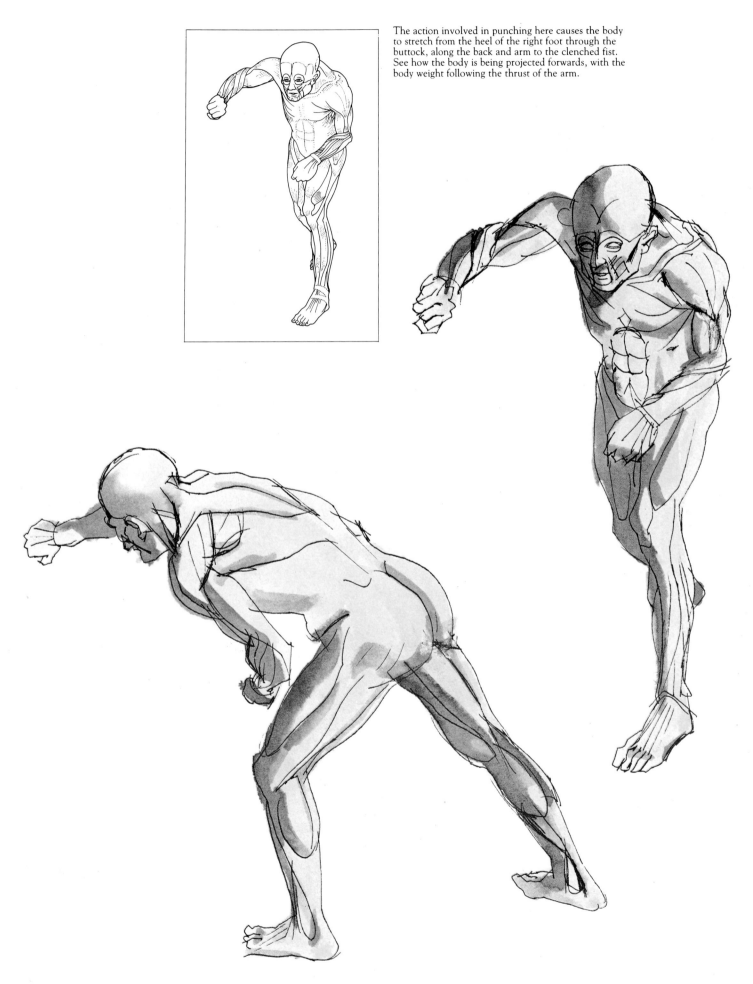

The action involved in punching here causes the body to stretch from the heel of the right foot through the buttock, along the back and arm to the clenched fist. See how the body is being projected forwards, with the body weight following the thrust of the arm.

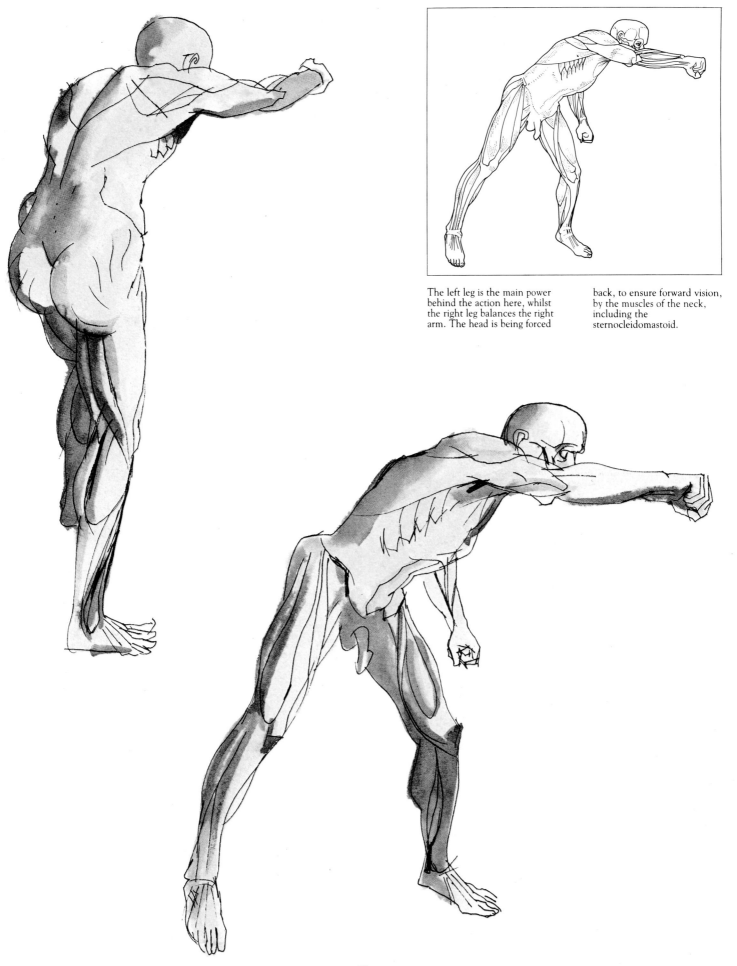

The left leg is the main power behind the action here, whilst the right leg balances the right arm. The head is being forced back, to ensure forward vision, by the muscles of the neck, including the sternocleidomastoid.

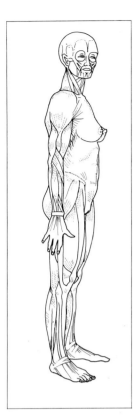

FEMALE FIGURE

The female figure differs from that of the male in some obvious ways, such as the breasts and genitals but there are also some less explicit characteristics which are important to the artist. In general, female hips are wider than the male's and the shoulders are narrower.

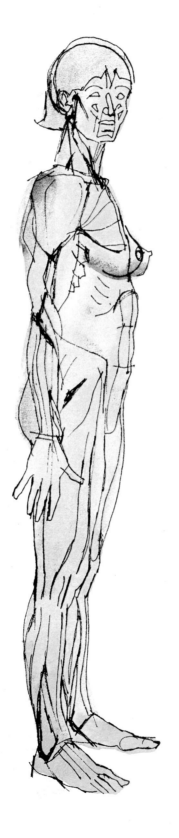

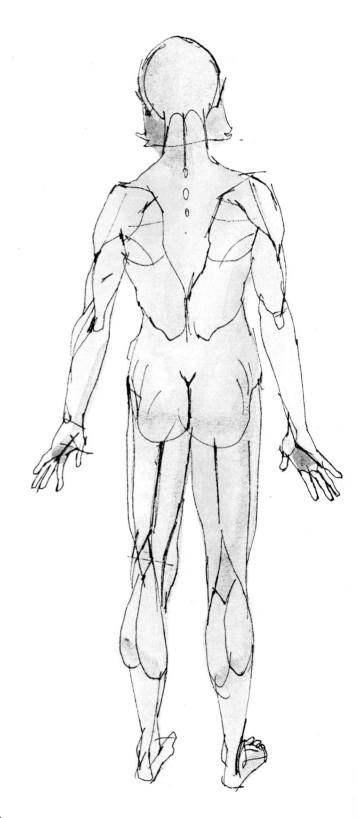

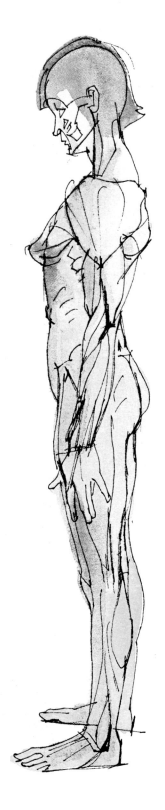

The surface form of a female body is usually less well defined because of subcutaneous fat which covers the muscles. Certain points of the female figure are often finer, for example, the neck, wrists, knees and ankles.

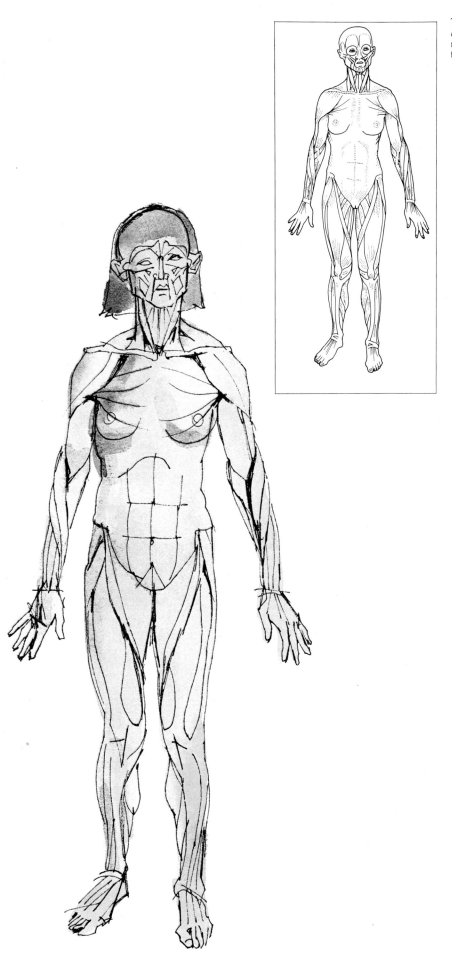

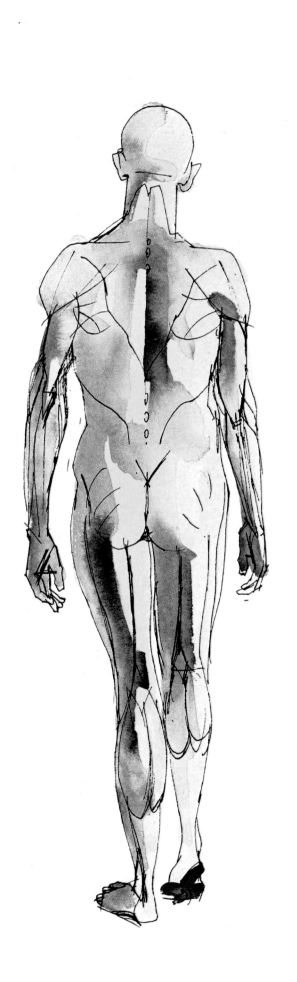

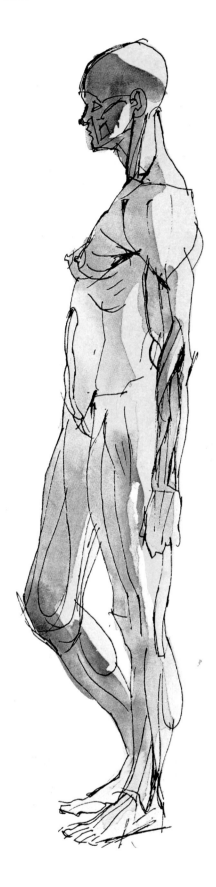

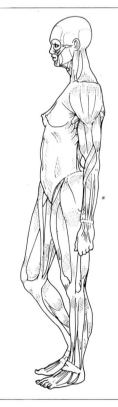

This relaxed walking pose demonstrates the counter-rhythms of the body well. The head is slightly tilted to the right, causing the trapezius muscle at the base of the neck to tense on the left.

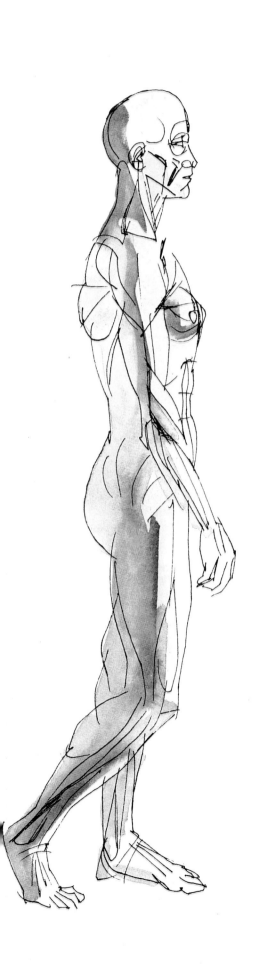

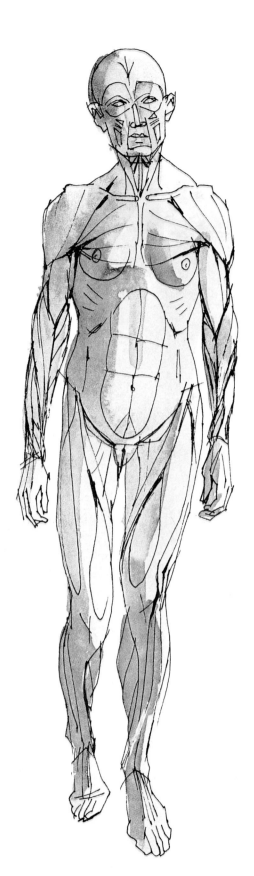

The shoulder girdle is sloping to the right in compensation for the pelvic girdle which is angled the other way in raising the right leg. Laterally, the same counter-rhythms are visible as the right shoulder and arm swing forward balancing the left pelvis and leg.

Dancing involves movement in most of the body. To allow for the upper contortions of the body, the legs are widely placed, one taking more weight than the other but by no means fully supporting.

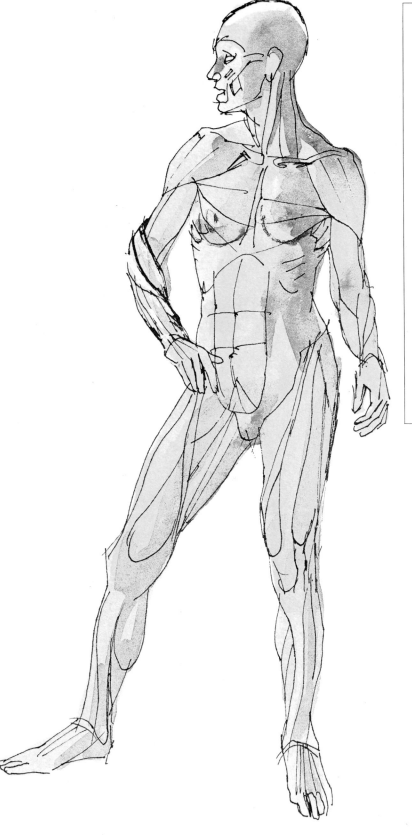

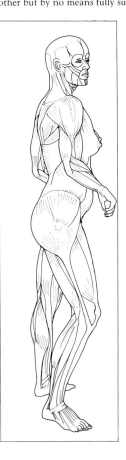

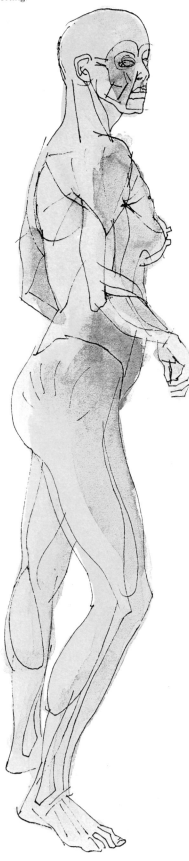

Again, the counter-rhythms of the body are
important, demonstrated by the back-view lateral
flexion of the spine. The turn of the head allows us to
see the well-defined muscles, implying the limit of the
range of movement.

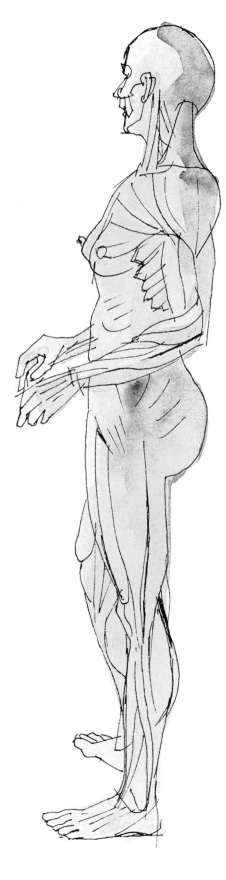

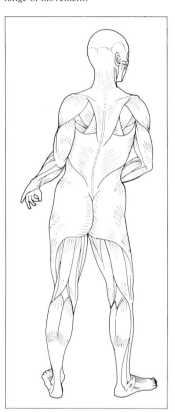

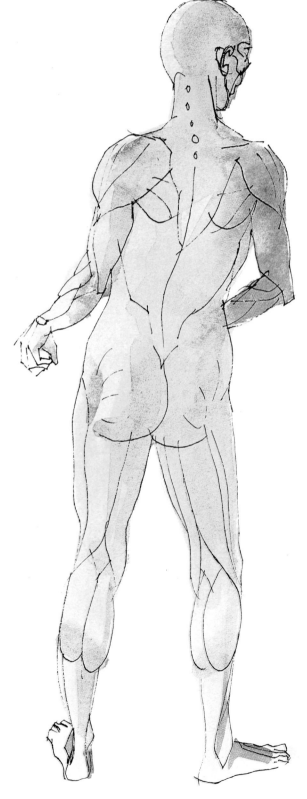

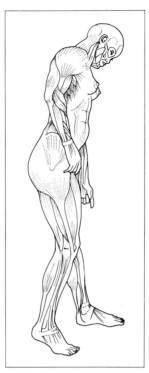

The action here involves bending sideways to pick up an object. The abdominal muscles (rectus abdominus) activate the torso, whilst the muscles of the left arm are bunched ready to pick up. Here the muscles of the side of the neck are tensed showing the limit of lateral movement.

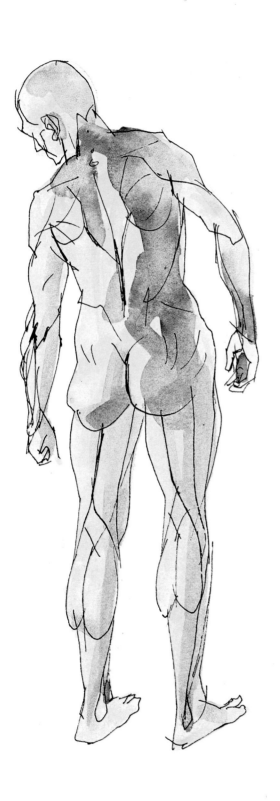

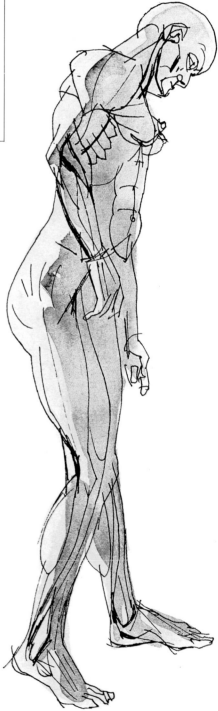

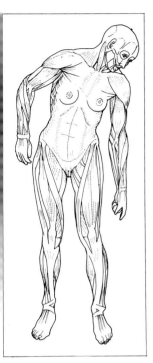

The curve in the torso can be followed from the breast bone (sternum), down the central break in the abdominal muscles, to the pubis. The same curve can be seen in the back-view outlined by the vertebral channel, caused by the tensed muscles either side of the spinal column.

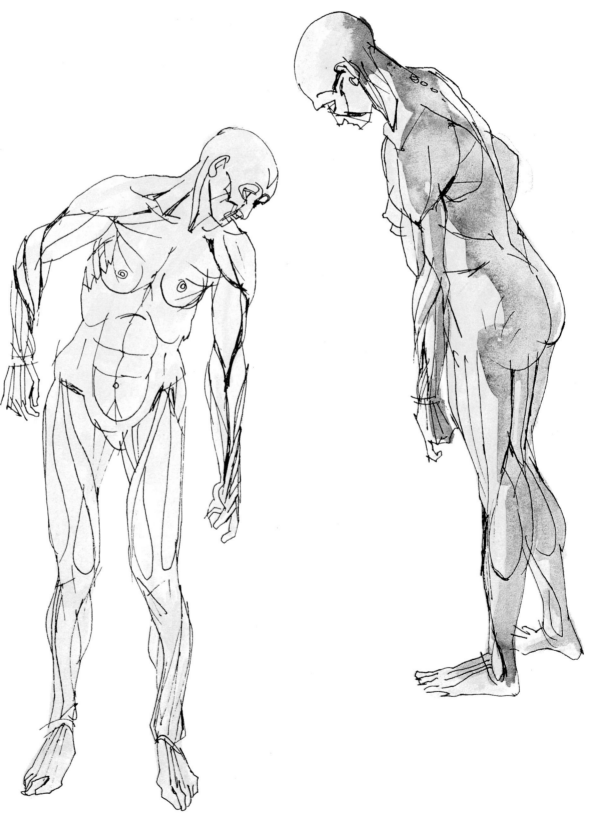

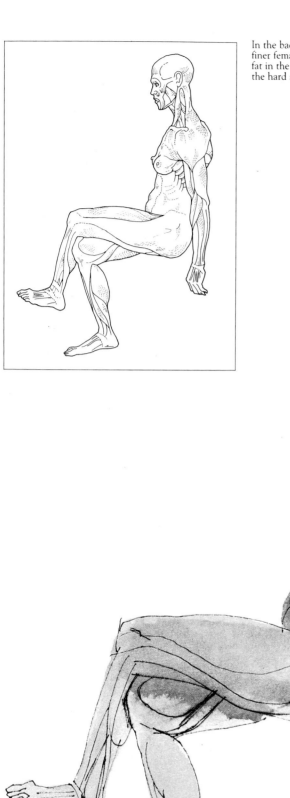

In the back-view, the relaxed shoulders emphasize the
finer female neck. The additional female subcutaneous
fat in the buttocks can be seen moulded upwards by
the hard seat.

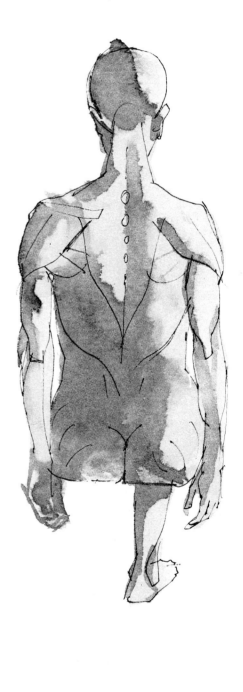

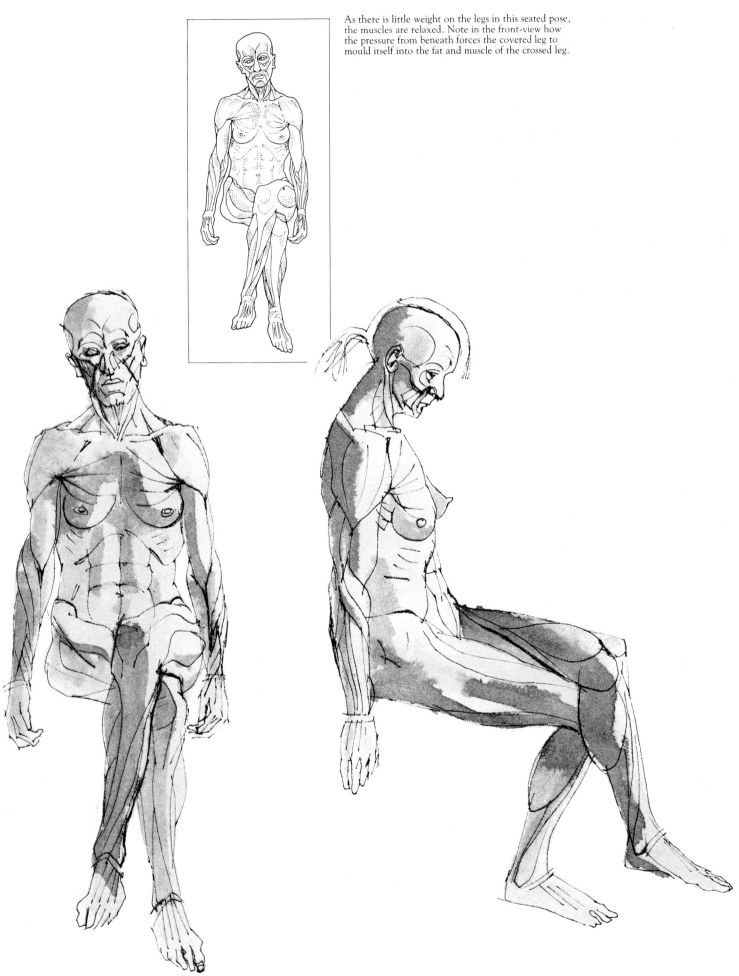

As there is little weight on the legs in this seated pose, the muscles are relaxed. Note in the front-view how the pressure from beneath forces the covered leg to mould itself into the fat and muscle of the crossed leg.

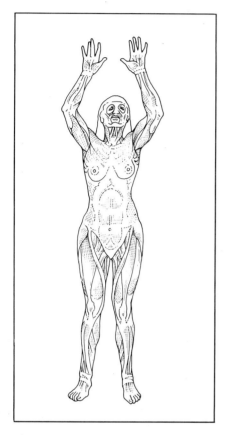

The raised arms in this pose arch the spine and cause the breasts to point upwards. The upward tilted head exposes the front muscles of the neck and the raised arms expose the fan-like muscle, the serratus anterior, under the arm.

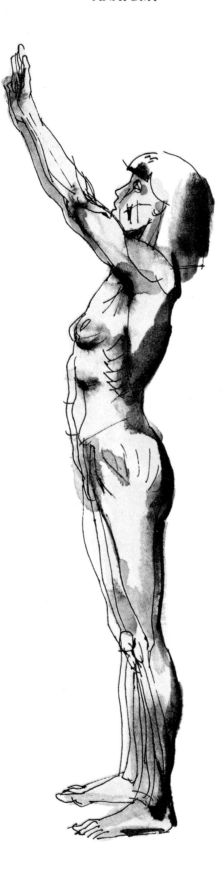

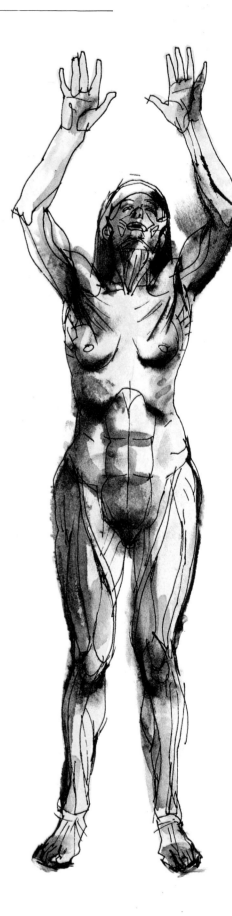

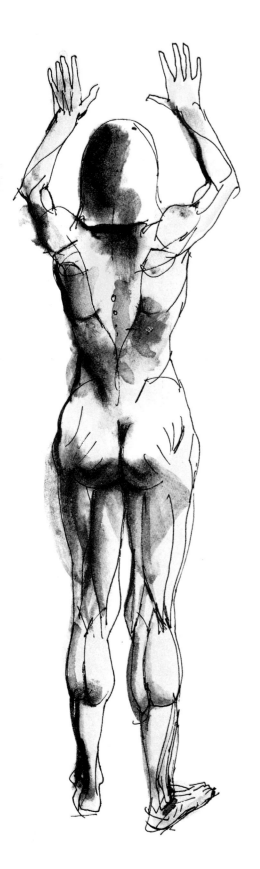

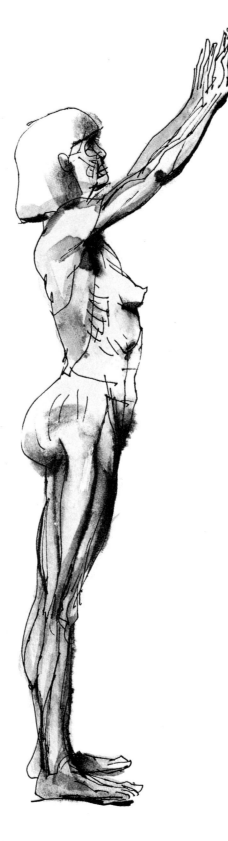

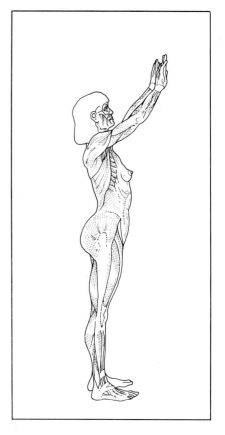

The wider pelvis of the female is more obvious here as is the store of subcutaneous fat on the thighs and buttocks.

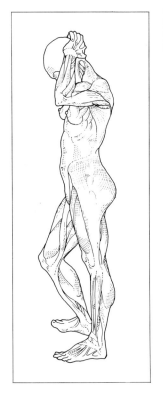

The weight here is very firmly taken on the left leg. Visual interest in the pose is created by the interrelating angles of the shoulders and hips, which stretch the abdominal muscles.

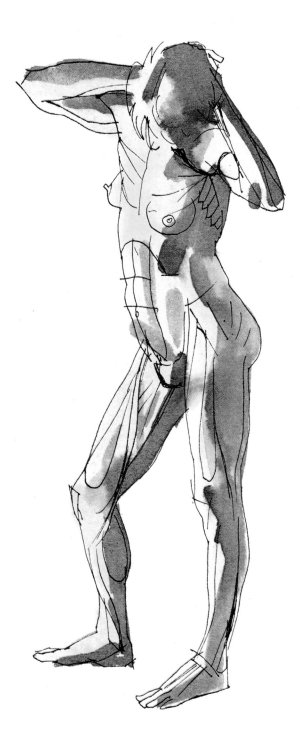

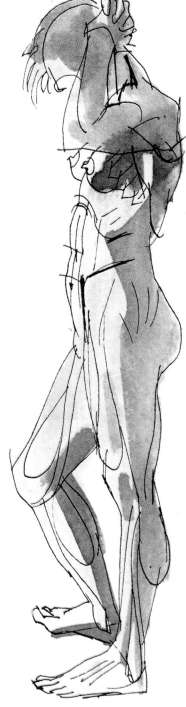

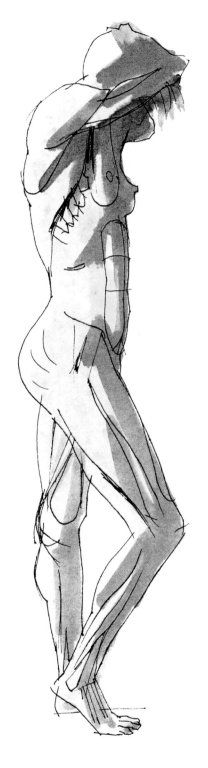

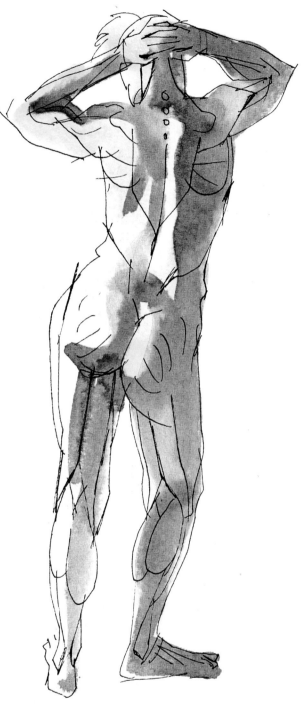

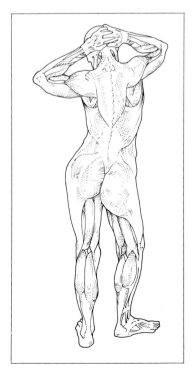

The nature of the side pose enables us to trace the latissimus dorsi from under the arm round to the back. In the back-view, the distinction between the clenched left and relaxed right buttock is displayed.

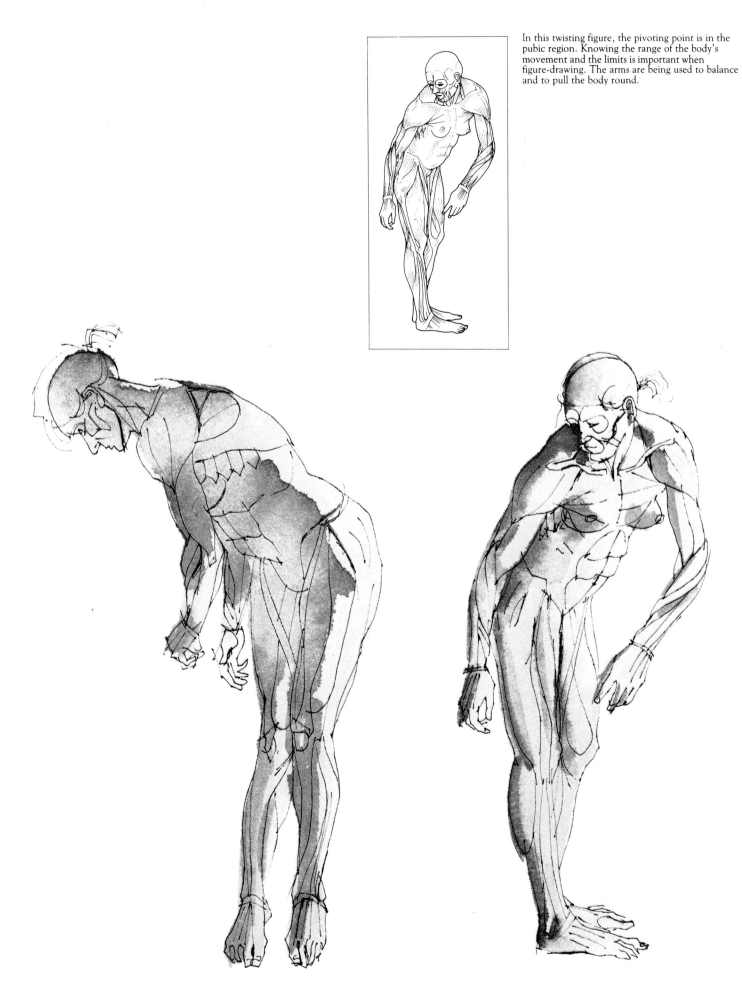

In this twisting figure, the pivoting point is in the pubic region. Knowing the range of the body's movement and the limits is important when figure-drawing. The arms are being used to balance and to pull the body round.

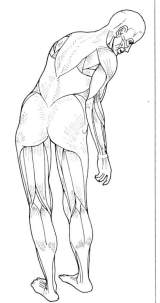

The toes are clenched in order to gain greater purchase. The braced right leg is taking most of the weight so the muscles are tensed.

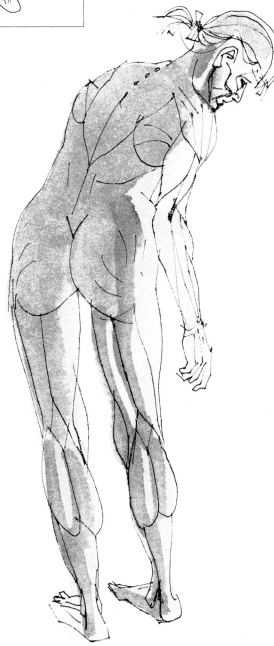

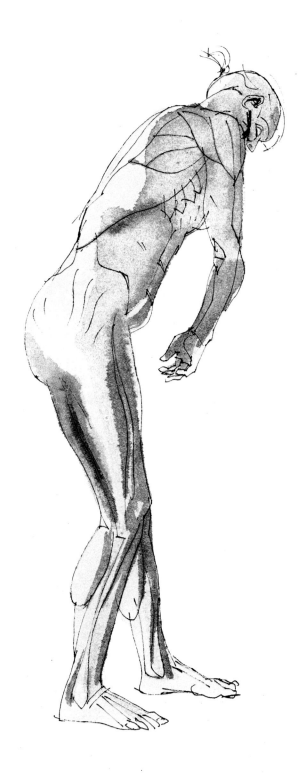

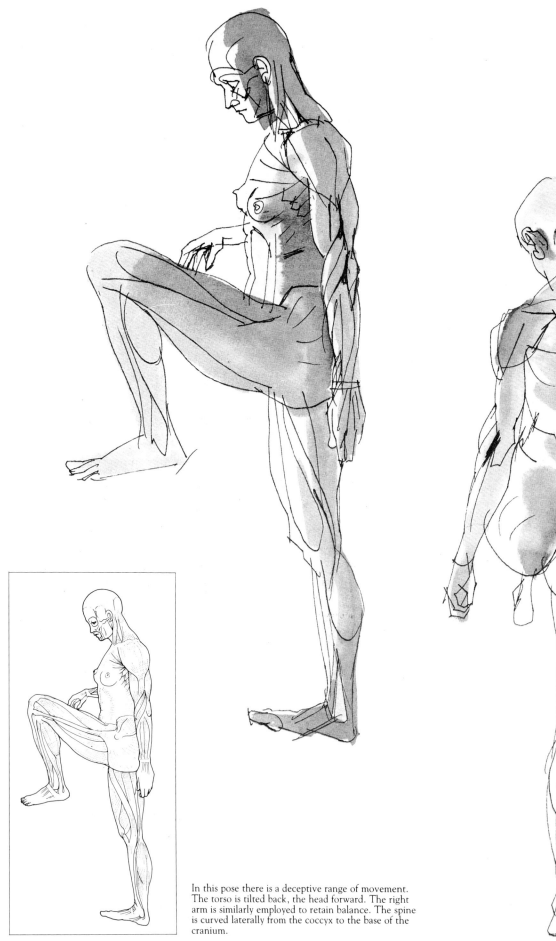

In this pose there is a deceptive range of movement. The torso is tilted back, the head forward. The right arm is similarly employed to retain balance. The spine is curved laterally from the coccyx to the base of the cranium.

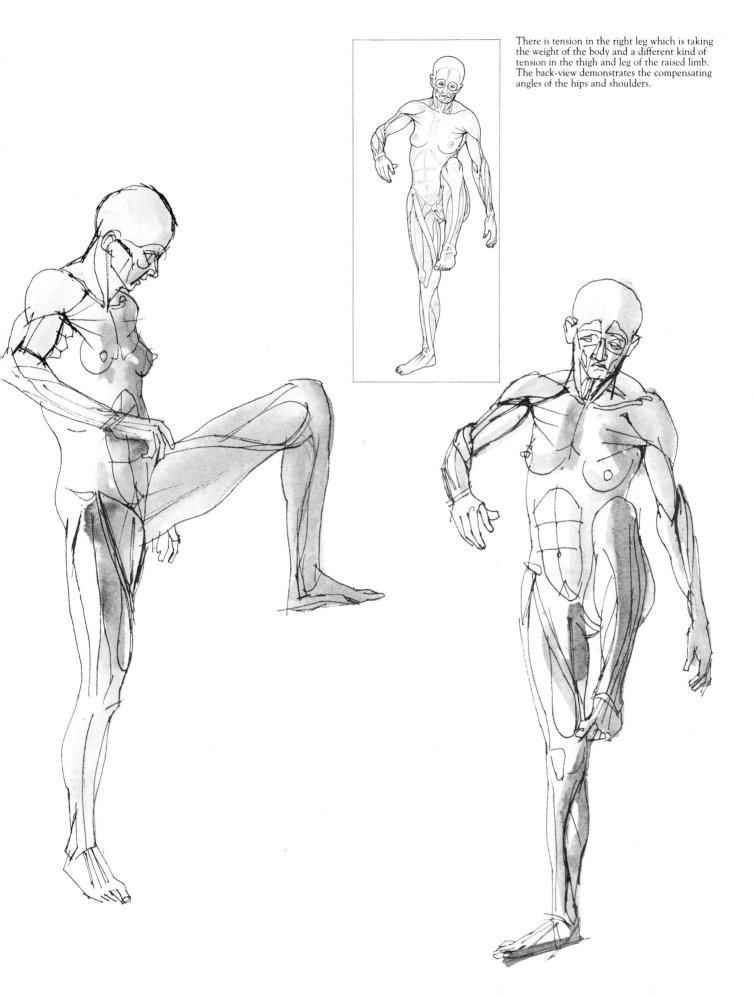

There is tension in the right leg which is taking the weight of the body and a different kind of tension in the thigh and leg of the raised limb. The back-view demonstrates the compensating angles of the hips and shoulders.

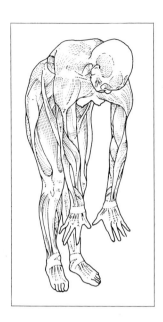

Much of the support for the upper part of the body in this stooping pose comes from the muscles of the vertebral column and the abdominal muscles, which are tensed causing the ribs to be well-defined.

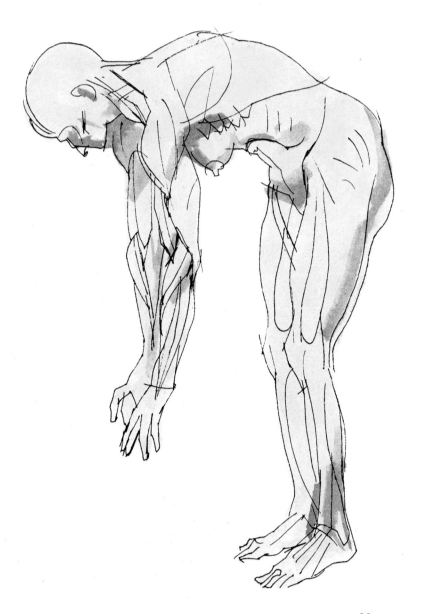

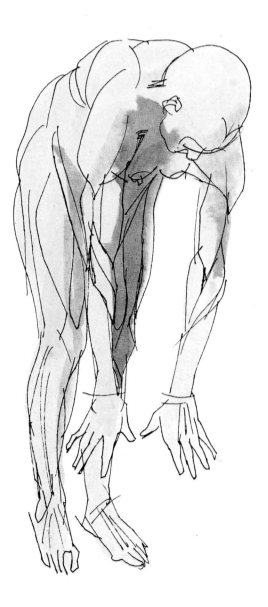

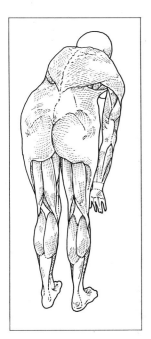

The head is being held out, supported by the trapezius at the back and the sternocleidomastoid at the front of the neck. You will notice how the legs bend as the arms reach for the floor.

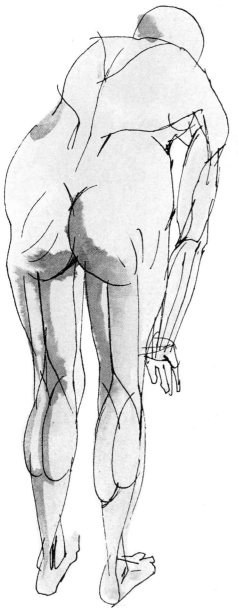

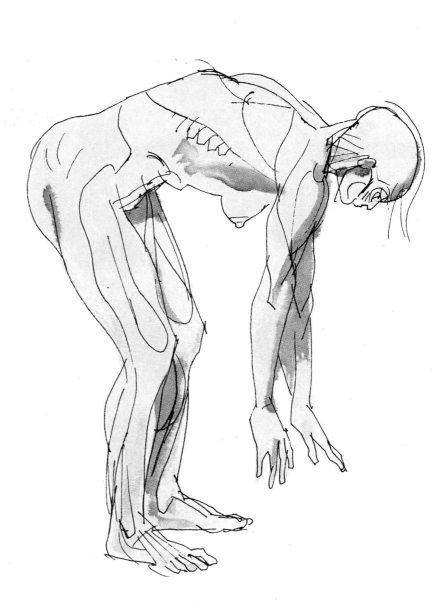

81

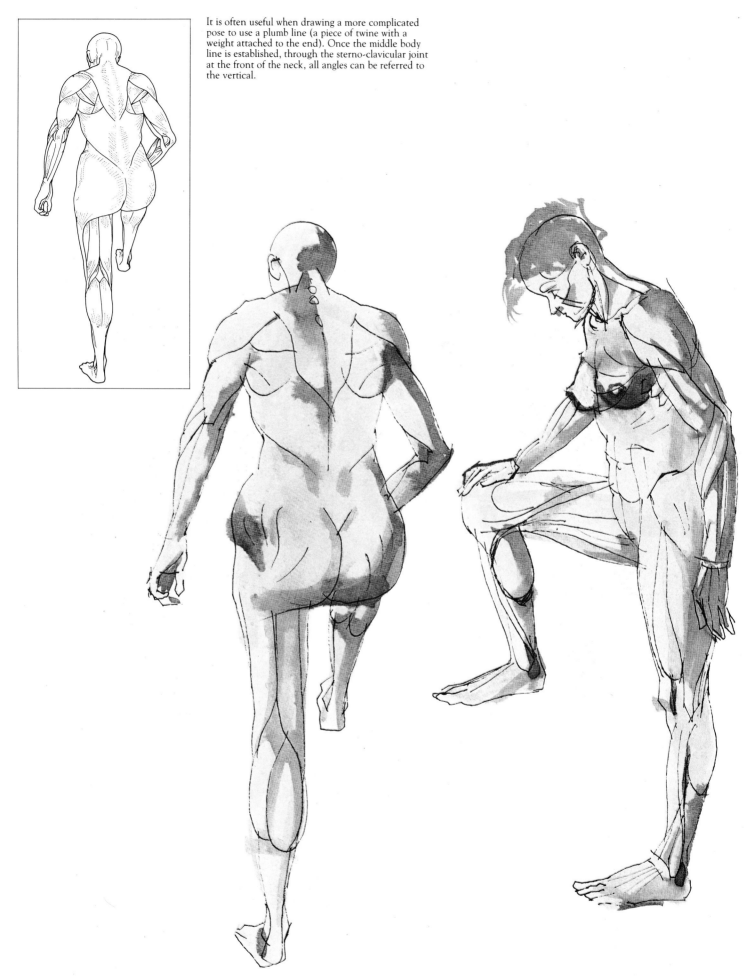

It is often useful when drawing a more complicated pose to use a plumb line (a piece of twine with a weight attached to the end). Once the middle body line is established, through the sterno-clavicular joint at the front of the neck, all angles can be referred to the vertical.

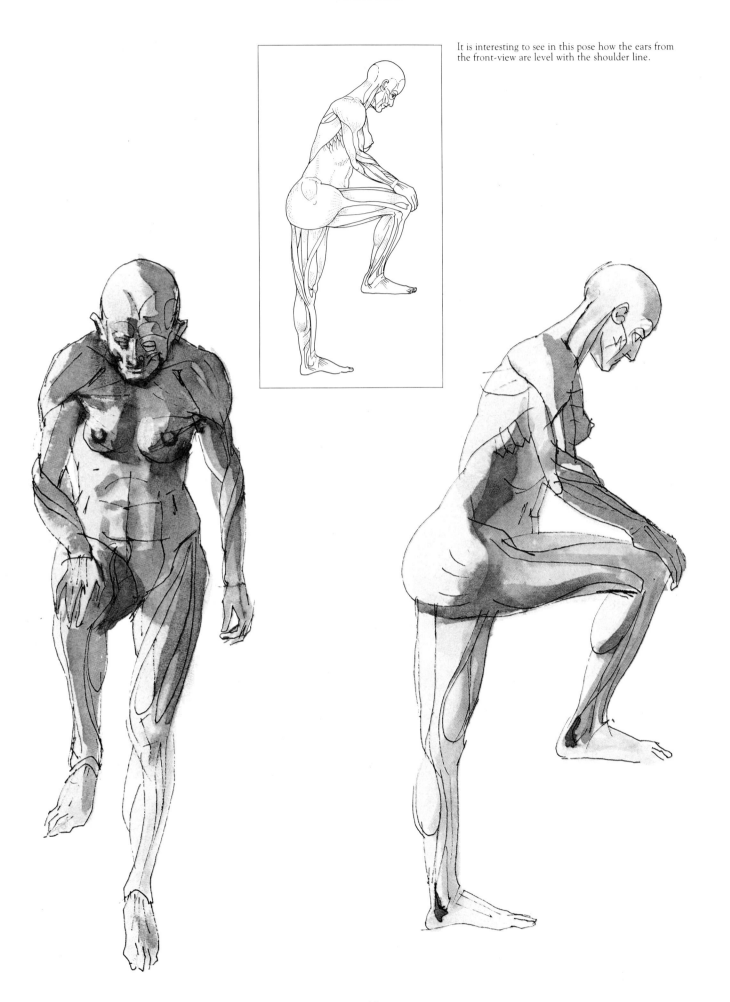

It is interesting to see in this pose how the ears from the front-view are level with the shoulder line.

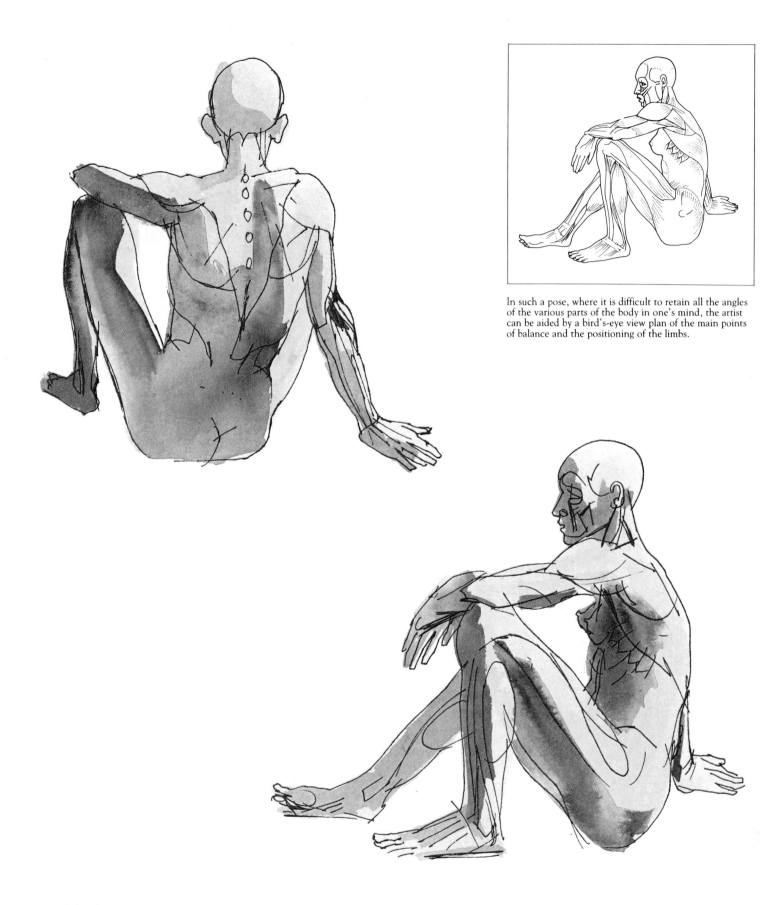

In such a pose, where it is difficult to retain all the angles of the various parts of the body in one's mind, the artist can be aided by a bird's-eye view plan of the main points of balance and the positioning of the limbs.

This pose is visually interesting from most angles due to the geometric shapes of the limbs and torso. The contrast between the tensed supporting right arm and relaxed left arm is noticeable.

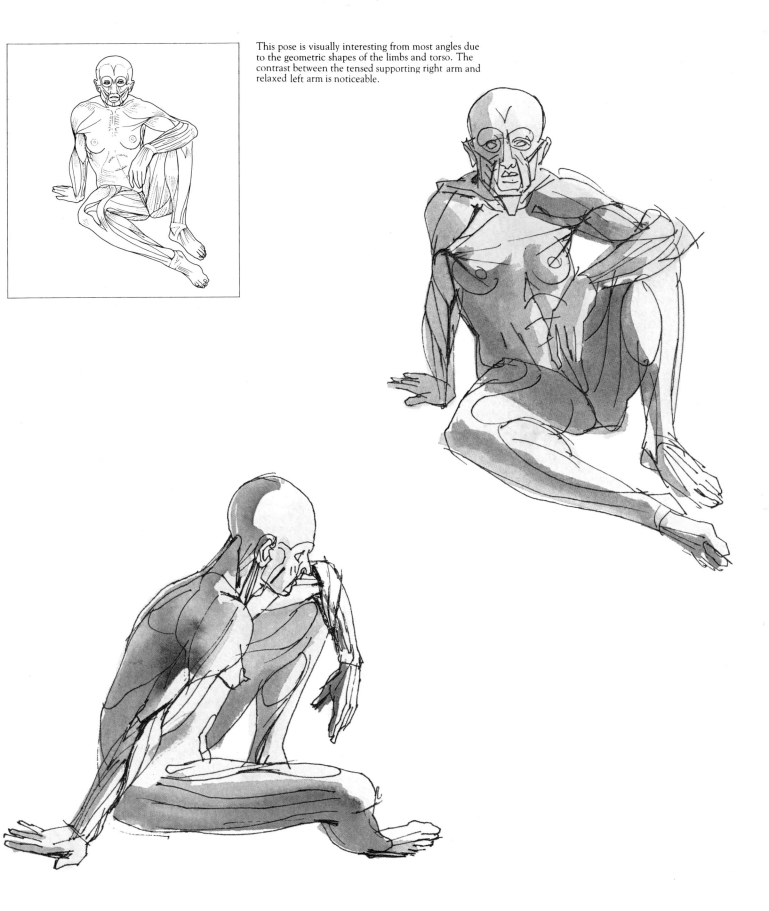

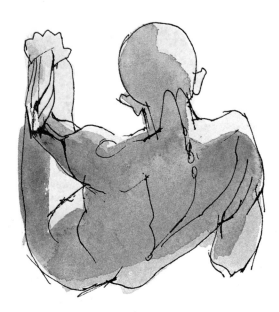

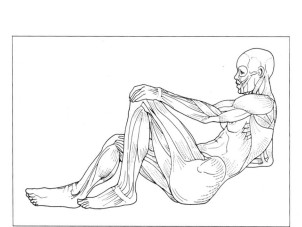

This classic pose of the prone figure propped on one arm is notable for the change of angles across the mid-line of the body, as seen in the front-view. The lower half of the body is relaxed but the shoulder and arms muscles are employed to support the upper part.

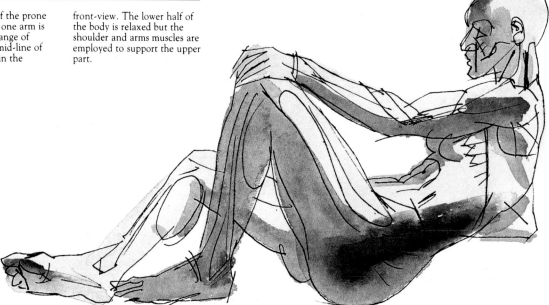

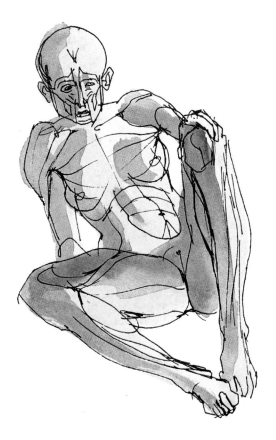

The symmetrical nature of the figure can be seen in the right side-view, where the head, torso and right leg form the diagonal of a rectangle formed by the arms and left leg.

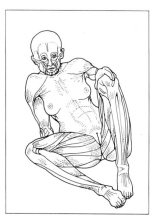

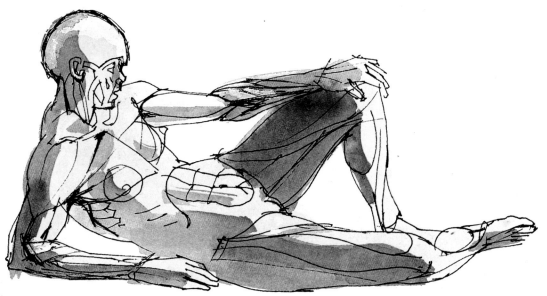

This female sprinter about to burst into action looks similar to the man although the subcutaneous fat on the buttocks is more apparent and the muscles not so well-defined.

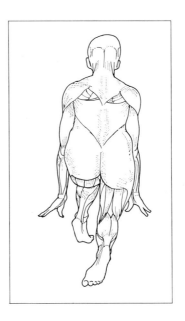

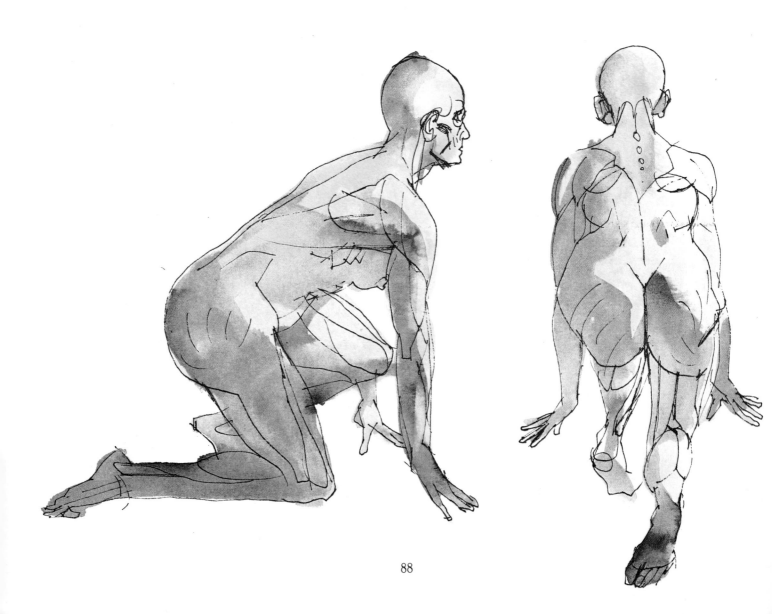

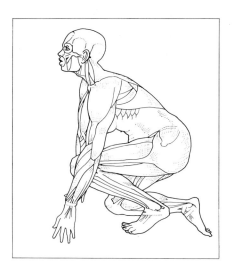

The shoulders, pulled downwards by the position of the arms, are rounded, making the shoulder blades clearly visible on the surface form at the back.

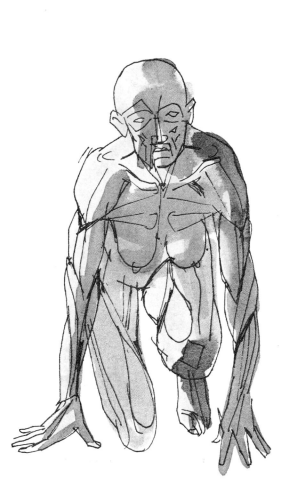

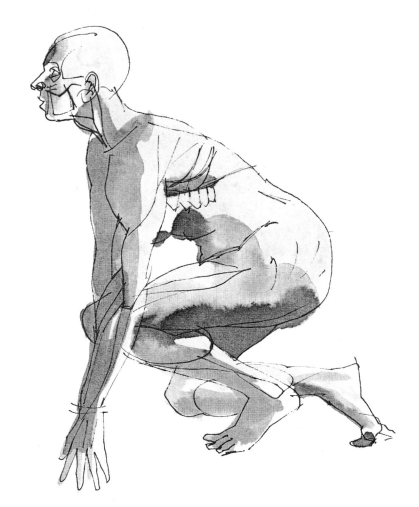

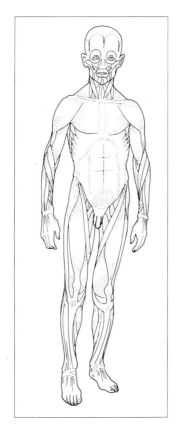

ADOLESCENT MALE

In this simple standing pose of an adolescent boy, the differences between young and adult bodies become apparent. Most important are the relative proportions between the length of the leg, length of torso and size of head to body. The front-view demonstrates well the perspective of figure-drawing. The line taken from heel to heel, from toe to toe, from hip to hip, and from shoulder to shoulder all converge to a vanishing point on the right.

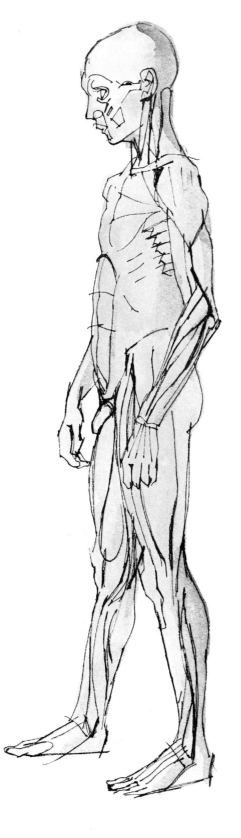

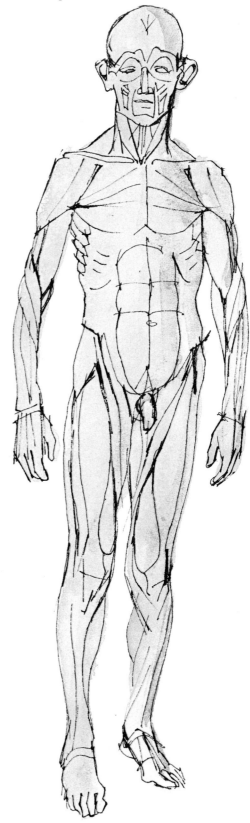

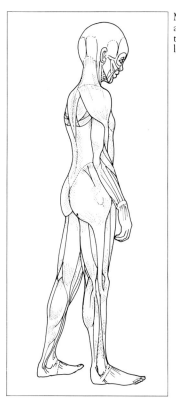

Muscular development in an adolescent boy is not so advanced as in an adult, so the shoulders and upper torso appear narrower and the general surface form is less modelled.

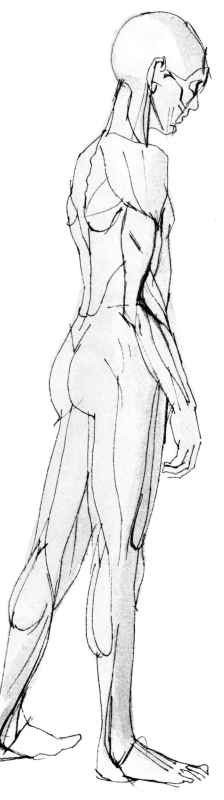

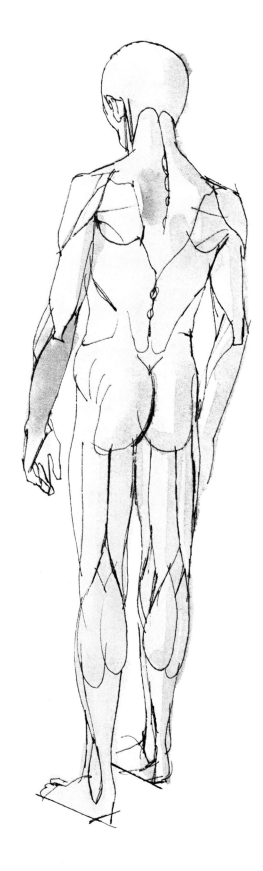

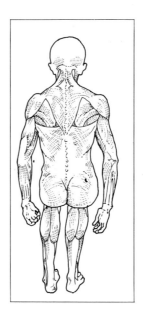

In this seated pose the proportions of legs to torso in the boy are well demonstrated. The muscles of an adolescent are not so well developed as those of an adult, so they will not affect the surface form so much.

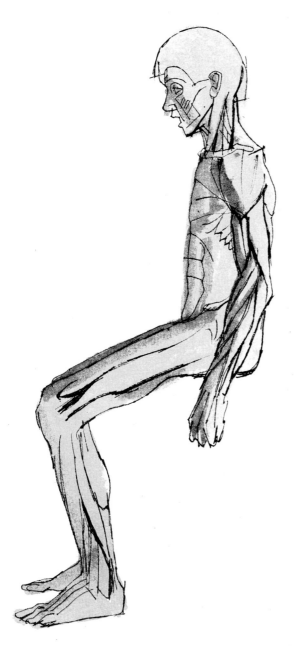

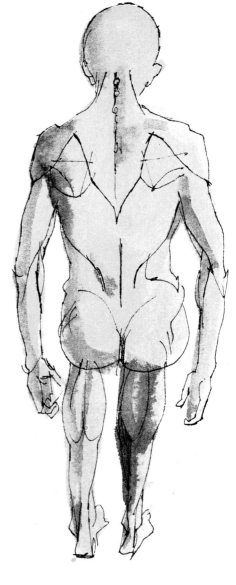

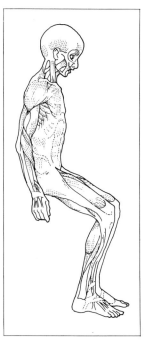

The lack of muscular formation is clearly noticeable in the upper thorax and thighs. The head is also larger in proportion to the body, compared with that of an adult.

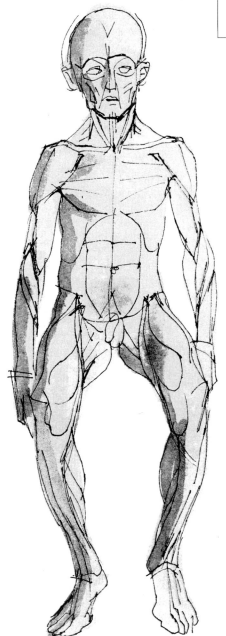

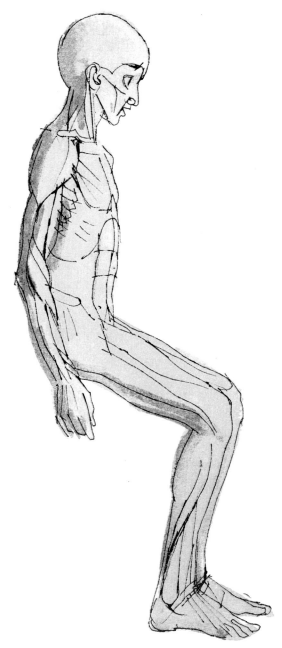

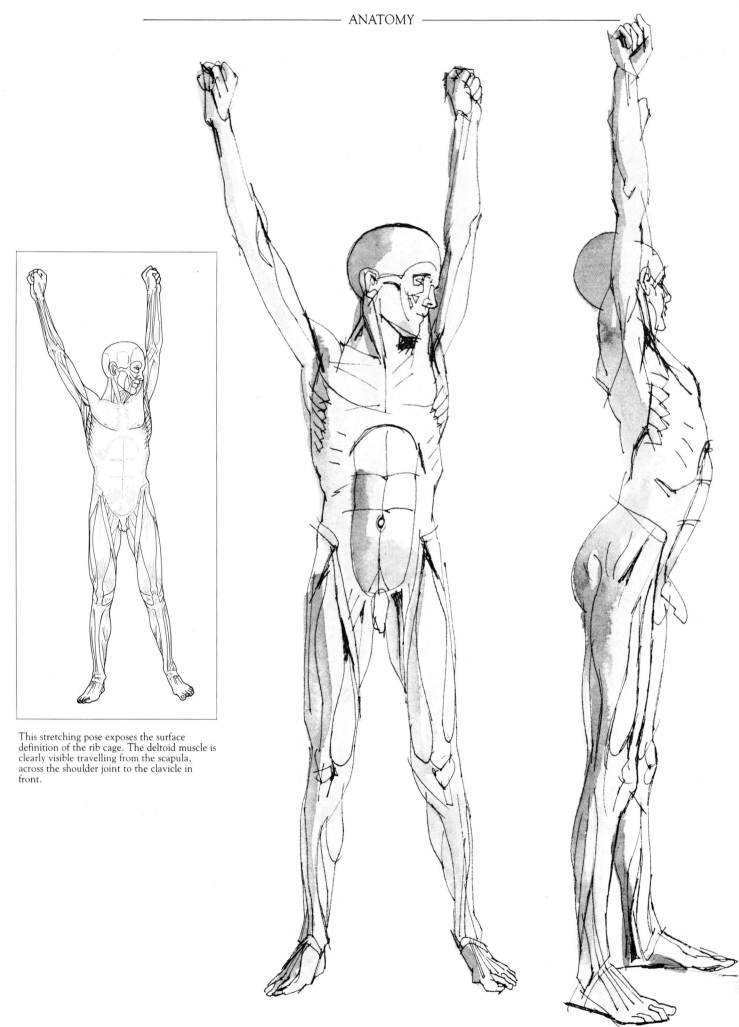

This stretching pose exposes the surface definition of the rib cage. The deltoid muscle is clearly visible travelling from the scapula, across the shoulder joint to the clavicle in front.

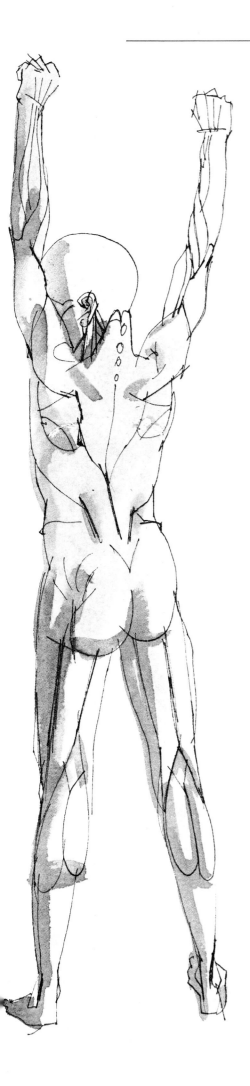

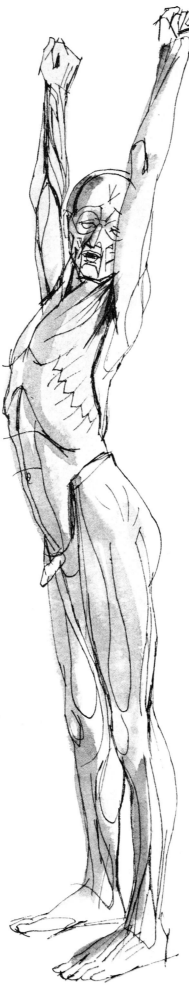

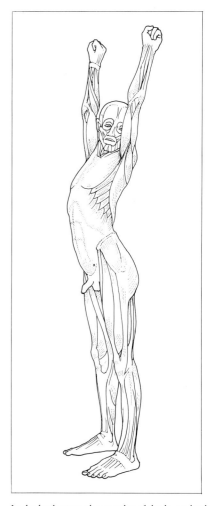

In the back-view, the muscles of the lower back and buttocks are tensed to support the action of the shoulders and arms. The forearm muscles are bunched to activate the clenching of the fists.

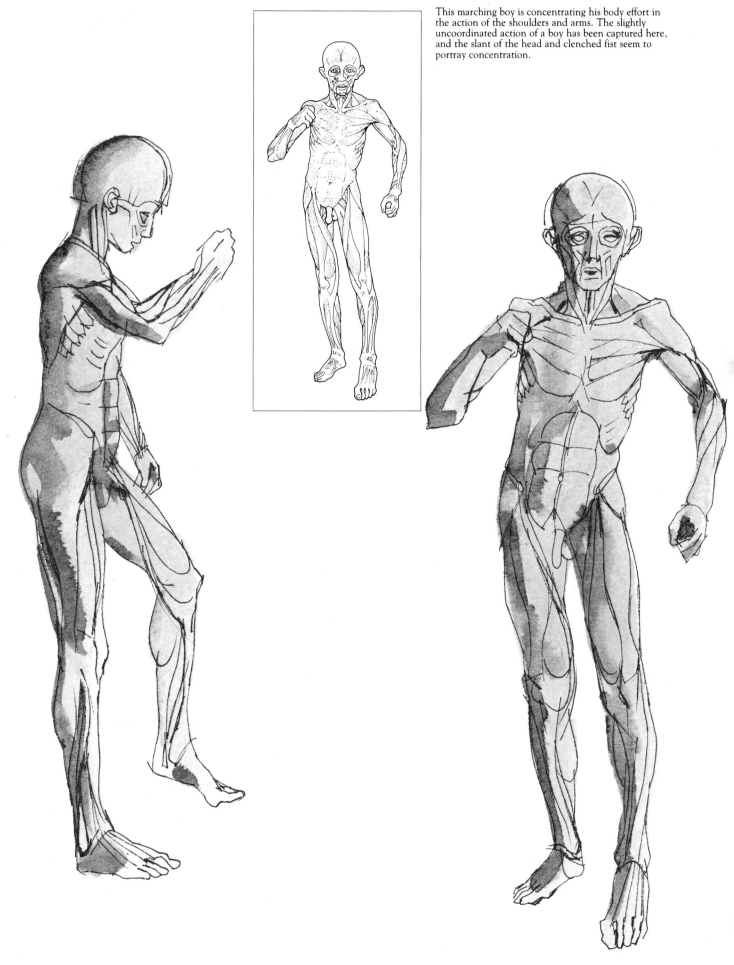

This marching boy is concentrating his body effort in the action of the shoulders and arms. The slightly uncoordinated action of a boy has been captured here, and the slant of the head and clenched fist seem to portray concentration.

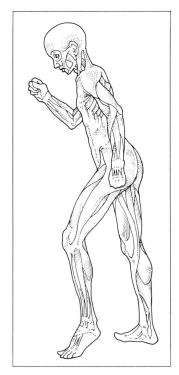

The arms are balancing the body by splaying outwards and by counter-balancing the legs. The under-developed muscle forms allow the spines of the vertebrae to show on the surface of the back.

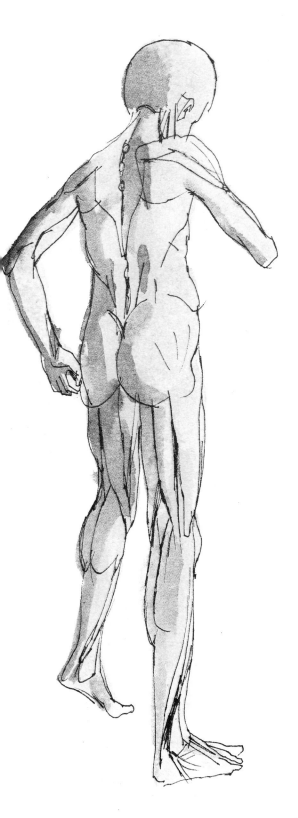

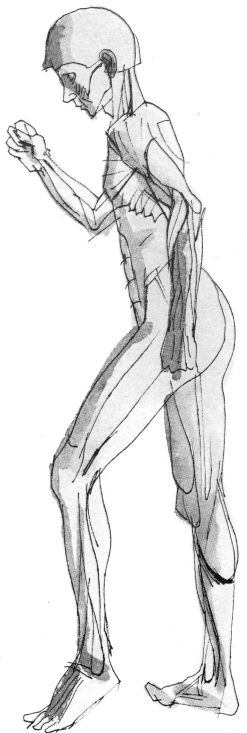

As can be seen in these drawings, raising a leg as if to climb a stair alters the shape of the buttocks; one bunches up while the other is relaxed. The head is in a position to concentrate on the terrain yet to come while the arms balance the body.

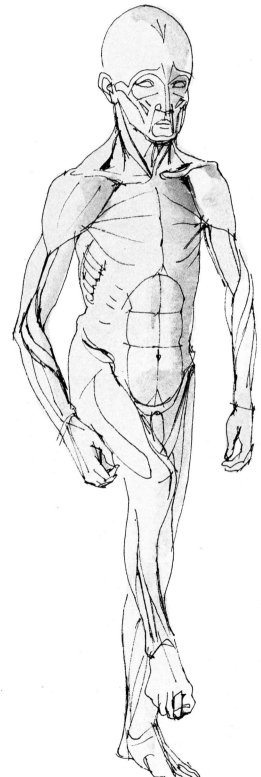

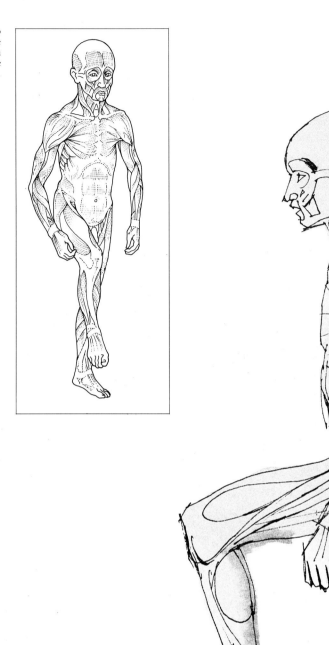

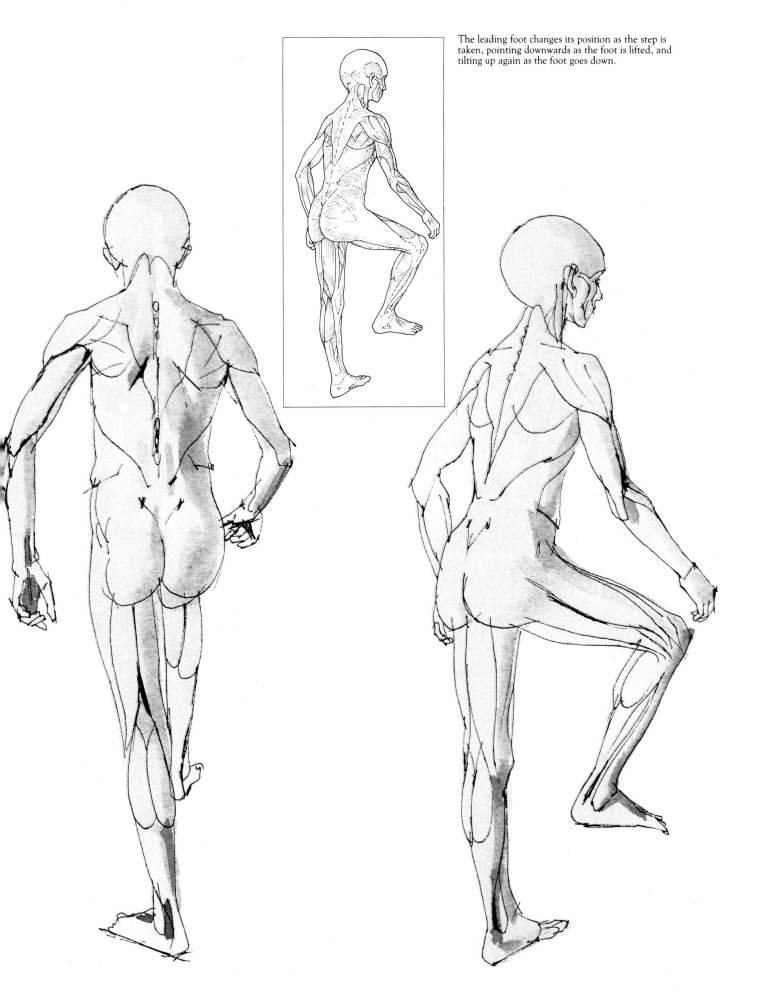

The leading foot changes its position as the step is taken, pointing downwards as the foot is lifted, and tilting up again as the foot goes down.

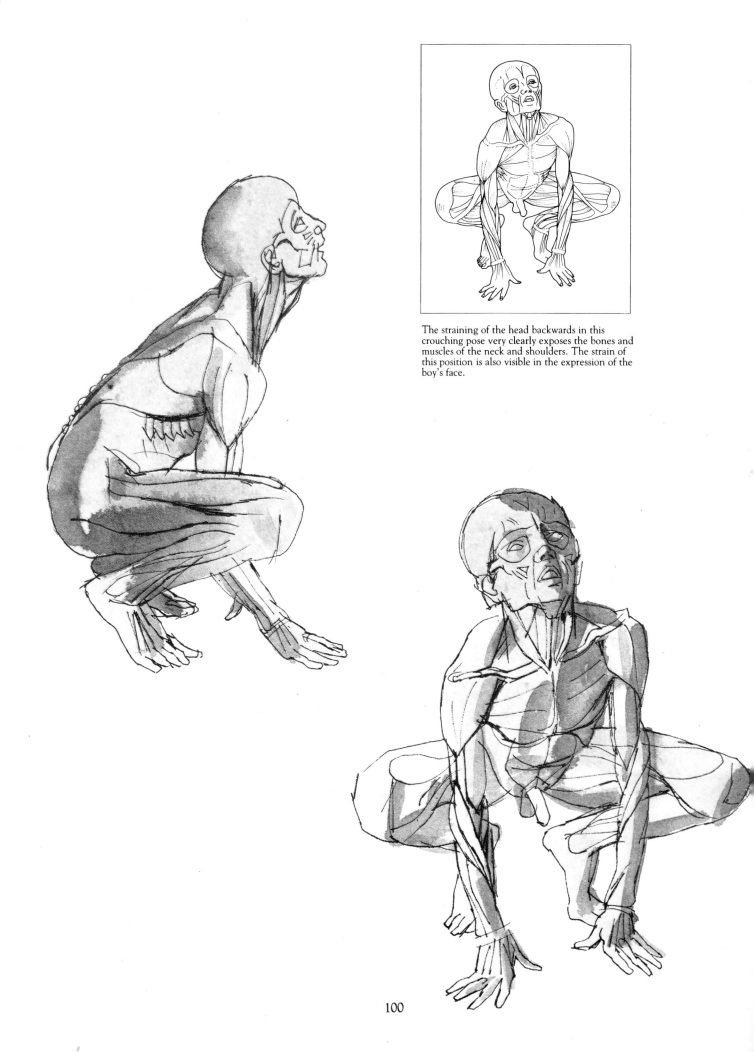

The straining of the head backwards in this crouching pose very clearly exposes the bones and muscles of the neck and shoulders. The strain of this position is also visible in the expression of the boy's face.

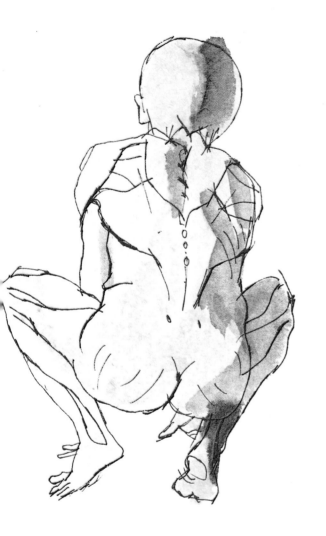

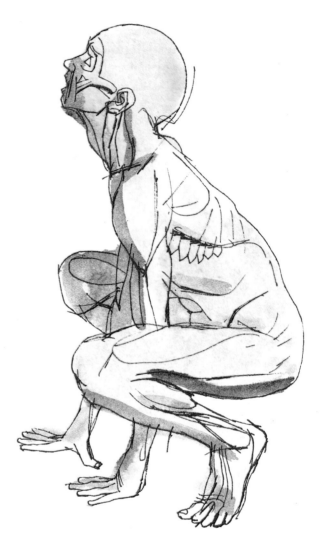

The body weight of this boy is being supported by his fingers and toes, all the muscles of the arms and legs are therefore being called into action. The ribs of the back can be easily seen through the stretched layers of thin muscle.

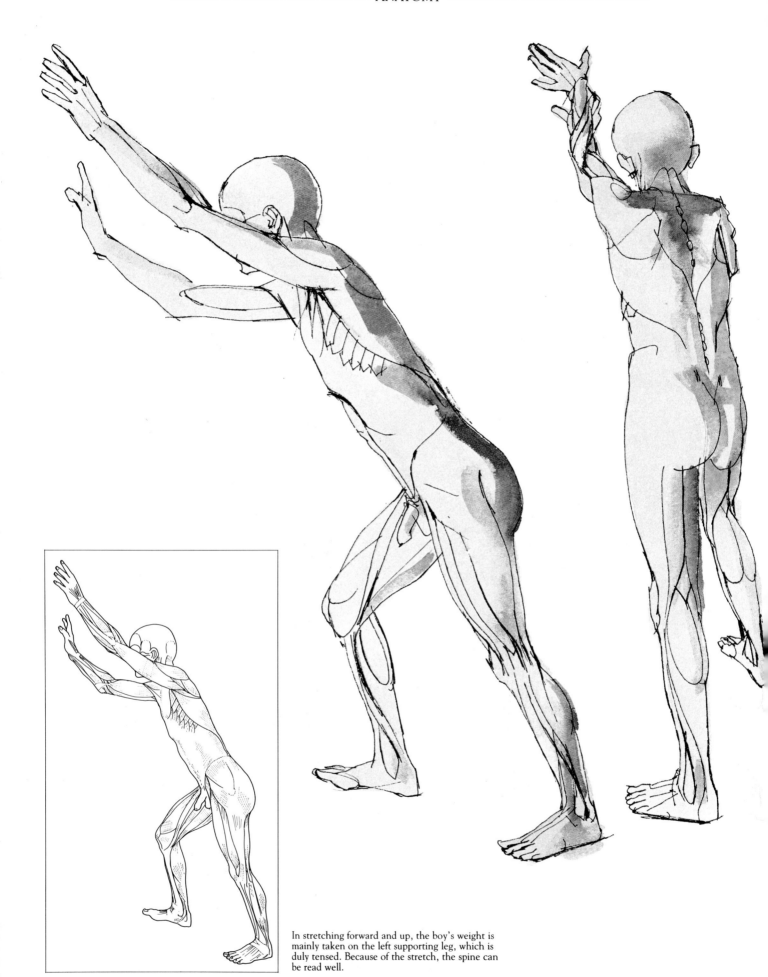

In stretching forward and up, the boy's weight is mainly taken on the left supporting leg, which is duly tensed. Because of the stretch, the spine can be read well.

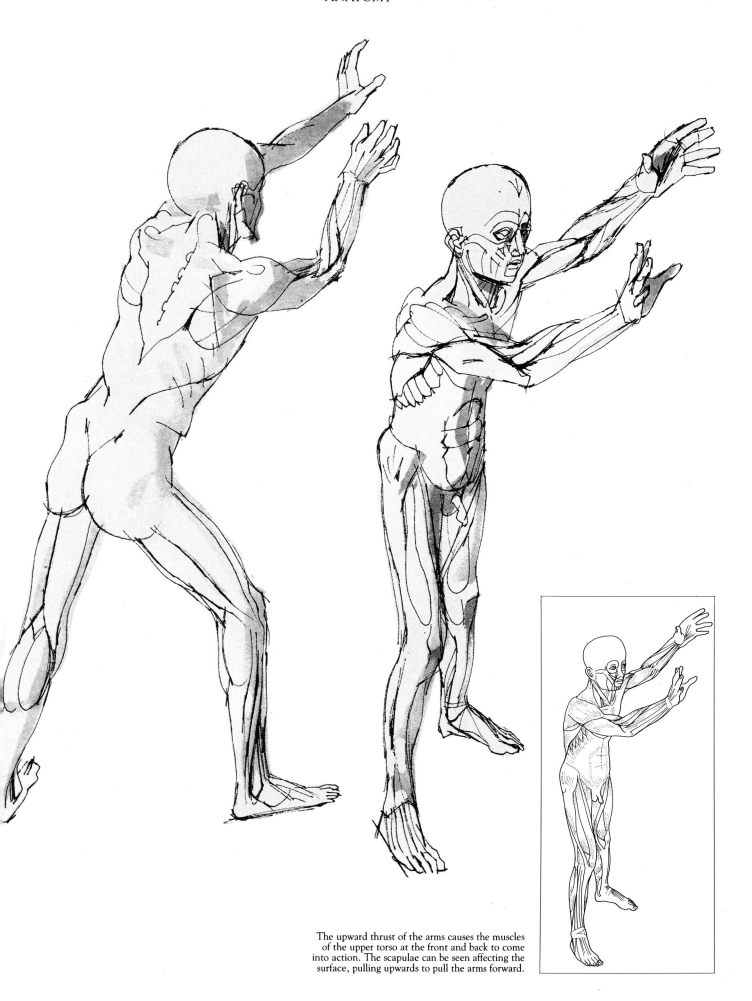

The upward thrust of the arms causes the muscles of the upper torso at the front and back to come into action. The scapulae can be seen affecting the surface, pulling upwards to pull the arms forward.

ANATOMY OF THE FACE

On the right, we see the muscles of the face and front of the neck which affect surface form. Particularly noticeable is the muscle (orbicularis oculi) round the eye, and the zygomaticus major, running diagonally across the cheek. The quadratus labii superioris runs down the side of the nose and the orbicularis oris encircles the mouth, enabling it to perform delicate speech movements. In most people these muscles are covered with a layer of subcutaneous fatty tissue, except when the face is very thin or elderly.

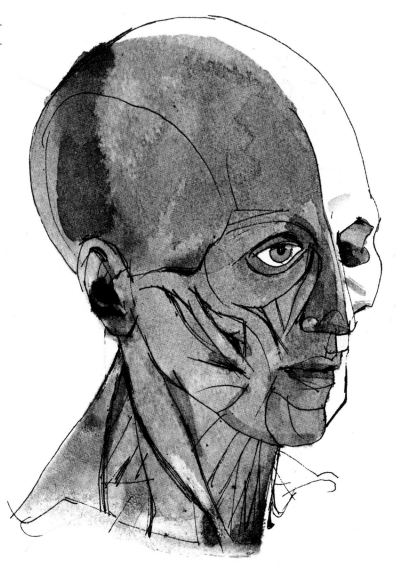

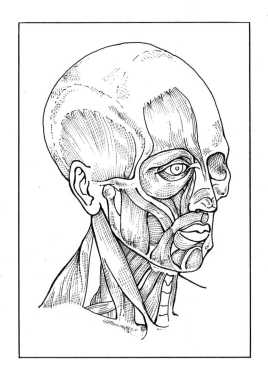

104

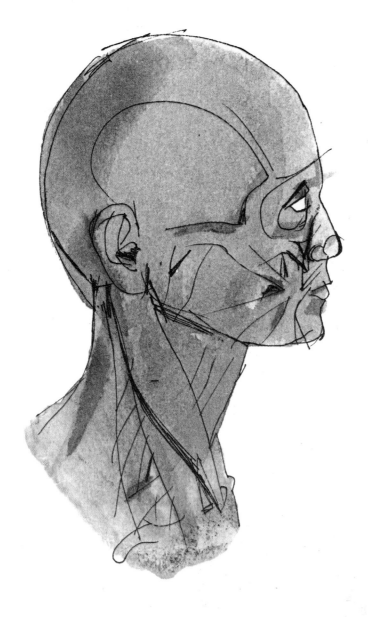

On the left, the junction of many of the face muscles can be seen at the corner of the mouth. The triangularis, passing under the chin, is very noticeable here. In most people, neck muscles are more obvious as the subcutaneous fat is usually very thin. The sternocleidomastoid is the main muscle, running from behind the ear across to the breast bone, and is particularly prominent when the head is turned. There is muscle covering the cranium, too: the temporalis above the ear and the occipitalis behind it. The occipito frontalis, on the forehead, wrinkles the brow.

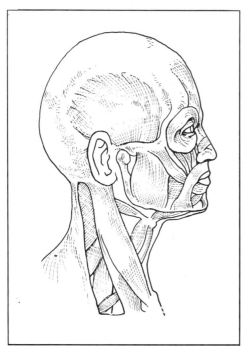

Look at the difference between the three skulls on the right. Top, is the skull of a baby, center, of a young adult and, below, of an old person. The profiles drawn show how different the facial proportions are between these ages. The teeth in the skull alter the face considerably, increasing the distance between nose and chin and making the lips more prominent.

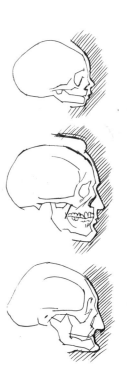

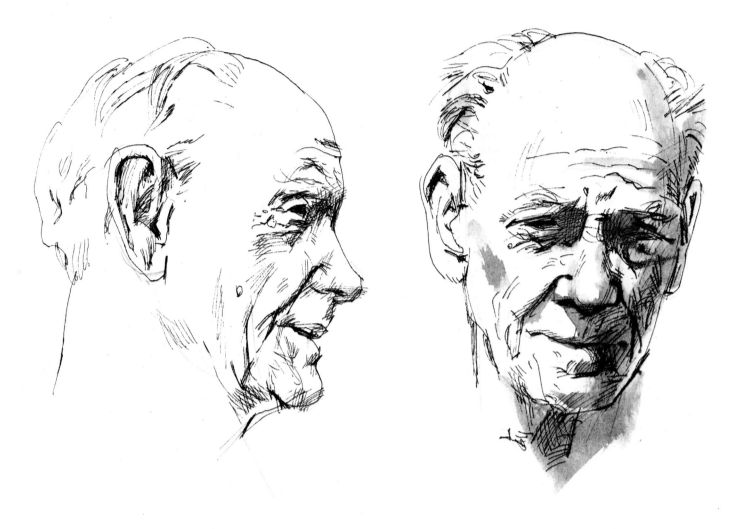

The octogenarian man, seen in profile and face on above, shows how the aged skin has set in furrows due to repetitive muscular activity. There is little fatty tissue, so the form of the cheek and brow muscles is easy to read.

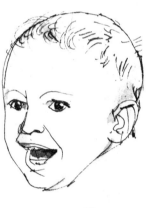

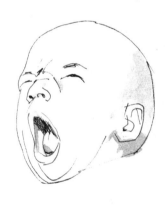

A sample of the infinite range of expressions capable by the facial mask is illustrated here. The smiling infant and yawning baby, left, have translucent, supple, unlined skin. Beneath, the fatty tissue conceals the muscular form. The angry, haughty and scowling men, below, show how muscles can contort the face. The scowling man uses the forehead muscles to furrow his brow, his nose and cheek muscles to wrinkle his nose, and mouth muscles to lower the outer angles.

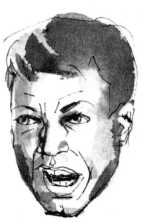

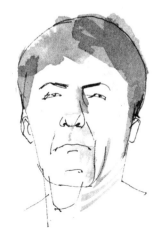

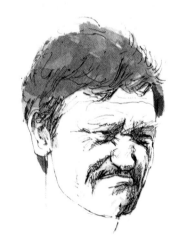

A smile affects not only the shape of the mouth, but also the cheeks and, particularly, the eyes. This smiling girl, left, has few wrinkles to show for her age and enough subcutaneous fat to give a soft line to the face. The cheek muscles push up the covering fatty tissue, causing small pads to appear below the eyes.

The eyes of this older man, left, are almost closed in the act of mirth. The skin shows a tendency to wrinkle below the eyes, where the cheeks are pushed up against the delicate skin. A smile usually bares only the upper row of teeth.

The face of this older woman, left, bears witness to many years of smiling; the crow's feet wrinkles, running from the outer corners of the eyes, and the parallel curved creases, echoing the laughter lines, at the side of the mouth. This sketch illustrates well the tiny folds of skin which form on the bridge of the nose when a person smiles.

2 PERSP

ECTIVE

INTRODUCTION

The ancient Egyptians ignored perspective, Giotto in the fourteenth century nearly mastered it, but it was another 100 years before its rules were established.

Over the centuries, many different systems of depicting three-dimensional space on a two-dimensional plane have been evolved. These theories on perspective were initially based on observation and empirical knowledge and then later based on scientific method, enabling the construction of very accurate and precise drawings. Sometimes perspectival systems are combined within a single picture — perhaps as a result of one culture's influence on another or marking a period of transition between two systems. More recently, the artist will use a mixture of systems to achieve special effects — a statement about space and our perception of things seen or a comment about the subject matter.

Seen from different viewpoints, an object may in appearance seem very different to what it is in reality. Our familiarity with photographs and two-dimensional representations has trained our eye to be aware of the changes caused by distance and angle. The human eye is in effect a camera so that wherever we look we see a perspective view. If an exact record is made of this view, it will be in perspective. But the eye is conditioned by

what we know the object looks like, for example, we know our arms are the same length, but a figure seen in perspective may appear to have arms of a different length.

Linear perspective

It is fortunate, therefore, that the artist need not rely on observation alone. By following the rules of linear perspective — otherwise known as scientific, central or geometric perspective — formulated in the fifteenth century, it is possible to construct artificially these apparent changes in form.

Perspective is by no means common to the art of all epochs and peoples. The art of the ancient Egyptians, for example, although highly developed, did not take account of the optical effects of recession. Most primitive art tends to ignore perspective, as can be seen in Stone Age cave drawings. Indian, Chinese and Japanese art — and medieval European art — manipulate perspective very freely to suggest an order of values which is philosophical, spiritual or narrative rather than purely representational.

One of the greatest monuments to the rapid advancement in the understanding of

Giotto (c. 1267-1337) brought a sense of vital reality to his work at a time when stylization and formalization was the norm. Giotto here in his *Lamentation over the Dead Body of Christ* creates a feeling of depth into the picture space through overlapping his figures and through strong compositional lines which lead the eye into the scene. The landscape is given little prominence as the emotions of the scene depicted need to be contained.

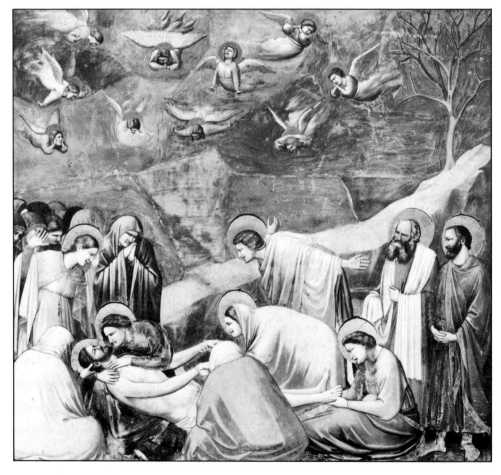

spatial realism was created in fourteenth-century Italy. This was the great fresco cycle, painted by Giotto in 1306, in the Arena Chapel in Padua. It tells the story of the life of the Virgin Mary, her parents, Joachim and Anna, and Jesus Christ and is remarkable in its display of empirical perspective. On the walls of the chancel arch, on the right- and left-hand sides as one look towards the altar, two Gothic chapels are depicted at eye-level. Both are constructed using a common vanishing point, showing that Giotto aimed at an illusionistic piercing of the walls. Nevertheless, his form of perspective was intuitive and practical rather than scientific. In fact, laws on perspectives were not formulated until a century later.

The Florentine architect, Brunelleschi (1377-1446), is generally acknowledged to have been the originator of the first construction using scientific perspective. There is no record of his prototype but, from Giorgio Vasari's *Life of Brunelleschi* we learn that he invented an ingenious system, including plan, elevation and intersection, with the aid of which he painted two famous panels (now lost) representing the Florentine Baptistry of San Giovanni and the Signoria. This discovery of geometric perspective grew out of a new emphasis on the representation of the natural world, reflecting the classical tastes of confident and wordly patrons. The perspective of artists like Brunelleschi was not an illusion, in the sense of *trompe l'oeil*, but a method of formalizing space according to a set of geometric assumptions. This search for a solution to such visual problems owed much to the renewed popularity of interior themes.

Having almost perfected the illusion of pictorial space, Italian artists of the sixteenth century used their theories on perspective to realize a new vogue, now described as mannerism. False lighting, violent foreshortening and a forced perspective, where parallel lines converge much more rapidly than in reality, created a mood of tension and ambiguity in painting.

The Baroque painters used perspective to create greater heights and depths than before. Marvelously ornate *trompe-l'oeil* ceilings harness the possibilities of perspective to express infinite vistas, rather than the finite space of the Renaissance.

A master of perspective, who used his theory with a great sense of flamboyance and skill, was Giovanni Piranesi (1720-78). Large vaulted interiors, dwarfing all human life, rows of columns disappearing to infinity and ever rising staircases are typical of his authoritative architectural inventions.

The Surrealists, earlier this century, revived the use of perspective to create spatial

In this study for his painting of the *Adoration of the Kings*, 1481, Leonardo da Vinci has taken great care in setting up his perspective system, so that the turmoil of the action can be given a solid structure and the picture space is well-defined. The grid makes it possible to place the figures to scale in the space.

illusion and to convince us that the dream is a reality. Perspective was used to show a real world in which accepted notions of reality were defied and challenged. Giorgio de Chirico's paintings depict an environment of elongated shadows thrown across empty squares, often a solitary figure in a concrete space, showing us the unreality and bizarre fantasy of a strange world. False perspective, often from a number of viewpoints, adds to the sense of the unreal.

Further evidence of a disturbed state of mind is reflected in the use of forced perspective in the works of the Expressionist painters. Look at the works of Edvard Munch (1863-1944). In *The Cry*, for example, the perspective lines converge so rapidly that our own sense of reality is challenged and infinity is brought uncomfortably close. Many other Expressionist painters used perspective to express the same attitude to space — a telescoping of distance so that we are drawn into the picture in a headlong rush.

We can rely, then, on the rules of linear perspective to achieve an illusion of space.

But in many ways a painting depending solely on the laws of linear perspective will not match our own real-life experience. Pictures by Renaissance artists using such theories carry a certain intrinsic beauty consciously intended. But a scene in such a picture should be viewed with monocular vision from an absolutely fixed position to gain the full effect, which is very restricting for the observer. In real life, we see with two eyes, which constantly move, scanning objects within our range of vision — from foreground to horizon, from sides to center. How can we avoid the pitfalls of linear perspective? The answer is to use the theory but not to be bound by it, combine it with your own observation and other well-founded illusionistic devices explained in this section.

Atmospheric perspective

Another system used, often in conjunction with linear perspective, to create an illusion of depth into the picture space, is aerial, or atmospheric, perspective. This system creates illusionary space through the representation

of the tonal modification of colors caused by the atmosphere. Basically, this means that, as things retreat from the eye, they become lighter in tone. Objects in close focus have more tonal strength than objects seen in the middle distance and these objects, in turn, are stronger in tone than those seen in the far distance. Not only would those objects located in the full focus of the foreground have more overall tonal strength — and would thus appear darker — but parts of such objects, the areas receiving full light, would tend to be darker in tone than anything else included in the picture.

Consider setting up a scene in theatrical terms where the foreground boards are strong and dark, the next layer is middle toned and the background ones are light. By this means, the eye is led inevitably into the picture space. On this stage, the foreground figures, in full focus, are in the darkest part of the picture. These foreground forms stand out well against the rest of the painting because they contrast strongly with the background features which pale progressively as they recede. The color itself becomes affected by distance, so that the further an object is from the eye, the more modified become the various colors. As colors recede, they have a bluish tendency.

Blue is the key to the distant hues as perceived in nature. In the past, the formula for painting landscape was to color the foreground very dark and brown, the middleground green and bright but qualified by blue and, finally, the far distance pale blue. This formula was used by Leonardo da Vinci and later by many of the Dutch seventeenth-century landscape painters. As a basic principle of observed truth, the range of tone to color was correct; it was no easy and slick formula but a time-honored method in which recession was suggested, apparent distance created, and the eye invited to travel in to the world invented by the artist.

Anything located in the same approximate area in the picture space must fall within the same tonal range, otherwise it will not integrate into the picture. Since standing objects tend to be darker in tone than horizontal ones (the light coming from the sun above illuminates the ground plane), it is important to observe the tonality very closely indeed. This is best done by screwing up the eyes in order to increase the contrast between dark and light — such a practice is invaluable in all objective drawing and painting but especially so in this case. When ascertaining the tonal relationships, you can also study how haze and atmospheric dust affect the colors, and it is these relationships which particularly reward attention by the artist.

The credibility of three-dimensional space can be augmented by details of texture and pattern as they recede away from us and reach out beyond the picture plane. Blades of grass, cobblestones, bricks and wallpaper patterns, the texture of velvet, of furs and tablecloths, all have clear and discernible detailing when close which becomes blurred and less distinct at a distance.

Shadows

Shadows are an important element in many pictures, whether cast by standing figures to consolidate the form, or as positive shapes to

Vincent Van Gogh (1853-90) in this pen-and-ink landscape drawing manages to create an impression of depth into the picture through atmospheric perspective. Note how the detailing in the foreground is depicted using broad pen strokes. These become closer together and lighter in the middle ground and almost disappear in the background.

balance the composition. Sometimes, too, shadows are introduced to create a mood, as in paintings by the twentieth-century American artist Edward Hopper, or to lead the eye through and across the picture plane.

Chiaroscuro is the study of light and shade, developed by Renaissance artists, which became an important part of the science of picture-making. By the end of the sixteenth century it had become a major artistic device. Caravaggio's *Supper at Emmaus*, painted in about 1600, demonstrates a wonderfully structured composition in which the use of dramatic light and shade is an essential part. Later, in seventeenth-century Holland, Frans Hals painted some group portraits deserving of study. Not only are the shadowed areas in the picture balanced with the brighter, lightly focused heads on the surface, but they also lead the eye into the picture and out again. Because these paintings were commissioned jointly, all the characters depicted wanted equal prominence in the painting and, to do that, the artist required great skill. Probably the most renowned artist for his use of light and shade, however, was Rembrandt, a contemporary of Frans Hals. He composed his paintings around a focal point of light, casting the rest of the picture into ever deepening shadow. His art was in making

the darker parts of the paintings as alive as the highlighted central subject. All these artists have employed light and dark to balance, to stress and to create solid appearances.

Reflections

In Lewis Carroll's *Alice Through the Looking Glass* a magic world is created in the mirror image of reality: this idea can be extended into the world of picture-making. The familiar becomes strange by being reversed and reduced in size — and yet it remains familiar.

One of the best known details of a painting in the history of art is the convex mirror in the background of Jan Van Eyck's portrait of *Arnolfini and his Wife* of 1434. This is virtually a picture within a picture, showing a back view of the main subjects — Arnolfini and his wife — and a self-portrait of the artist making the painting. The idea of using a mirror as an interesting and intriguing visual device is not unique to Van Eyck; Diego Velazquez has a cupid holding a mirror for the Rokeby Venus of about 1649. The reflection shows the nude's face but this is not a correct view for the angle at which it is held. This artist was perfectly capable of accurately positioning the mirror, so one can only assume that it was positioned thus for compositional reasons.

Pierre Bonnard (1867-1947) used a

Rembrandt (1606-69) always made interesting use of light. In this painting, *The Feast of Belshazzar: The Writing on the Wall*, he leads the eye into the composition through the gesture of the main character, and then directly on to the important detail, the 'writing on the wall' in the background. This 'writing' provides the principal light source for the painting so that the shadows come forward towards the observer.

The Supper at Emmaus by Caravaggio (1573-1610) demonstrates a wonderfully structured composition in which the use of dramatic light and shade is an essential part. The artificial light source is hidden behind the foreground pilgrim, casting strong shadows across the table cloth and creating extra depth with the shadow of Christ on the back wall.

mirror, as do all artists making a self-portrait, but, in his case, the mirror itself was featured, incorporated in its entirety so that the reflection of the painter's head is almost incidental. Ambrose McEvoy (1878-1927) used a reflection in his painting of a girl putting on an earring and the counter-rhythms of her back-view against her portrait seen in the mirror make an interesting composition. Reflections have featured, too, in the work of American photorealists — large and careful pictures of whole streets reflected in shop windows, inviting the eye to accept the ambiguities associated with the double image.

Mixed systems and distortion

Assuming always that the basic lessons have been learnt, it has always been the duty of the artist to find new avenues to investigate. So, how can we apply this to perspective? One way is through using the powers of perspective to distort rather than bring order to a composition. Some theories maintain that, as what we see is a projection onto a concave spherical surface centred in the eye, linear perspective is an unsatisfactory method of reproducing this.

This is not only because of the wide angle distortions inherent in its projection, but also because it represents objective straight lines as straight whereas, they maintain, in natural vision some of them would appear curved. Several British landscape painters of the 1940s and 50s, having observed this phenomenon, used such a system as the basis of their compositions. Other systems, used by earlier civilizations and cultures, have been revived and introduced into Western art by artists wishing to examine an alternative way of portraying forms in space.

Reference to perspectival systems in other cultures is particularly rewarding. Their systems of describing space, whether limited or infinite, often have intentions quite at variance with traditional Western painting. For instance, orthographic projection is more commonly used than linear perspective and some cultures are much more concerned with hierarchy, real precedence, than with accurate depictions of space. Hence, some aspects of the subject matter depicted might have more significance than others and are therefore given greater prominence: an important character will be represented as larger in scale than his less important brother, standing next to him in the picture space.

Any painter wishing to extend his range of expression would do well to study the unfamiliar systems of picture organization which abound in the contemporary art scene today.

Pierre Bonnard (1867-1947) in this *Interior at Antibes* shows his interest in the effect of light. The bright light falling through the window creates depth in the painting and adds visual vitality to the composition.

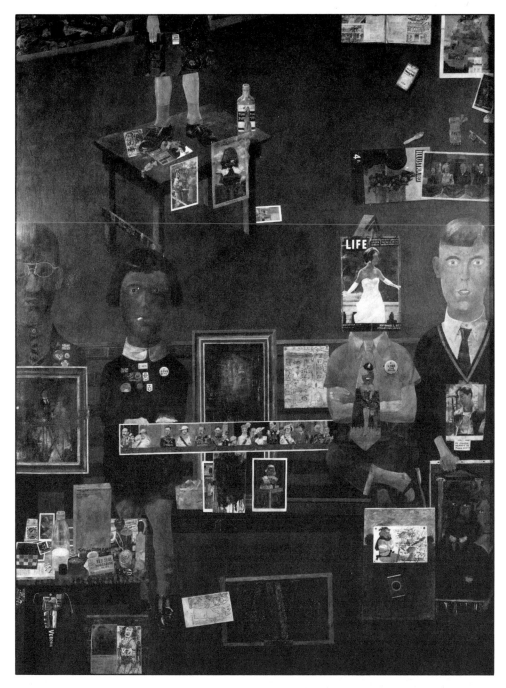

Peter Blake (*b.* 1932) enjoys playing with the spectator's emotions. In this painting *On the Balcony* the foreground figures are made to appear flat. Where they are exactly placed in space is ambiguous: the photograph of the Royal Family appears in front of the girl on the left and behind the headless boy on the right. The cropping of the outside figures makes the group come forward onto the picture surface. This makes the truncated figure on the distorted table in the background even more confusing. Peter Blake makes use of various spacial systems to evoke these emotions which are closely concerned with the subject matter of the painting.

UNDERSTANDING PERSPECTIVE

By mastering the tricks of linear perspective, combined with other well-founded illusionistic devices and the powers of observation, the artist can create an illusion of depth into the picture space.

The artist, when employing artificial perspective, aims to create the illusion of a real scene as viewed through a window. This illusion can only be achieved, however, by viewing with one eye from the correct position — the fixed position of the artist.

How do we choose this viewpoint? Through experience the artist will find that altering the viewpoint — through distance, height or angle — will change the mood of the picture. So every aspect of this viewpoint, or station point, must be considered.

Cone of vision

The viewpoint must enable the artist's field of vision to encompass the subject without moving the head. This field of vision is called the cone of vision, because of the infinite number of sight lines which radiate in a cone-like shape from the eye. For drawing purposes the angle of this cone is about 60° because, although we normally possess a field of vision of 180°, only 60° is in focus for us to see clearly enough to draw. If a greater angle than 60° is used, it implies a moving cone of vision — meaning that the head has been rotated — and the picture will seem distorted and out of perspective. This is similar to the distortion sometimes seen at the edges of photographs. The peripheral area around our cone of vision is sensitive to light and movement but, in order to see objects in this area clearly enough for drawing purposes, it is necessary to turn our head and shift our focus. This naturally changes the perspective and, therefore, when larger objects are drawn, and a greater range of vision is required, the subject matter needs to be observed from a greater distance. A landscape or street scene, for example, would occupy the entire range of the cone, whereas a still-life would usually not.

Perspective terms

Before proceeding with the next step in drawing a perspective scene, we need to understand some of the technical terms used. When we look about us, we focus upon a succession of spots of interest, each of which is fixed by a sight line at the exact center of the cone of vision. This line is known as the *center line of sight* or the *central visual ray*. The artist stands on the *ground plane* and where this meets the *picture plane* (the imagined plane between the artist and subject) is known as the *ground line*. Unless you are looking up or down at your subject, creating a tipped picture plane, the picture plane is always at right angles to the ground plane. Your paper or canvas therefore is the picture plane and on it is drawn what would be seen if it were transparent and held perpendicular to your central visual ray.

Horizon line

On the picture plane, at eye-level (if, that is, your central visual ray is parallel to the ground

Perspective terms The artist stands at the station point on the ground plane, looking towards the object he wants to represent on the picture plane, his canvas or paper, which is an imagined plane between the artist and object. The ground line is where the picture plane and ground plane meet. The central visual ray, emanating from the eye, is parallel to the ground plane. It meets the picture plane at right angles on the horizon line, drawn at eye-level horizontally across the picture plane. Where the central visual ray and horizon coincide is the center of vision

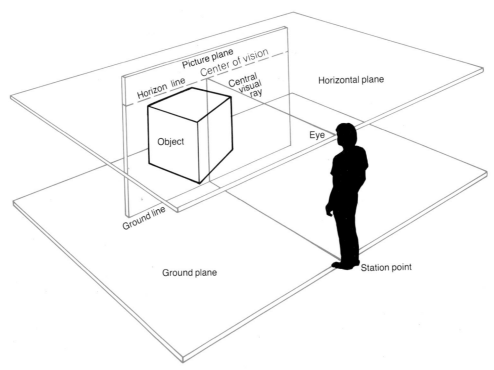

The horizon line occurs at sea level. If you are standing by the sea, you can test this by holding a ruler up at eye-level. You will find that it coincides with the horizon. On land, however, your horizon line will usually be hidden behind undulating ground, but it can still be found and drawn in on the picture plane.

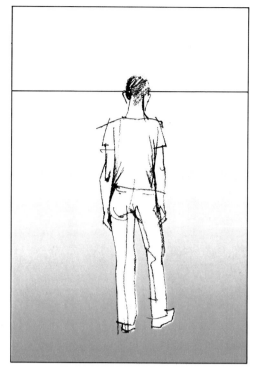

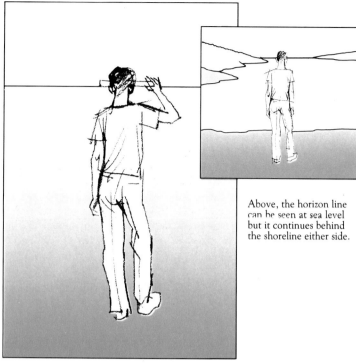

Above, the horizon line can be seen at sea level but it continues behind the shoreline either side.

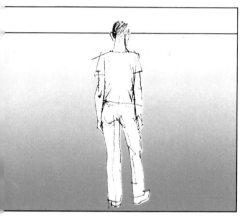

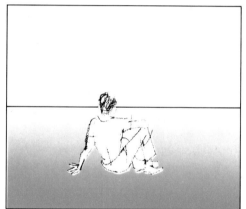

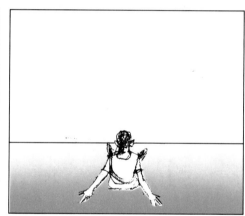

The three illustrations above show how you can change the horizon line. The higher up you position yourself, the more of the ground plane you can see, and the higher the horizon line will appear. You can try this out for yourself in different positions. The eye-level you choose is dictated by the requirements of the subject matter.

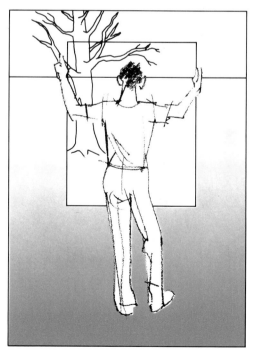

The picture plane can be imagined as a sheet of glass held vertically between you and the subject matter. It is what you see through this plane that you will transpose onto your support. The first step is to draw in the horizon line.

Using perspective The simple landscape, right, shows a plain with a mountain range in the distance. What if the artist decides to add a level road across the plain, from his station point, receding towards the mountains? The road, far right, has been drawn in without the use of perspective and the result is ambiguous.

Right, with the aid of perspective, the road is seen disappearing to a vanishing point on the horizon line, creating an illusion of depth into the picture space.

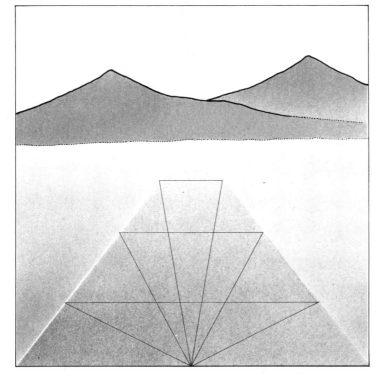

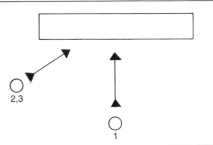

This bird's-eye view of the observer of the road shows how, as the distance increases, the road appears to diminish in breadth.

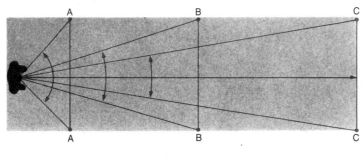

A side-view of the observer illustrates why the road appears to rise on the picture surface.

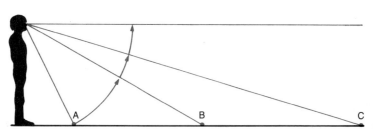

Views of a brick wall will ably demonstrate the use of perspective. In the top illustration, the plan (bird's-eye view) of the wall can be seen, with two station points indicated. Below this, the wall is viewed from 1 in the plan.

It is not necessary to employ perspective here as parallel lines, parallel to the picture plane, do not converge to a vanishing point. In 2, the wall is viewed from the corner with no perspective. As a result, the eye finds it difficult to locate the wall in space. Using the same station point, in 3, it becomes obvious that the wall is receding from us at an angle, with the two visible planes and the parallel lines of the brickwork converging.

Locating a vanishing point If a box is viewed from one corner with three planes visible, and the central visual ray is parallel to the top plane, the vanishing points of the two side planes can be located on the horizon line, within the picture plane, or sometimes outside it. The vanishing point is found where a sight-line, parallel to the set of parallel lines of the object, meets the horizon line. So, a line from the station point, B, parallel to the side plane of the box, ED meets the ground line at A. A vertical line from A meets the horizon line to locate the left vanishing point. The right vanishing point is found in the same way.

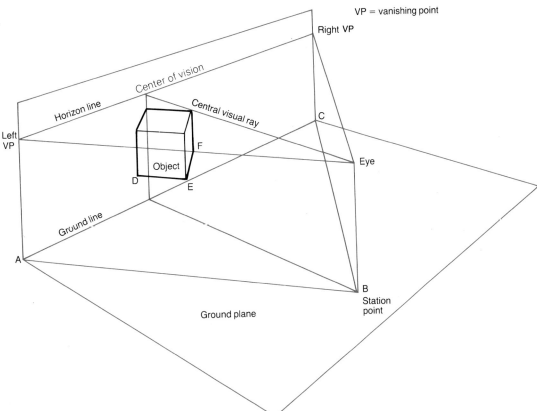

plane) the *horizon line* can be drawn. This means that the height of the horizon line above the ground line is the same as that of the eye above the ground plane, whether you are lying on the ground or sketching from the top of a lighthouse.

The height at which the artist places himself can change the mood of the picture. The higher his position, the more of the ground plane he is able to see. A small child sees less than an adult. Similarly, an artist sitting down sees less than one standing up. Panoramic views must necessarily have a high eye-level: the emotional effect is one of detachment.

By lowering the viewpoint the artist can increase the feeling of drama in the picture. In a landscape, this invariably has the effect of silhouetting objects against the sky. Figures seen from low down appear menacing.

Distance of artist from picture plane

The position of the artist with respect to the picture plane is important too. Although the distance between the two is dependent upon the length of the artist's arm and the control he wishes to retain, its effect can be quite considerable. To test this, you can trace round various objects seen through a window using chalk or a wax crayon on the glass. You will notice that the closer you stand to the window, the smaller your representation will be and that, by moving back only a few inches, the scale will be altered quite considerably.

Distance of picture plane from object

To get the best illusionistic effects, the artist must be at least one and a half times the height away from the tallest object, usually a building or tree in a landscape drawing. A close or distant viewpoint gives a different effect and should always be considered in relation to the choice of subject.

Vanishing points

Any two or more lines that in reality are parallel (the two opposite edges of a table, for example) will, if extended with continuing imaginary lines appear to converge at a point on the horizon. This point is known as *the vanishing point*. The classic example of this phenomenon is that of railway tracks receding into the distance. In this case, the lines retreat from the spectator at right angles to the picture plane, so the vanishing point coincides with the *center of vision*, the point where the central visual ray meets the horizon.

In the real world, instances of long straight uninterrupted parallel lines are fairly rare occurrences. But we come across sets of shorter parallel lines in every detail of our lives — architecture, furniture, roads, rivers, cars, books — and in each case, when seen obliquely, these lines will appear to converge as they recede into the distance. Each set of these parallel lines has its own vanishing point which is always placed somewhere along the horizon line.

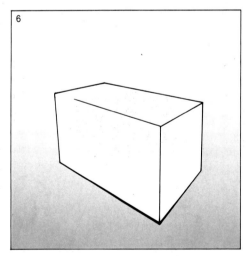

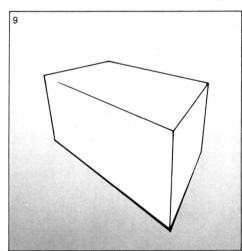

Altering the station point can dramatically change the view of the object to be represented, but it does not affect the size substantially. In 1, the artist is standing at a distance from the object, a box, using a narrow angle of vision, as seen in 2. This will result in a reasonable representation of the box (3).

In 4, the artist has moved closer, the angle of vision is wider (5), and the box appears dramatically foreshortened (6).

Standing close up to the object, as in 7, does not permit the object to be covered by a 60° cone of vision (8), and results in a distorted box (9). Although the latter position is not recommended for representational drawing, it can be visually interesting for, say, a surreal composition. The distance between the artist and picture plane need only be changed by a few inches for these characteristics demonstrated to become apparent.

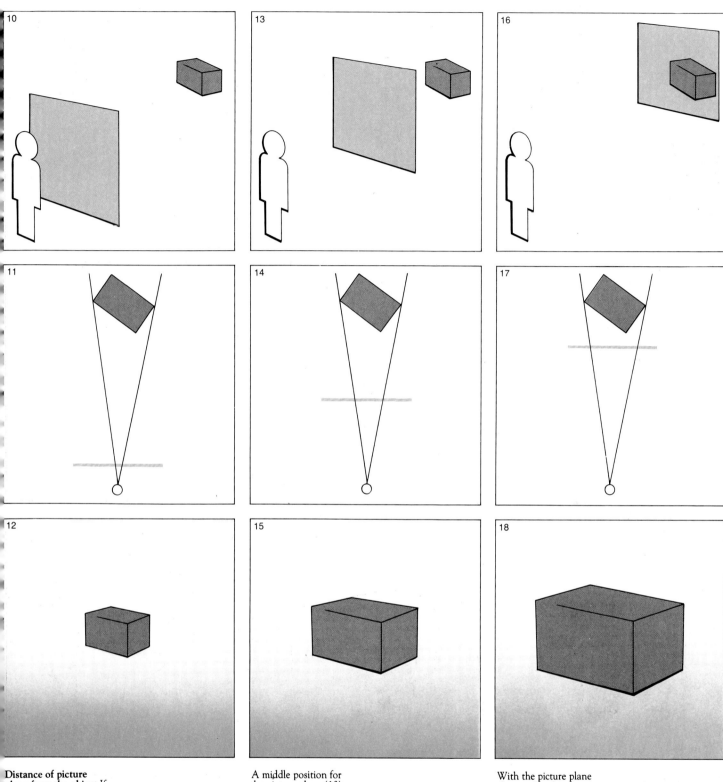

10

13

16

11

14

17

12

15

18

Distance of picture plane from the object If the station point and the box remain constant but the picture plane is altered, the view remains the same, but the size depicted is affected. With the picture plane close to the artist, as in 10, the object appears small (12).

A middle position for the picture plane (13) results in a middle-sized representation (15).

With the picture plane close to the object, as in 16, the box takes up most of the picture surface. The importance of the object in the composition will very much dictate which position to adopt.

PERSPECTIVE SYSTEMS

There are various types of perspective systems to choose from. Once these have been explained, it will become more obvious which system suits the subject matter chosen.

One-point perspective

Simple one-point parallel perspective is regarded as the layman's option, yet Leonardo da Vinci used it in one of the most renowned paintings in history, *The Last Supper* in Milan.

It will be useful to demonstrate the difference between the various perspective systems with a box-like shape, as objects can usually be visualized within a box which facilitates their representation in perspective. For example, it is easier to draw a head in perspective if it is envisaged in a rectangular box.

In one-point, or parallel, perspective our box will have two planes visible; one parallel to the picture plane and the other with sides which appear to converge at a single point on the horizon.

Two-point perspective

If we rotate the box slightly so that a corner presents itself to us, the vanishing point of the length lines will be located further along the horizon line, until, from a certain angle, it passes out of the picture. The width lines of the box are, therefore, no longer parallel to the picture plane, so a vanishing point has to be established for them too. This is called angular, or two-point, perspective.

Often vanishing points are concealed behind undulations in the countryside, architecture or a prominent figure in the foreground, but they can still be found and drawn in on the picture plane.

You will find, however, that if your vanishing points are too close together, your box appears distorted. This means that you are standing too close to the subject. If you step back where you can see more with your fixed cone of vision, the vanishing points spread apart and the distortion is eliminated. If the vanishing points are too far apart this results in minimal convergence and conveys a sense of flatness.

Three-point perspective

With three-point, or oblique, perspective the observer can see the three planes again, but this time there are three sets of converging lines, not two. With this system, two of the sets of parallel lines meet at vanishing points on the horizon, and the third set intersects at a point either above or below that line. This occurs when there is a very high or low viewpoint and can be demonstrated by looking up at a very tall building.

VP = Vanishing point

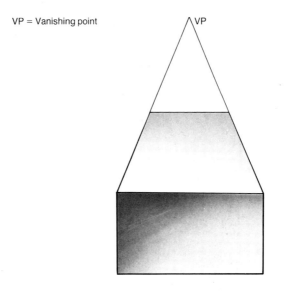

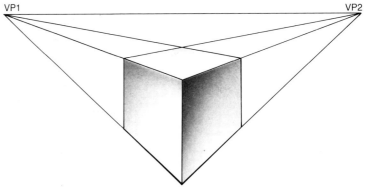

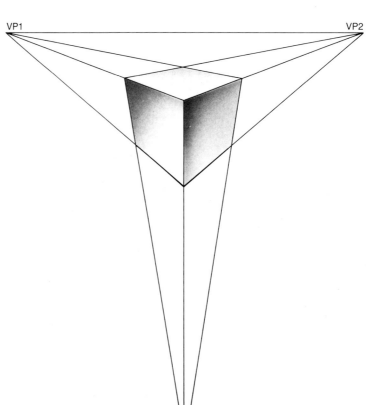

One-point perspective
Here our box is only visible on two sides and the plane facing us has parallel lines, parallel to the picture plane, so will remain unaffected. The parallel lines of the top of the box, if extended, meet at the vanishing point on the horizon line. Some exciting effects can be achieved using this simple system, but it can be restricting.

Two-point perspective
Some more visually interesting views can be depicted if the box is rotated so that a corner appears. Three sides of the box are then visible and two vanishing points can be located on the horizon line. Take care not to place the vanishing points too close together or too far apart, otherwise the box will appear distorted.

Three-point perspective
If a tall building is included in the composition or the eye-level is high above the ground, as in a bird's-eye view, then three-point perspective is essential. Here, three vanishing points can be located: two on the horizon line and the third below.

Elevation Side elevation

Plan

Central visual ray

90°

Station point

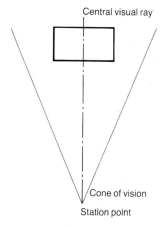

Central visual ray

Cone of vision

Station point

One-point perspective, step-by-step 1. It is useful to draw the object from three views (an orthographic projection): from above (plan), from the front (elevation) and from the side (side elevation).

2. Locate the station point and the central visual ray at right angles to one side of the box.

3. Check that the station point is within the cone of vision.

VP = Vanishing point

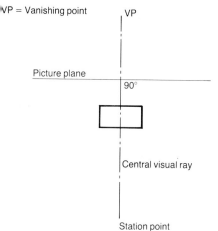

VP

Picture plane

90°

Central visual ray

Station point

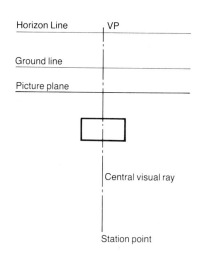

Horizon Line VP

Ground line

Picture plane

Central visual ray

Station point

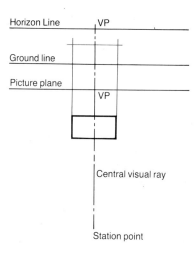

Horizon Line VP

Ground line

Picture plane

VP

Central visual ray

Station point

4. Locate the picture plane at right angles to the central visual ray. The vanishing point will lie on it for the visible plane of the box which has sides parallel to the central visual ray.

5. Draw in the ground line, then the horizon line above it. The vanishing point will occur where the central visual ray meets the horizon line.

6. Draw the true elevation of the box on the elevation of the picture plane.

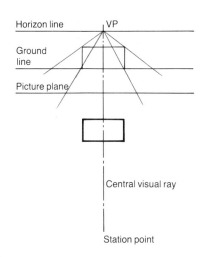

Horizon line VP

Ground line

Picture plane

Central visual ray

Station point

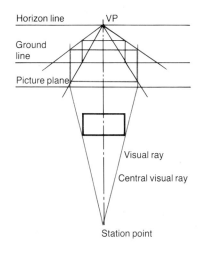

Horizon line VP

Ground line

Picture plane

Visual ray

Central visual ray

Station point

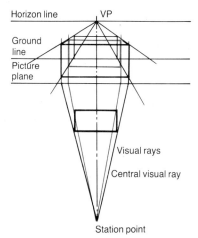

Horizon line VP

Ground line

Picture plane

Visual rays

Central visual ray

Station point

7. From the vanishing point, draw perspective lines through the points of the elevation.

8. Draw visual rays from the station point through the lower corners of the box to locate the front face of the box in the perspective view.

9. Draw visual rays from the station point through the upper corners of the box to locate the rear face of the box in the perspective view, thereby completing a one-point perspective view of the box.

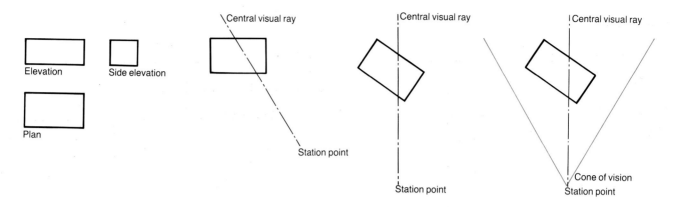

Two-point perspective, step-by-step 1. Draw an orthographic projection of the object (box), including plan, elevation and end elevation.

2. Locate the station point and the direction of view, drawing in the central visual ray.

3. Turn the drawing so that the central visual ray is vertical.

4. Check that the station point allows the object to fall within the cone of vision.

VP = vanishing point

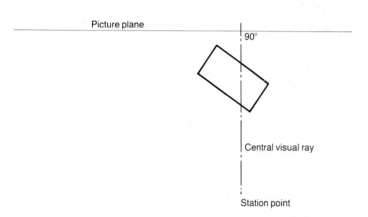

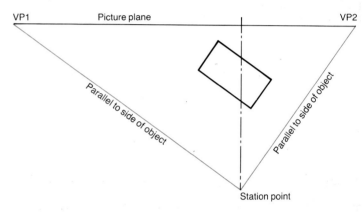

5. Draw in the picture plane at right angles to the central visual ray.

6. Locate the vanishing points of the two visible planes by drawing visual rays parallel to the sides of the object. Where they meet the picture plane will be the vanishing points.

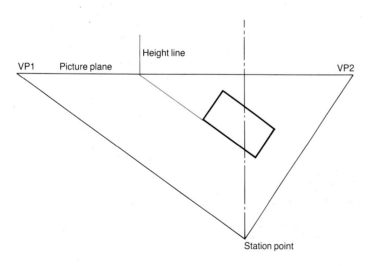

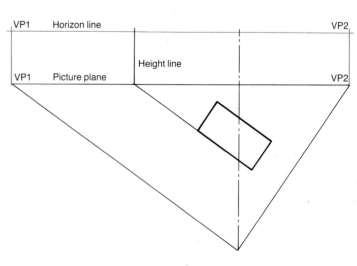

7. Continue one side of the object up to the picture plane to locate the height line.

8. Draw in the horizon line parallel to the picture plane and project up from the picture plane to locate the vanishing points.

VP = vanishing point

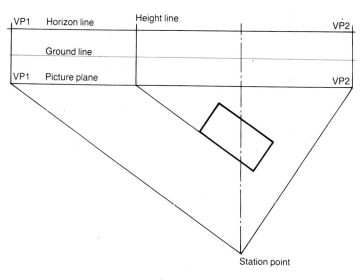

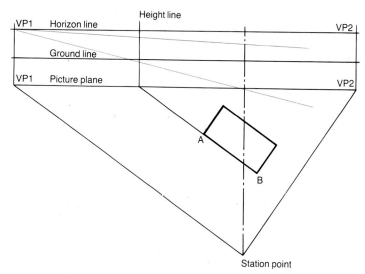

9. Draw in the ground line, between the picture plane and horizon line.

10. From the elevations, the height of the object can be taken and measured up the height line from the ground line. Then, from vanishing point 1, draw two lines through the top and bottom of this measured height.

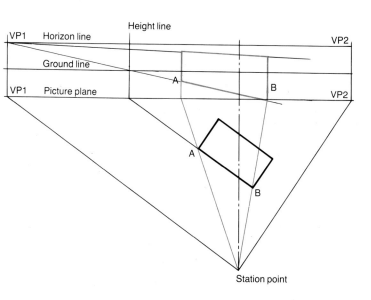

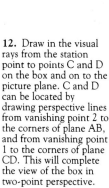

11. Draw in the visual rays from the station point to points A and B on the plan of the box and on to the picture plane. Then, project vertically upwards to locate A and B on the perspective view of the object, where it is seen as a receding plane.

12. Draw in the visual rays from the station point to points C and D on the box and on to the picture plane. C and D can be located by drawing perspective lines from vanishing point 2 to the corners of plane AB, and from vanishing point 1 to the corners of plane CD. This will complete the view of the box in two-point perspective.

127

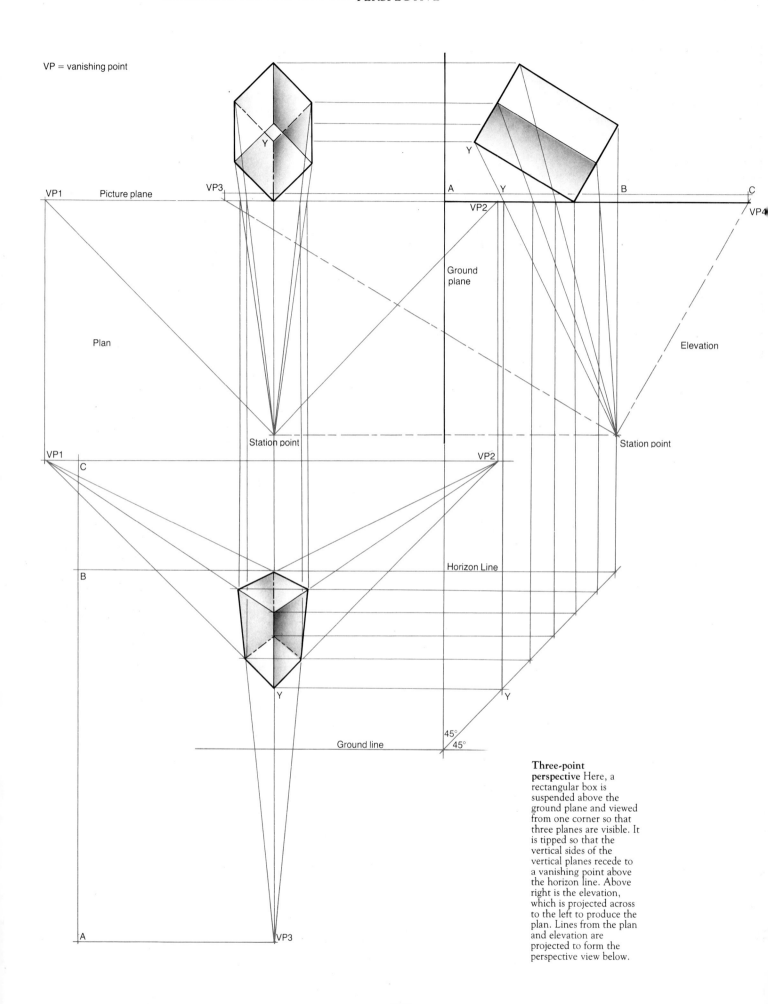

VP = vanishing point

VP1 Picture plane VP3

Ground plane

Plan

Elevation

Station point

Station point

VP1 VP2

Horizon Line

C

B

Ground line

45°
45°

A VP3

Three-point perspective Here, a rectangular box is suspended above the ground plane and viewed from one corner so that three planes are visible. It is tipped so that the vertical sides of the vertical planes recede to a vanishing point above the horizon line. Above right is the elevation, which is projected across to the left to produce the plan. Lines from the plan and elevation are projected to form the perspective view below.

128

PERSPECTIVE OF INCLINED PLANES

So far, we have been learning to cope with the linear perspective of the simple box. Very soon the artist will come across more complicated structures, and common to many of these will be the inclined plane. Almost any scene of architecture will include inclined planes — roofs, gables, pediments, stairways — which, if correctly represented in perspective, add to the visual interest.

VP = vanishing point

The key to the perspective of inclined planes is that their vanishing points lie vertically above or below where they would be located if the plane were horizontal. Above, a spectator can be seen in side-view looking at a wedge-shaped object with an inclined plane facing him. VP1 is the vanishing point of the base which rests on the ground plane and VP2 is the vanishing point of the inclined plane located by a sight line parallel to the inclination which intersects with a vertical line through VP1 here the picture plane. On the right, is the perspective view of the wedge as seen by the spectator.

Locating the vanishing points for inclined planes This is based on the two-point perspective construction, steps 6 to 12, already described. First, draw a plan of the object in relation to the picture plane and station point. Add the ground plane, parallel to the central visual ray, to meet the picture plane at 90°. The station point can be located in the elevation by projecting across from the station point in the plan. The height of the eye is known so the central visual ray can be located parallel to the ground plane. Draw the elevation of the object by projecting across from the plan and using measurements from the orthographic projection. Then locate the vanishing points of the inclined planes on the picture plane with sight lines from the station point parallel to the inclined planes. Then as the vanishing point for inclined lines will be directly above or below the vanishing point of those lines should they be in the horizontal plane, so VP3 will be located at a height B above VP1, and VP4 at a height A below. These points can then be used to draw the object in perspective as shown.

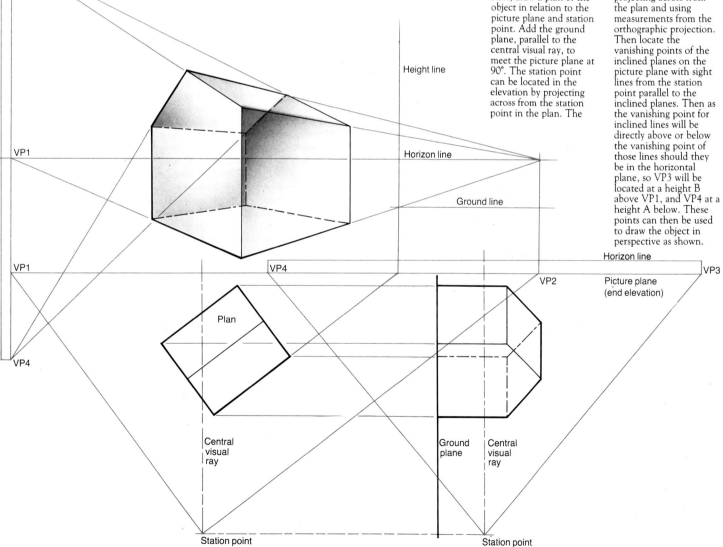

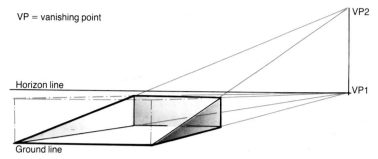

VP = vanishing point

Horizon line

Ground line

VP2

VP1

Inclined planes in perspective A very satisfying project to consider experimenting with the perspective of inclined planes is in the perspective of a flight of stairs. A simplified staircase is wedged-shaped, so the vanishing point can be located above or below (depending on whether the stairs are ascending or descending) the vanishing point of the base of the stairs and the horizontal steps, which converge to a point on the horizon line.

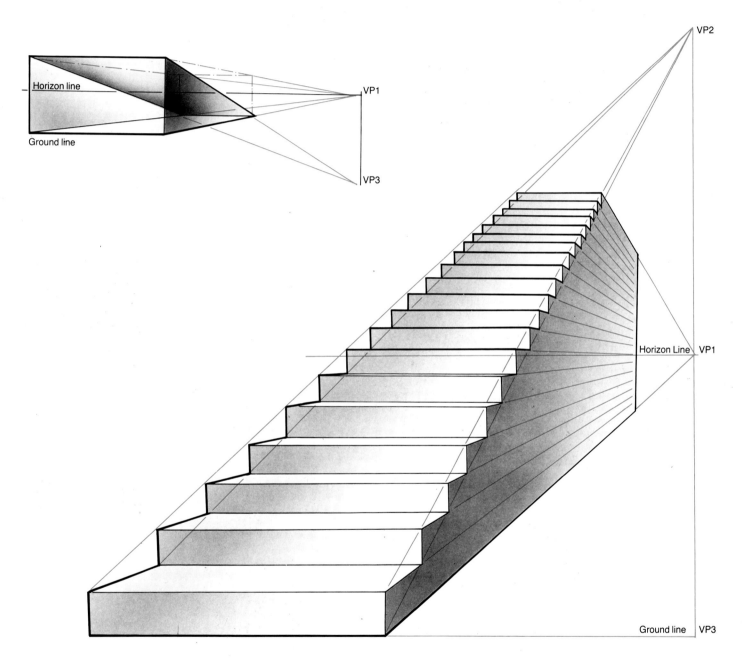

Horizon line

Ground line

VP2

VP1

VP3

Horizon Line VP1

Ground line VP3

130

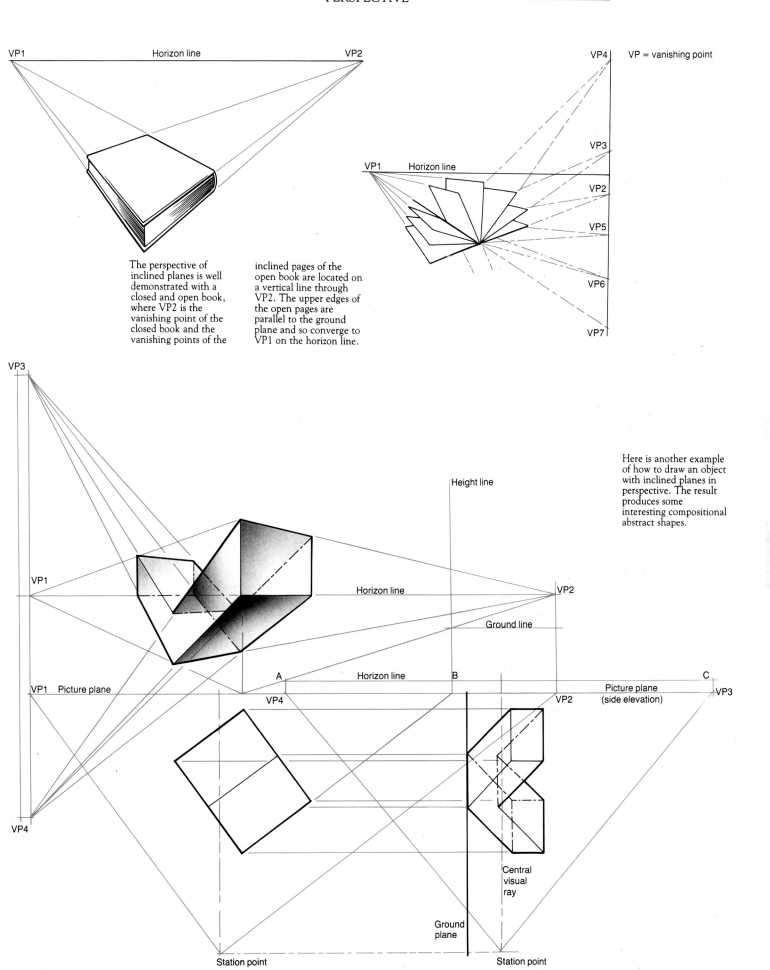

VP1 Horizon line VP2

VP4 VP = vanishing point

VP3

VP1 Horizon line

VP2

VP5

VP6

VP7

The perspective of inclined planes is well demonstrated with a closed and open book, where VP2 is the vanishing point of the closed book and the vanishing points of the

inclined pages of the open book are located on a vertical line through VP2. The upper edges of the open pages are parallel to the ground plane and so converge to VP1 on the horizon line.

VP3

Height line

Here is another example of how to draw an object with inclined planes in perspective. The result produces some interesting compositional abstract shapes.

VP1

Horizon line

VP2

Ground line

A Horizon line B C

VP1 Picture plane

VP4

Picture plane (side elevation) VP3

VP2

VP4

Central visual ray

Ground plane

Station point Station point

PERSPECTIVE PROJECTION

It is also very simple to draw a perspective view from a ground plan. Alternatively, a complicated subject matter can be reduced to a plan and then reconstructed in perspective. As we have established, if you look down a long straight road disappearing into the distance, it will appear to converge on the horizon. In this case your center line of vision will be parallel to the sides of the road. This applies to all sets of parallel lines. So, to establish a vanishing point of the side of, say, a truck on this road, all you have to do is draw a sight line parallel to the side of the truck as seen in plan. Where this line intersects with the picture plane is the vanishing point. The scene can then be drawn in perspective.

The accurate projection of a perspective interpretation of a building from available information, for example a blue-print, not only requires technical skill but also demands of the artist a certain visual common sense which is an indispensable part of making pictures.

Orthographic projections

Orthographic (literally 'correctly drawn') projections are widely used for architectural and engineering drawings in the form of plans, elevations and end elevations. Such a projection is usually sufficient to define an object in every detail. Exact dimensions are given, from which another person can interpret the precise nature of the three-dimensional object represented to them on a two-dimensional plane.

Orthographic projection was understood and used in the early Renaissance, as can be seen in drawings by Paolo Uccello and Albrecht Dürer. It was not fully standardized, however, until the mid-eighteenth century when Gaspard Monge, a French military engineer, developed a system known as first-angle projection. This method places the object of known dimensions into an imaginary box. The planes of the object are projected back onto the sides of the box which are then unfolded. This method is used in Britain and in Europe generally.

The Dutch, however, like the Americans, use a system known as third-angle projection. This method projects the planes of the object forward so that the images appear on the outside of the box and the lines are dropped from the horizontal plane. From these views other auxiliary views can be obtained by projection across the picture surface, either by showing the object from another direction or by showing it in perspective.

Orthographic projection is used to draw three-dimensional objects on a two-dimensional plane, by establishing the plan (bird's-eye view), elevation (side-view) and end elevation (end view). It is usually from the plan that the perspective view is projected and the measurements are taken from the elevation.

First-angle projection
The object, here a simple house, is placed in an imaginary box whose sides are parallel to the sides of the house. The planes of the house can then be projected back on to the sides of the box to form the plan on the 'floor' of the box and the elevations on the sides, as shown. To represent these views two-dimensionally, the box is opened out so that the projections lie in the same plane.

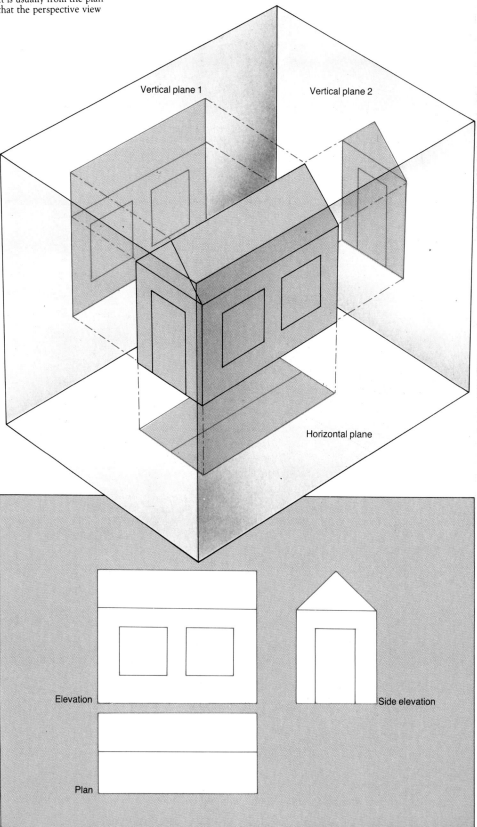

Vertical plane 1

Vertical plane 2

Horizontal plane

Elevation

Side elevation

Plan

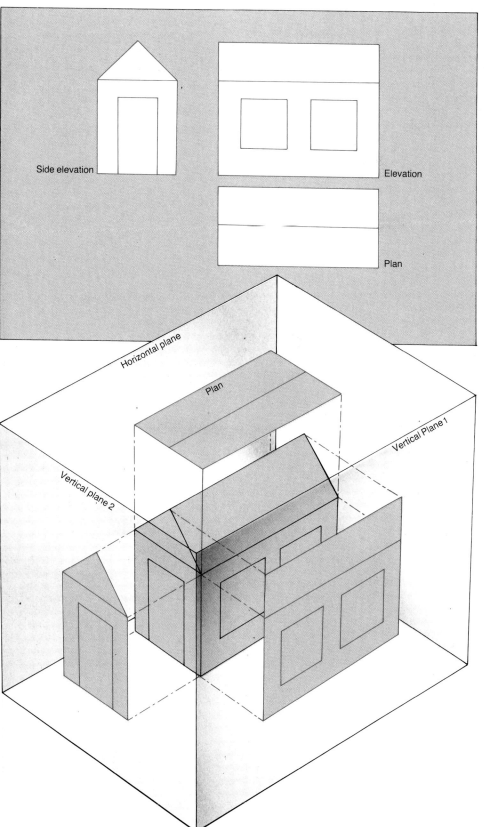

Side elevation

Elevation

Plan

Horizontal plane

Plan

Vertical plane 2

Vertical Plane 1

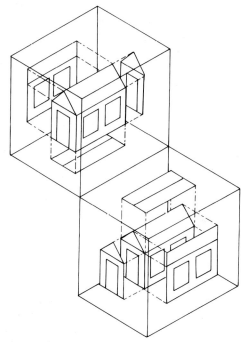

Third-angle projection
On this page an example of third-angle projection is shown, where the plan is projected upwards on to the 'ceiling' of the box.

LOCATING A POINT ON THE FLOOR OR CEILING PLANE

If you have a plan of your proposed composition, it is useful to be able to translate the position of, say, a chair in a room, with respect to its surroundings, from the plan to the picture plane. A simple geometric construction makes it possible to do this and, having practiced this method, and the similar one for a point of the ceiling plane, one's eye becomes trained to position objects using simply one's judgment.

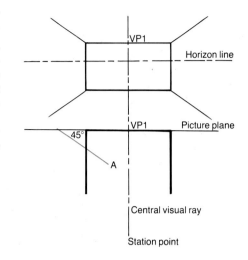

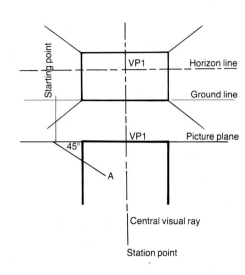

VP = vanishing point

Locating a point on the floor plane 1. Point A on the floor plane is to be located in the perspective view. First draw a line from point A to meet the picture plane at 45°.

2. At this point of intersection, project a vertical line upwards to meet the ground line, sometimes called the starting point.

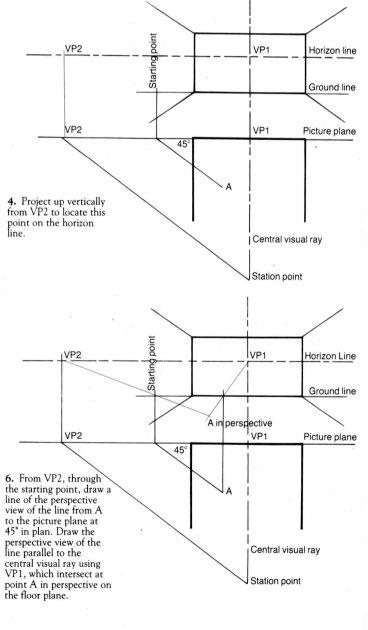

3. Find the plan position of the vanishing point of this line, by drawing a sight line parallel to it to meet the picture plane.

4. Project up vertically from VP2 to locate this point on the horizon line.

5. From point A in plan draw a line parallel to the central visual ray to meet the picture plane and continue this line up to meet the ground line.

6. From VP2, through the starting point, draw a line of the perspective view of the line from A to the picture plane at 45° in plan. Draw the perspective view of the line parallel to the central visual ray using VP1, which intersect at point A in perspective on the floor plane.

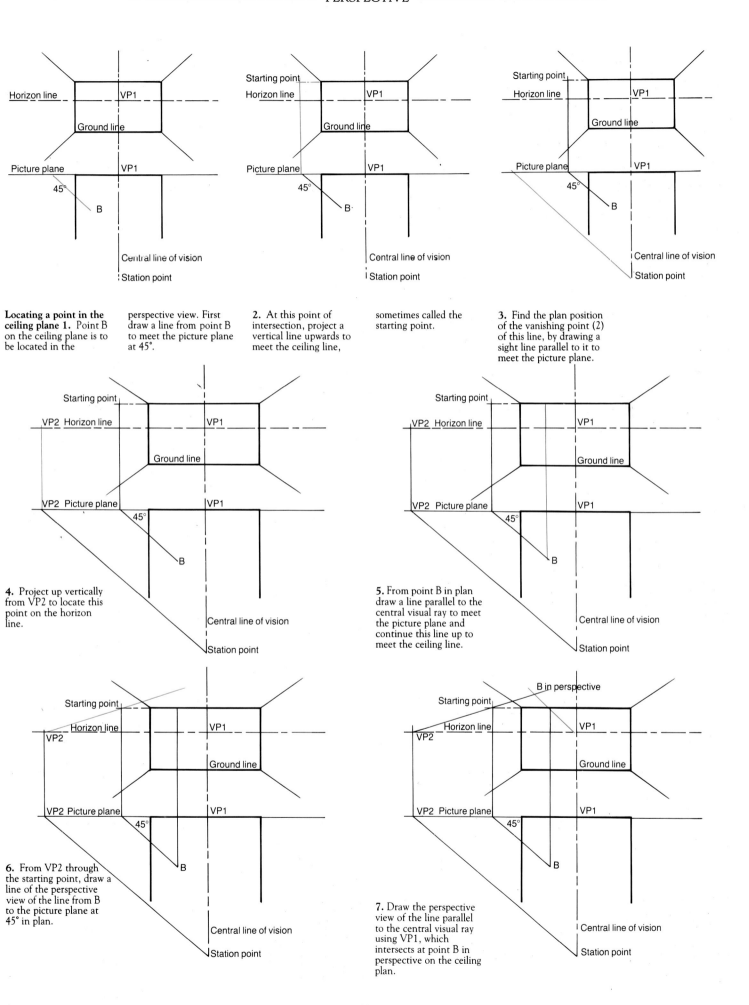

Locating a point in the ceiling plane 1. Point B on the ceiling plane is to be located in the perspective view. First draw a line from point B to meet the picture plane at 45°.

2. At this point of intersection, project a vertical line upwards to meet the ceiling line, sometimes called the starting point.

3. Find the plan position of the vanishing point (2) of this line, by drawing a sight line parallel to it to meet the picture plane.

4. Project up vertically from VP2 to locate this point on the horizon line.

5. From point B in plan draw a line parallel to the central visual ray to meet the picture plane and continue this line up to meet the ceiling line.

6. From VP2 through the starting point, draw a line of the perspective view of the line from B to the picture plane at 45° in plan.

7. Draw the perspective view of the line parallel to the central visual ray using VP1, which intersects at point B in perspective on the ceiling plan.

135

VP = vanishing point

CONSTRUCTION OF A GRID

A compositional detail much loved by seventeeth-century Dutch artists, such as Johannes Vermeer (1633-75), was a black-and-white checkered floor, creating a well-defined illusion of space beyond the picture plane. The inclusion of a grid in a composition acts as a useful framework and makes it easier to place the various compositional elements on the ground plane.

The construction of such a grid also makes it possible to draw a measured area to scale. If we need to represent a specific length on the ground plan beyond the picture plane, we cannot measure it out with a ruler as, seen in perspective, it will appear shorter than it is in

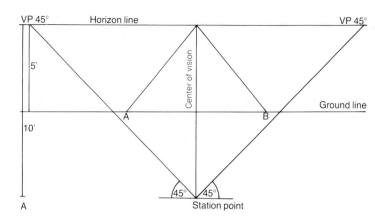

Points beyond the picture plane Mark off a point A, 3 feet to the left of the spectator, and B, 3 feet to the right. Then take lines from A and B back to their vanishing point at the center of vision. Draw lines at 45° from the station point up to the horizon line to find the vanishing points.

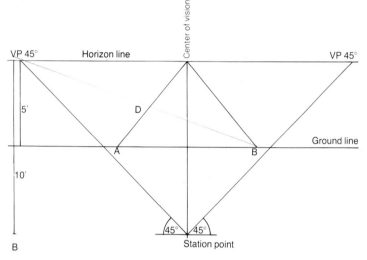

2. Draw a line from the left vanishing point to B to locate D.

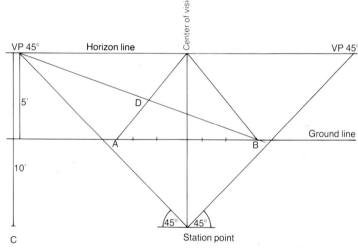

3. Divide the ground line equally into six.

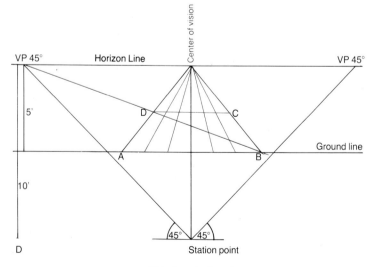

4. Take lines back to the center of vision from the divisions. Locate C by drawing a line through D parallel to the ground line.

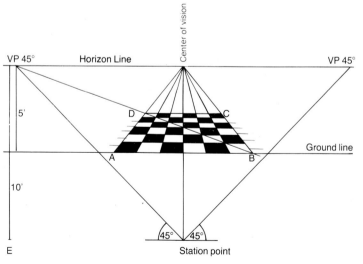

5. Where the receding lines cut the diagonal, draw other lines parallel to the ground line to complete the checkered floor.

actuality. But, it is possible to measure this length on the ground plane and then, with a simple geometric construction, find the receding lengths.

Geometric construction also allows us to draw to scale an object receding from the picture plane, for example a wall which is cropped by the frame of the composition, disappearing into the distance. Similarly, an object of a particular height can be drawn to scale beyond the picture plane.

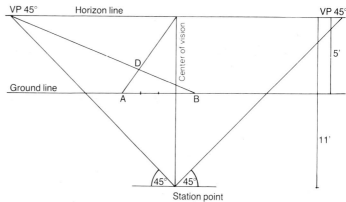

Locating an exact point beyond the picture plane To find a point D which is 2 feet to the left of the observer and 4 feet beyond the picture plane, measure 3 feet left along the ground line to point A. Draw a line from A to the centre of vision. From A measure 4 feet to the right along the ground line, and from this point B go back to VP 45° on the left. Where these lines cross is point D.

VP = vanishing point

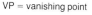

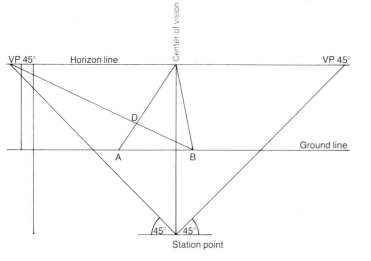

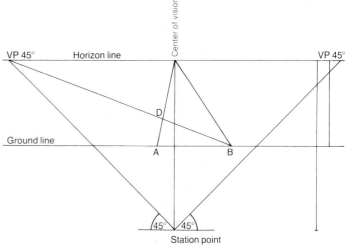

Locating points either side of center The square to be reproduced as a floor in perspective need not lie directly in front of the observer, it can lie to the left or right, as illustrated above.

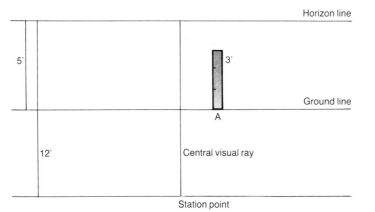

Heights touching the picture plane Just as lines along the ground line can be measured with a ruler, so can they going up the picture plane. Above, at point A, 2 feet right of the spectator, we have a height line of 3 feet. Measure 3 feet to scale up the picture plane from point A for the height required. On the right, a wall 1 foot thick and 3 feet high has been drawn receding into the distance.

137

Heights beyond the picture plane These instructions make it possible to construct an object to scale at a particular height beyond the picture plane. This can be useful in drawing precise representations of interiors or of buildings, but it is also a useful exercise for the more general artist in acquiring a sense of diminution, a feeling for the effects of perspective, and a sense of scale. In the diagrams on these pages, we will construct a two foot cube in perspective, whose plane ABDC rests on the ground plane.

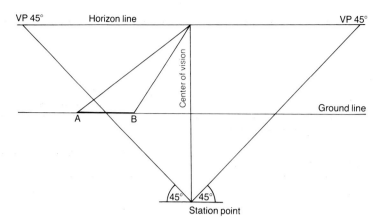

VP = vanishing point

1. Measure off a length AB ($\frac{1}{4}$ inch = 1 foot therefore $\frac{1}{2}$ inch = 2 feet) and take lines back from A and B to the center of vision.

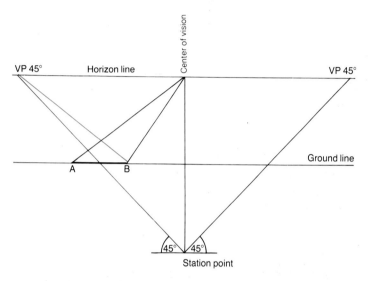

2. Draw a line from VP45° to B to find the diagonal of the plane on the ground plane

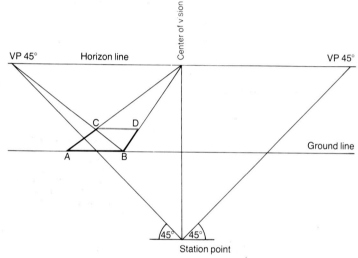

3. From C, draw a line parallel to AB to complete the plane ABDC.

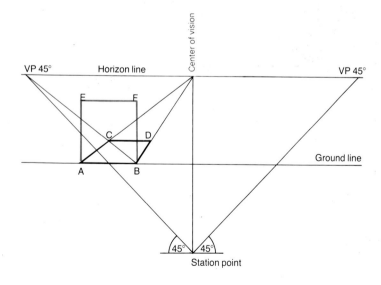

4. As all the sides are equal, we can complete the front plane of the cube, ABEF.

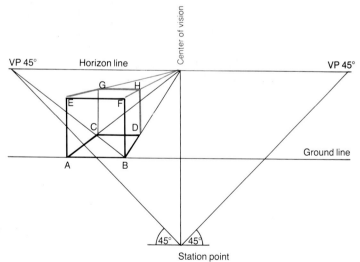

5. By drawing in lines from E and F to the center of vision, and projecting vertically up from D and C, the points G and H can be found to complete the cube. As AB = BF = DH, we have constructed a particular height in perspective beyond the picture plane.

138

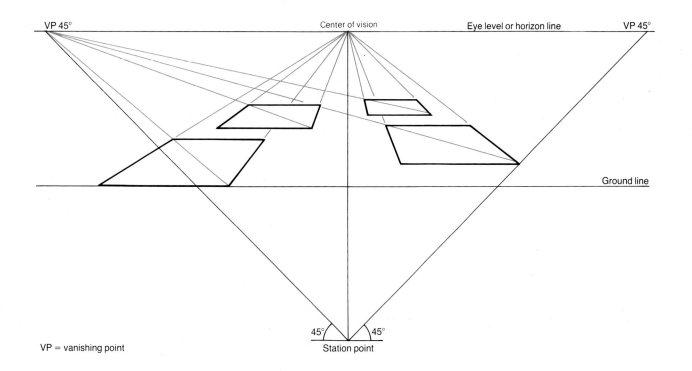

VP 45° Center of vision Eye level or horizon line VP 45°

Ground line

45° 45°
Station point

VP = vanishing point

By using the system on the opposite page, more complicated arrangements can be drawn. The measurement can be taken of the distance between the ground line and eye-level and the scale is then based on this. The final result is seen below, where a scene of some buildings is drawn to scale.

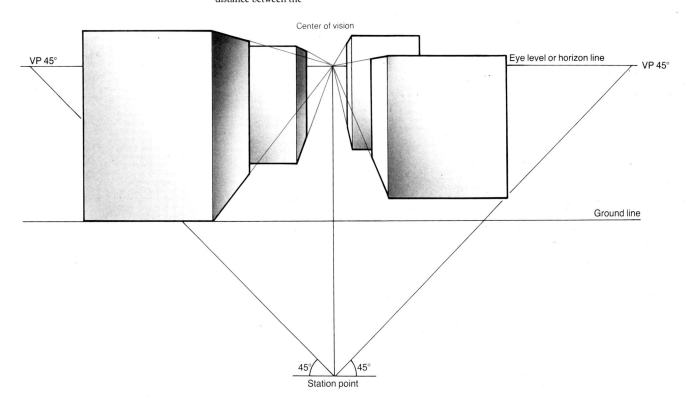

Center of vision

VP 45° Eye level or horizon line VP 45°

Ground line

45° 45°
Station point

Constructing a house Here the basic construction of a house, which we have already tackled, is given practical detailing. In the bottom left-hand corner is the plan of the walls of the house. The lighter sections denote the widths of the ground-floor windows, and the break, the door. The plan of the house touches the picture plane at C, making angles of 60° and 30° with the picture plane.

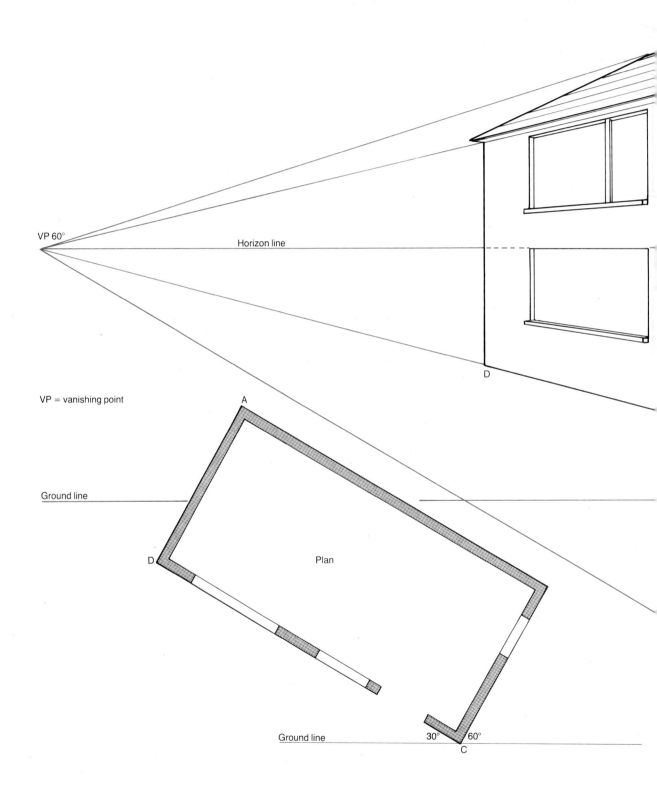

VP 60°

Horizon line

VP = vanishing point

D

Ground line

A

D

Plan

Ground line

30° 60°

C

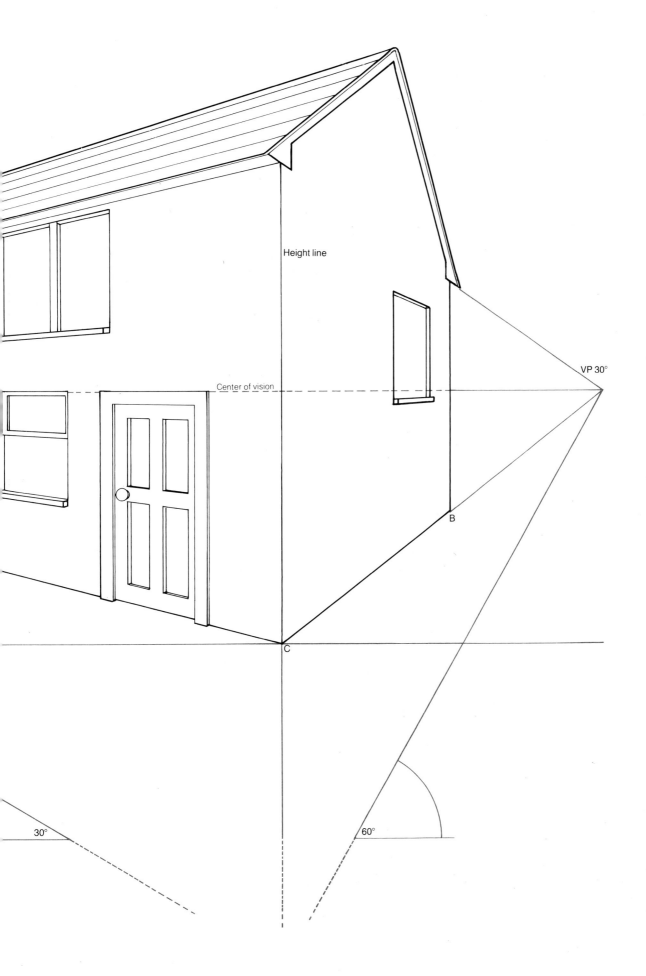

Height line

Center of vision

VP 30°

B

C

30°

60°

Using a grid If the artist is faced with depicting a complicated shape or arrangement of the landscape, then it is often useful to simplify the problem with this grid method. Again, it will help the artist to set himself such a project as the results justify the preparation. The plan on the right shows a bird's-eye view of the landscape we wish to represent in perspective. In the diagram below, at the lower left-hand side, a grid has been superimposed on the plan. Any size of grid can be chosen, depending on the accuracy required. The grid is then set up in two-point perspective, above this, and the contours of the shoreline and island are mapped by plotting the points where the contours intersect with the grid lines. Lines are then taken from the station point, through the contour points on the grid plan to the picture plane, and then vertically up to where they meet the grid in perspective. The points of the contour are then joined up free-hand.

VP = vanishing point

Sea

Land

Island

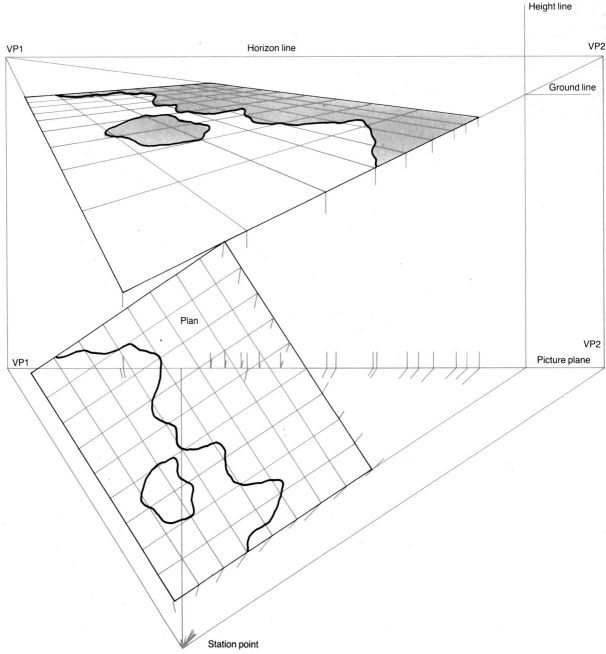

Height line

VP1

Horizon line

VP2

Ground line

VP2

Plan

VP1

Picture plane

Station point

Drawing a landscape from a map This grid method can be used to draw a landscape three-dimensionally in perspective from a detailed map drawn to scale. On the right is the same plan of shoreline and island but with the contour lines of the land added, showing how the land undulates. Detailed maps will give the height of individual contours so that the form of the land can be constructed in perspective. Below, the same construction is made as on the opposite page to plot the shoreline and island in perspective on the ground plane, but here the heights, taken from the contour lines, can be found at each intersection of the grid lines. Sections are then set up along the grid lines to give an idea of the contours of the land. Of course, if the artist can work with the landscape in view, then this grid method can be used in conjunction with observation to produce a much more accurate scene.

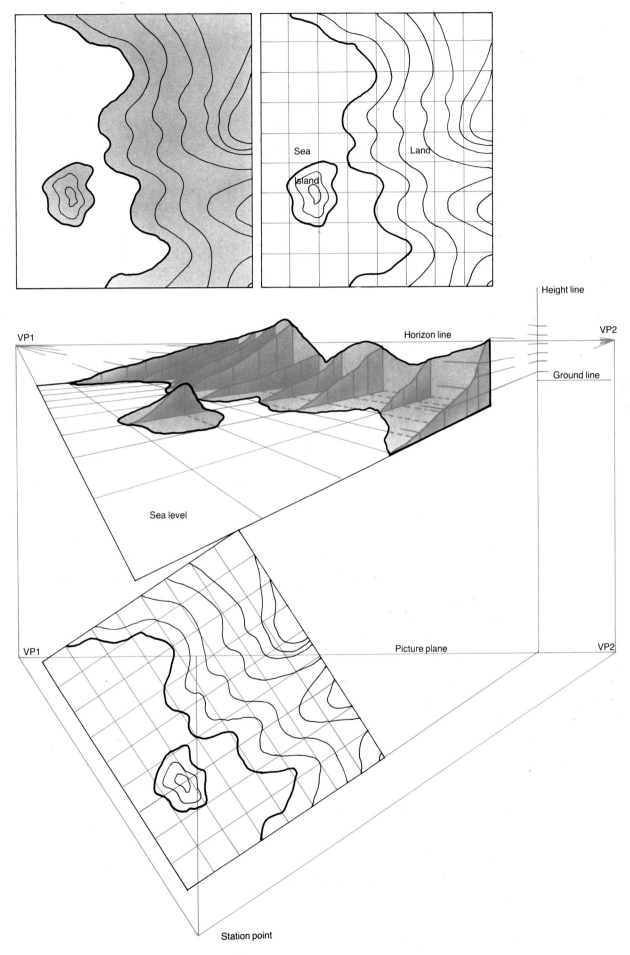

143

Planning a garden You can plan out a garden using the grid method. First of all, you measure up your plot of land and, using squared paper, decide on a scale. Then, lay out the garden in plan as you visualize it on this paper. In the plan below, there is a path on the left, leading up to the gate with a garden pond, with stones leading up to it, laid in the lawn. A tree is represented by a circle. On the right is a gravel drive, broadening out in front of the house. There is a shaped flower bed in front of the house. To make the perspective view of the garden, using one-point perspective, mark off the squares along the ground line and use a diagonal line to locate the grid lines. By counting the squares on the plan and plotting the points, the various features of the garden can be reproduced in perspective.

VP = vanishing point

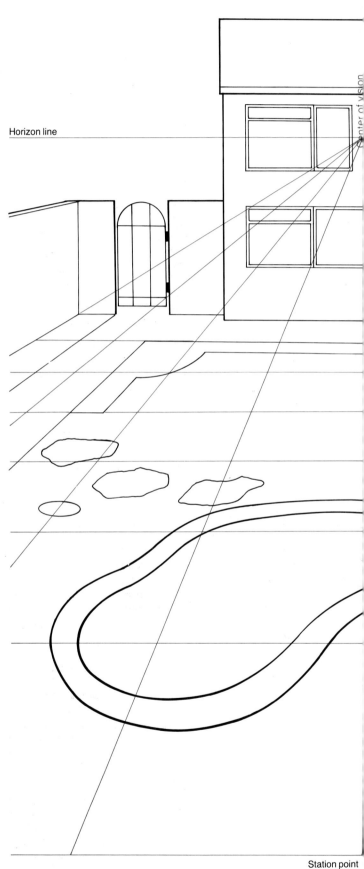

Horizon line

Center of vision

Station point

4'

Plan

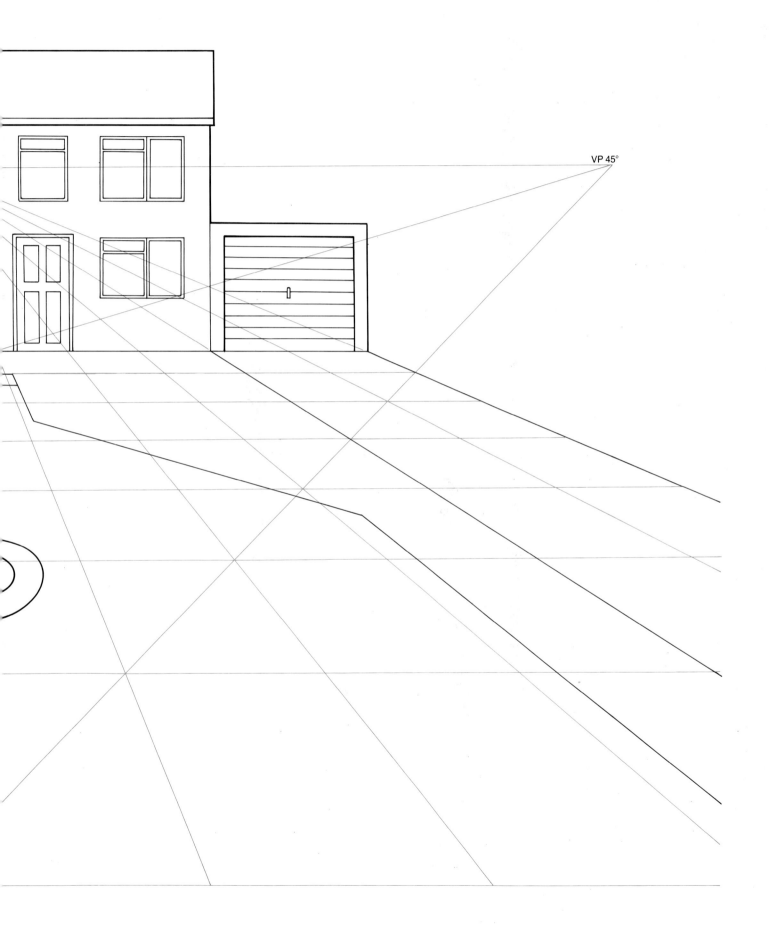

VP 45°

DRAWING A CIRCLE IN PERSPECTIVE

Many artists shy away from drawing circles in perspective. Yet there is a simple method to solve this problem. The perfect circle fits into the perfect square. We can draw a square in perspective, so it is a matter of fitting the circle into that square.

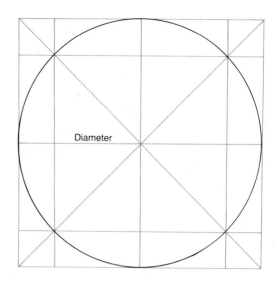

The geometry of a circle is illustrated on the right. A true circle is shown set in a true square and another square is set inside the circle. The diagonals of these squares intersect at the center of the circle. We know how to draw a square in perspective. It is simply a case of plotting the circle within the perspective square.

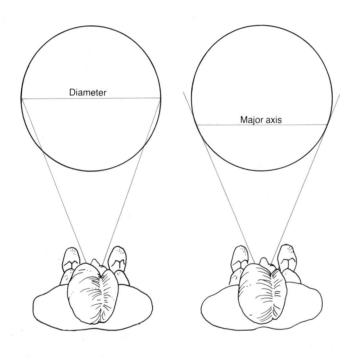

Far left shows a plan of a spectator looking at a circle in perspective and how his visual rays do not permit him to see the true diameter of the circle. What he sees, as shown on the left, is the major axis of the ellipse in view. You can test this by looking at a mug from the side, and marking with a pencil the outer edges of the sides in view. Look at it from above and you will find the marks joined up would come before the diameter.

On the right is the spectator's view of the circle, which shows that the center of the circle cannot coincide with the intersection of the major and minor axes of the ellipse, but falls behind the major axis and on the minor axis.

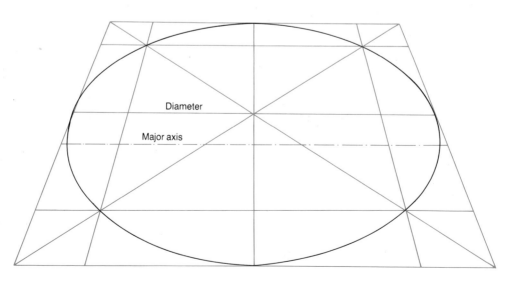

146

VP = vanishing point

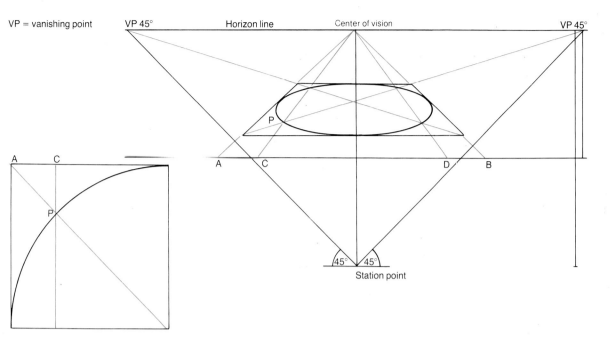

VP 45°　　　Horizon line　　　Center of vision　　　VP 45°

A　C

P

A　　C　　　　　　D　　B

45° 45°

Station point

Here the circle is drawn in one-point perspective. A square lies on the ground plane parallel to the picture plane. First, draw a plan — a quarter of a circle is enough (far left). At P, where the diagonal intersects with the circumference of the circle, draw a line parallel with the side of the square to find the length AC. This length is marked off on the ground line. A line is drawn from C to the center of vision, cutting the diagonals at two points on the circumference of the perspective circle. Repeat these steps with DB so that the circle in perspective can be sketched in.

A circle is drawn here using two-point perspective. The plan is drawn as in A on the opposite page. The perspective of the square is then set up in the normal way. The points where the circumference intersect the axes and diagonals are located in the perspective view. The ellipse is then drawn by joining these points of intersection free-hand.

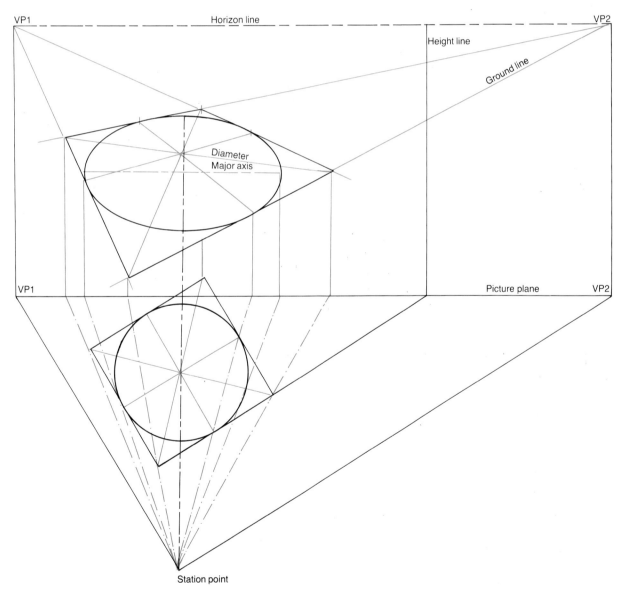

VP1　　　　　　Horizon line　　　　　　VP2

Height line

Ground line

Diameter
Major axis

VP1　　　　　　　　　　　Picture plane　　　VP2

Station point

DRAWING REFLECTIONS AND SHADOWS IN PERSPECTIVE

Many surfaces are capable of reflecting images with varying degrees of clarity. As we all know, the surface of still water can reflect as clearly as the surface of a mirror, the difference being that water lies in a horizontal plane while mirrors are generally vertical or at an inclined angle. Reflections can create interesting and fascinating visual propositions but it is necessary to acquire a knowledge of their basic principles in order to use them to their full potential.

The most important basic principle is that a reflected image will always appear to be the

VP = vanishing point

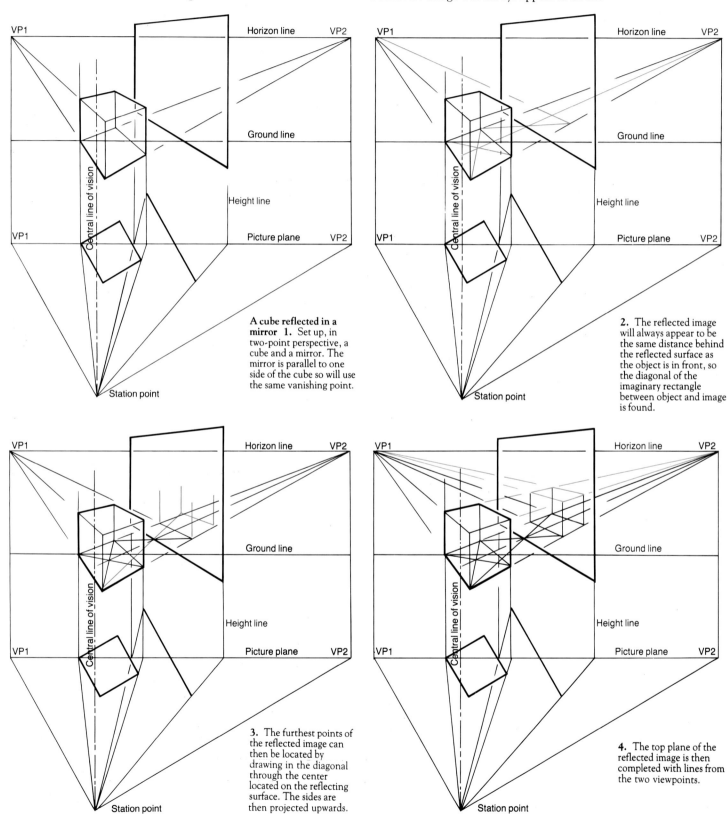

A cube reflected in a mirror 1. Set up, in two-point perspective, a cube and a mirror. The mirror is parallel to one side of the cube so will use the same vanishing point.

2. The reflected image will always appear to be the same distance behind the reflected surface as the object is in front, so the diagonal of the imaginary rectangle between object and image is found.

3. The furthest points of the reflected image can then be located by drawing in the diagonal through the center located on the reflecting surface. The sides are then projected upwards.

4. The top plane of the reflected image is then completed with lines from the two viewpoints.

148

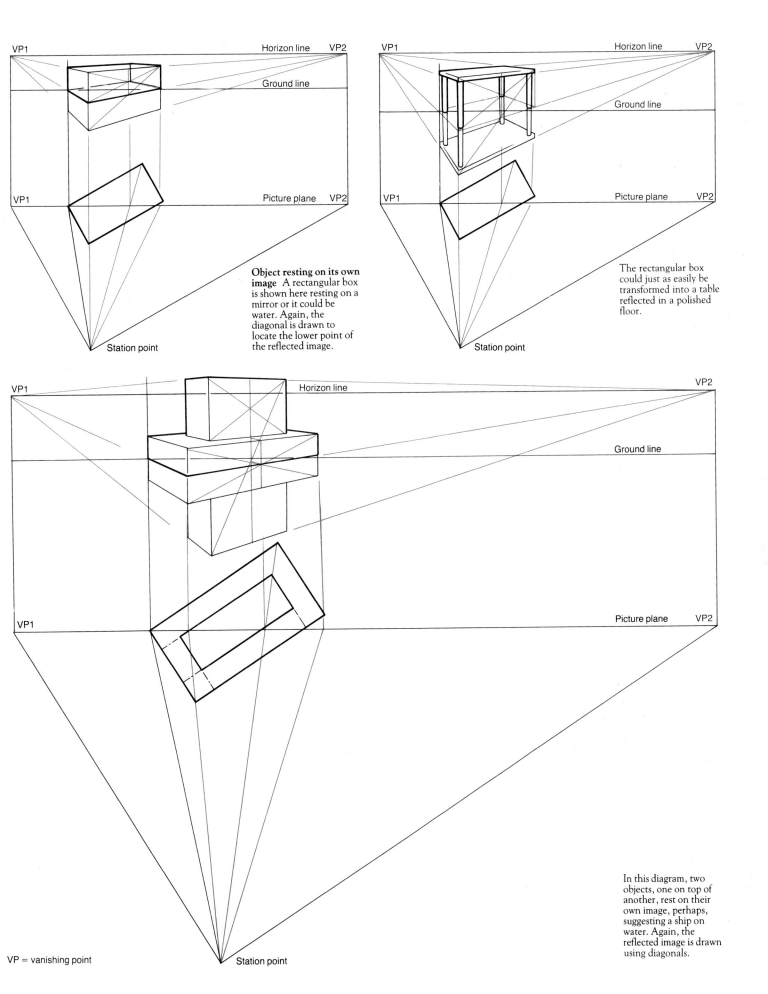

VP1 · Horizon line · VP2

Ground line

VP1 · Picture plane · VP2

Object resting on its own image A rectangular box is shown here resting on a mirror or it could be water. Again, the diagonal is drawn to locate the lower point of the reflected image.

Station point

VP1 · Horizon line · VP2

Ground line

VP1 · Picture plane · VP2

The rectangular box could just as easily be transformed into a table reflected in a polished floor.

Station point

VP1 · Horizon line · VP2

Ground line

VP1 · Picture plane · VP2

In this diagram, two objects, one on top of another, rest on their own image, perhaps, suggesting a ship on water. Again, the reflected image is drawn using diagonals.

VP = vanishing point

Station point

149

same distance behind the reflecting surface as the object is in front of the surface. When an object is reflected in water, for example, vertical lines can be dropped from certain points on the object to plot the measurement below the surface. Even if the object is a complicated shape, verticals may still be dropped, equal measurements taken and horizontal lines returned to their respective vanishing points.

A mirror with a box placed in front of it will not only reflect the box, but the ground between the box and the mirror. It is this which makes the reflection of the object look as though it is the same distance behind the reflecting surface as the object is in front of it. It is this particular property of reflection which can lead to ambiguity of space within the picture plane. If the reflection of an object appears to be the same distance behind the reflecting surface as the object is in front of it, then a second or 'mirror' image can be drawn.

An object and its reflection can be located in a perspective drawing in the normal way. When the object is a simple rectangular box, this is not a long or involved process. More complicated shapes, however, need more attention in the setting-up of the perspective system as shown in the diagrams.

Shadows

To represent correctly the forms of shadows caused by an object, such as the projecting roof of a house, a cornice or window-sill, requires as much attention to the rules of perspective, as for the drawing of the objects that cast them. If the shadow cast by a projecting roof is shown to be deeper at the further angle of the building than at a nearer one, it would produce the effect of a wider projection at the further end which would look extremely awkward. It is worth, therefore, paying attention to the characteristics of shadows as affected by the light that casts them.

Sunlight and artificial light

The character of a shadow changes from that cast from the sun and that from an artificial light source. In general, the nature of artificial light — whether gas or electric — is harsher and stronger than most daylight. The decision to use a strong stream of light — perhaps by placing the subject alongside a window with full afternoon sunlight streaming in or very close to an electric lamp — brings with it problems of both tone and color.

Within such a picture, all shapes and areas must interrelate to bring unity so the high contrast of the direct light and the resultant shadow calls for care in construction. To end with a picture in which the 'negatives' are lost — disregarded in favor of the excitement of

those forms taking strong light — is to lose one of the positive aspects of such an enterprise. As an aid to assessing tonal relationships of such a pronounced kind, the need to 'kick up' the contrasts is invaluable. Shadows will be inclined to be more contained and better defined if the light is harsh and close just as a late afternoon summer sun will diffuse the tone and cast a less strong shadow.

Sunlight

Because the rays of the sun are considered to be parallel, and because they strike the ground plane obliquely, they can be regarded as any other inclined lines. Being parallel they will converge to a common vanishing point and because they are inclined to the ground plane, their vanishing point is located either above or below the horizon line depending on whether the sun is in front of or behind the spectator.

Shadows cast by the sun

There are two factors concerning shadows cast by the sun in the picture plane: first, the position of the sun governs the direction in which the shadows fall; and, second, the height of the sun governs the length of the shadows.

If the sun is high in the sky at midday, and the picture plane has been extended to include the sun, then the light rays emanating from the sun would make our shadow parallel to the ground line but the steep light rays will cast short shadows. If the sun shines from the West, shadows of objects will lie due East and vice versa. If the sun is low in the sky, as in the evening, the light rays come down at a lower angle and the shadows are longer. When the sun's rays come down at an angle of 45° with the ground plane then the shadows are equal in length to the object casting the shadows.

If the object casting the shadow is at all complicated, vertical lines can be dropped at convenient places, the shadows of these cast and the various extremities joined. When the shadow from a vertical object such as a fence-post meets another vertical surface, for example, a brick wall, which is at right angles to the picture plane, then the shadow will continue up this plane until a ray from the sun cuts it off.

Rules to remember

1 If a post is viewed in ordinary sunlight the side facing the light source appears lighter than the side facing away from the light source which is in the shade. The line between the face seen in light and the face seen in shade is known as the line of separation because the post stops light rays from reaching the ground. The area on the ground behind the post on the opposite side to the light source

VPS = vanishing point of the shadows

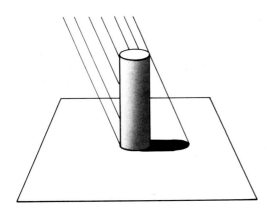

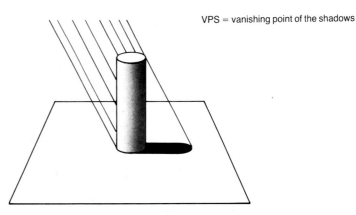

Shadows — sunlight Rays of light from the sun are considered to be parallel. The direction of the rays affect the shadow. If the sun is due West, then the shadows will go towards the East, and vice versa. The shadow is cut off by the first ray to pass over the top of the object.

Objects standing on flat ground will cast shadows at 90° which can be drawn using a T-square.

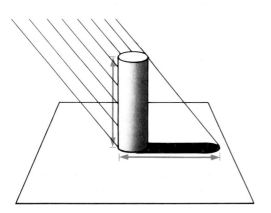

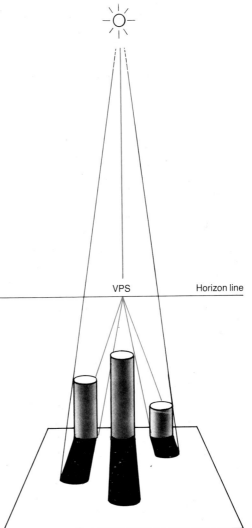

The height of the sun governs the length of the shadow cast — when the sun is high, the shadow is short, when it is low, the shadow long. When the sun is at 45°, the shadow cast is the same length as the object casting it.

VPS

Horizon line

The sun here is almost overhead, so the shadow can only just be seen. The side facing the light source appears lighter than that facing away, which is in the shade.

In the diagrams above, the sun is in the picture plane. Here the sun is in front of the spectator and beyond the picture plane. Drop a vertical from the sun to the horizon line.

Where they intersect is the vanishing point of the shadows and from this point, all shadows will fall towards the spectator.

will be in shadow. This shadow will start at the base of the post and will finish with the first light ray which is able to pass directly over the post. It is important therefore to know the angle of the sun and its position in the sky in order to calculate the length and shape of the shadow. If we relate this to a figure standing on the ground, his shadow similarly will start from where his feet touch the earth's surface. Should he jump in the air, because he is no longer in contact with the ground no part of him can obstruct the light rays between his feet and the ground, which means that the shadow no longer starts from his feet.

2 Shadow will always fall in the direction in which the light rays travel from the light source.

3 In shadow projection, parallel lines cast parallel shadows. The shadow of the arms of a person stretched out and parallel to the ground will share the same vanishing point as his arms.

Shadows cast by the sun in front of the artist

If the sun is in front of the spectator and is beyond the picture plane, then the spectator's own shadow will fall behind him. When the sun is beyond the picture plane a vertical can be dropped from it to the horizon line and it is from this point that the shadows will fall forward towards the picture plane. The point where this vertical ray touches the horizon is known as the *vanishing point of the shadows* (VPS), for all shadows of verticals on the ground plane will appear to come from here. By taking a line from the VPS through the base of a vertical line, the direction of its shadow is obtained. A ray from the sun through the top of the vertical line will cut off the length of the shadow.

Shadows cast by the sun behind the artist

Because the sun is so far away and the rays are considered to be parallel to one another, this means that, if the sun were directly behind you, the shadow would vanish to your own center of vision. When the sun is behind you to the left, the shadows go towards the right, and, when the sun is behind you to the right, the shadows go to the left. With sun behind the artist, the vanishing point for light rays is below the horizon.

Artificial light

The second type of light source is artificial which differs from sunlight in that light rays from the sun are considered parallel whereas those emanating from an artificial source, in their simplest form, radiate from a single point. Because of this, the further away from the light source the light rays are, the further apart they will be. The shadows cast by artificial light, therefore, differ from those cast by sunlight, first, in shape and, second, in that

a shadow cast will be larger than that cast by parallel light rays. In many ways they remain the same: they travel in straight lines; they cannot change direction unless a reflector is introduced; and they cannot pass through solid matter.

The construction of shadows cast by artificial light is similar to that cast by sunlight in that they both rely on the intersection of an actual light ray and its plan to locate a shadow point. Light rays from an artificial light source are not parallel, so that vanishing points are not required.

Shadows cast by a single light source

There is an inevitable sense of monumentality in the strongly lit figure form. It looks like a piece of statuary — rich and rigid — with its light and dark sides describing solidity and dignity.

The commonest form of modelling, as employed by the masters of the Renaissance and after, is the result of a single light source. By simplifying this aspect, the painter was free to make objects easily identifiable in space — each was lit in the same general way, the shadows cast appearing in the same position.

It is a fair assumption that the light will come from above, for both sunlight and most artificial sources do so. But, it is also true that in interiors even sunlight will be directed — perhaps through a window. Artificial light when located in one position within the interior can be exploited to make interesting visual material for the artist. For instance, the shadows can radiate from a bright central electric light and the intensity of detail can be varied by distancing objects from the light's source.

Shadows cast by a multi-light source

Many of the drawings of Michelangelo show his brilliant use of implied multi-light sources. In his nude studies, for example, he often suggests a double light source — one to highlight the horizontal sections of the body, the other to highlight modulations in the vertical plane: they travel down from head to chin, back to neck, from chest down to hips, out and back towards knees and so on. Today, several light sources may be harnessed in the construction of a picture. With modern adjustable artificial light, it is possible to cross lights and achieve exciting and previously unimaginable visual opportunities.

Shadows on inclined planes

An interesting problem to solve lies in the description of shadows cast on to inclined planes. As an aid to composition and design such shadows are often invaluable, linking features within the painting. But, once they become an important structural element, the shadows must be doubly convincing.

Shadows — sunlight In these four examples, the sun is in front of the spectator and beyond the picture plane. The plane away from the light source is in the shade. In the diagram below, the vanishing point for the plans of the shadows is located — here marked as V1. The vanishing point for the sun's rays is V2.

The perspective view of the rectangular box is set up in two-point perspective. By drawing an arc from V1 plan position through the station point, the point O' is found on the picture plane. Then, project up to the horizon line to O and draw a line from there at an angle of x to find V2 on the vertical

through V1. The shadow is drawn, using V1 and the light rays cutting it off from V2.

The rectangular box in the example below is suspended above the ground plane. Again, the plan of the shadow is drawn using V1, and the light rays, from V2 through the eight corners of the box, are used to plot the shadow.

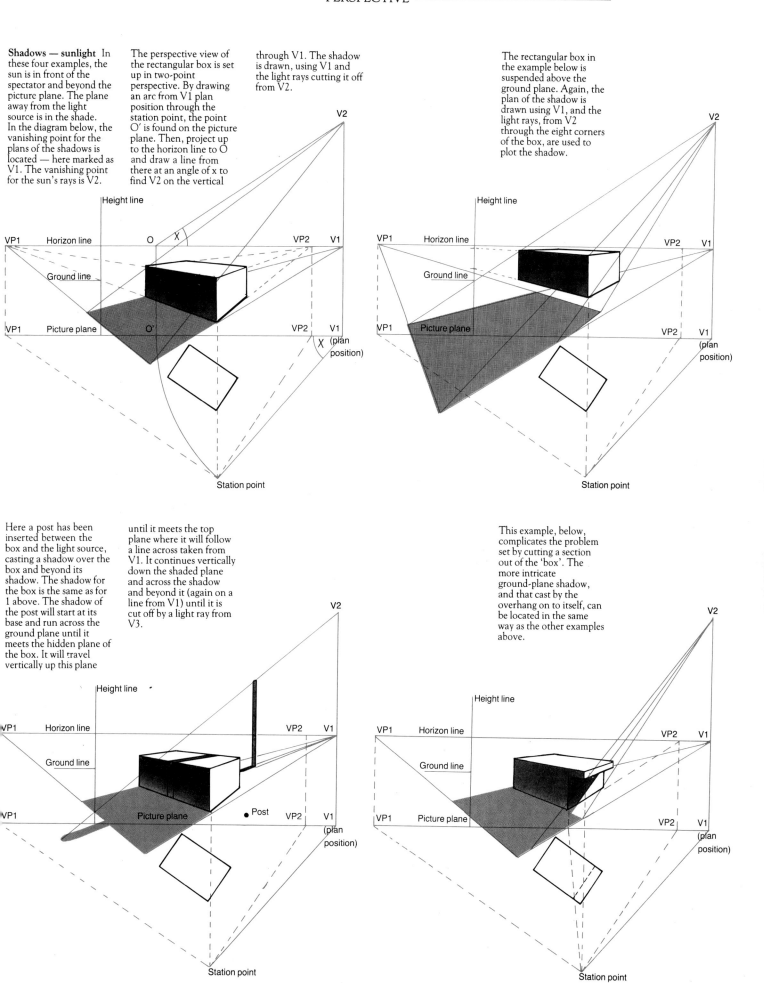

Here a post has been inserted between the box and the light source, casting a shadow over the box and beyond its shadow. The shadow for the box is the same as for 1 above. The shadow of the post will start at its base and run across the ground plane until it meets the hidden plane of the box. It will travel vertically up this plane

until it meets the top plane where it will follow a line across taken from V1. It continues vertically down the shaded plane and across the shadow and beyond it (again on a line from V1) until it is cut off by a light ray from V3.

This example, below, complicates the problem set by cutting a section out of the 'box'. The more intricate ground-plane shadow, and that cast by the overhang on to itself, can be located in the same way as the other examples above.

153

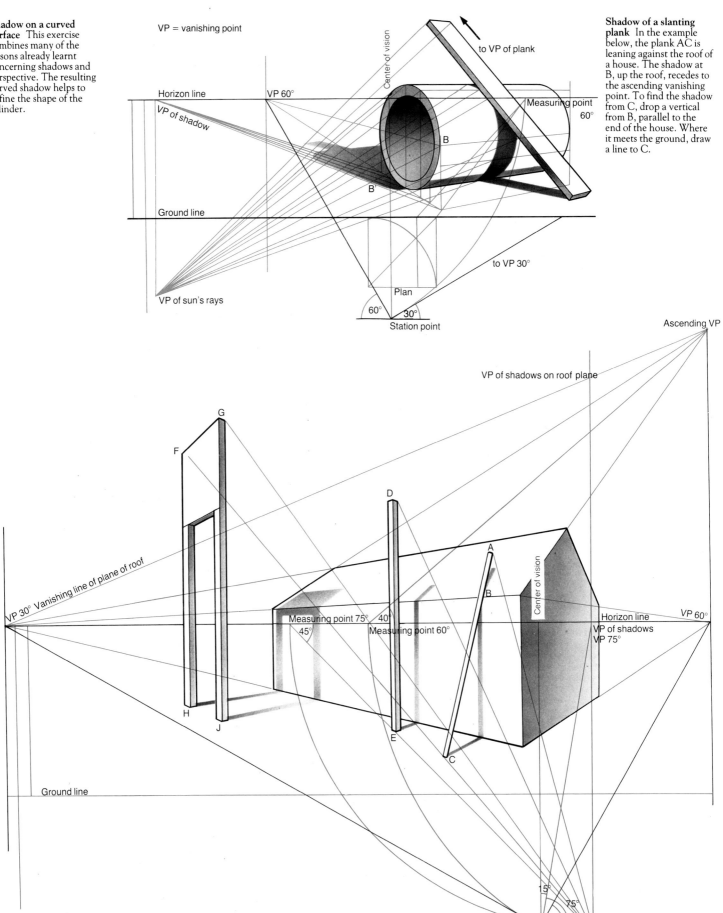

Shadow on a curved surface This exercise combines many of the lessons already learnt concerning shadows and perspective. The resulting curved shadow helps to define the shape of the cylinder.

VP = vanishing point

Horizon line

VP 60°

VP of shadow

Measuring point 60°

to VP of plank

Center of vision

B

B'

Ground line

to VP 30°

VP of sun's rays

Plan

60° 30°

Station point

Shadow of a slanting plank In the example below, the plank AC is leaning against the roof of a house. The shadow at B, up the roof, recedes to the ascending vanishing point. To find the shadow from C, drop a vertical from B, parallel to the end of the house. Where it meets the ground, draw a line to C.

Ascending VP

VP of shadows on roof plane

G

F

D

A

B

VP 30° Vanishing line of plane of roof

Measuring point 75°

40°

45°

Measuring point 60°

Center of vision

Horizon line

VP 60°

VP of shadows
VP 75°

H

J

E

C

Ground line

15°

75°

30°

60°

VP of the sun's rays

Station point

154

Shadows — artificial light Rays from an artificial light radiate from a single point. The further away from the light source the rays are, the wider apart they will be. When shadows are thrown from an artificial source, a point is found vertically below that source. It is from this point that the shadows will radiate. In this simple interior, there is a single light-source. A point is found vertically below the source of light, on the table, for those objects on it, and, on the floor, to find those shadows cast on the floor. Shadows cast by artificial light are usually larger.

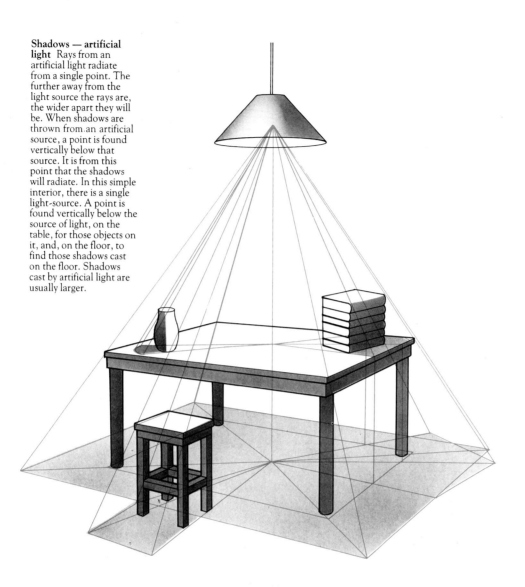

When more than one light-source is involved, the interplay of shadows can be used compositionally. Shadows cast by both lights, as can be seen in this drawing, are darker. By adding more lights, interesting tonal variations can be achieved.

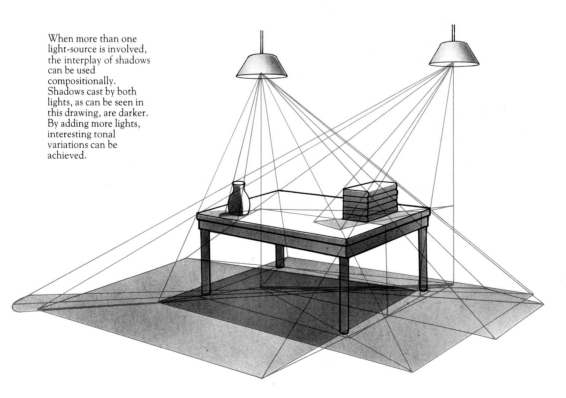

Most of the projects tackled so far have been set on wonderfully flat ground. It very seldom is and when it is represented as going up or down, it usually makes a more visually stimulating composition.

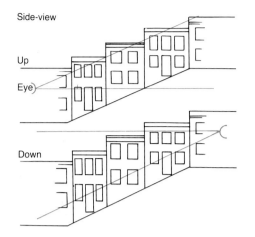

Side-view

Up

Eye

Down

Uphill and downhill We can see, on the left, how, even though the street in this scene rises steeply, the houses and architectural features are all horizontal and so converge to a vanishing point on the horizon line when seen in perspective (opposite). The street and any traffic on it will converge to a point directly above the first, when viewed from below, and below it, when viewed from above, being an inclined plane.

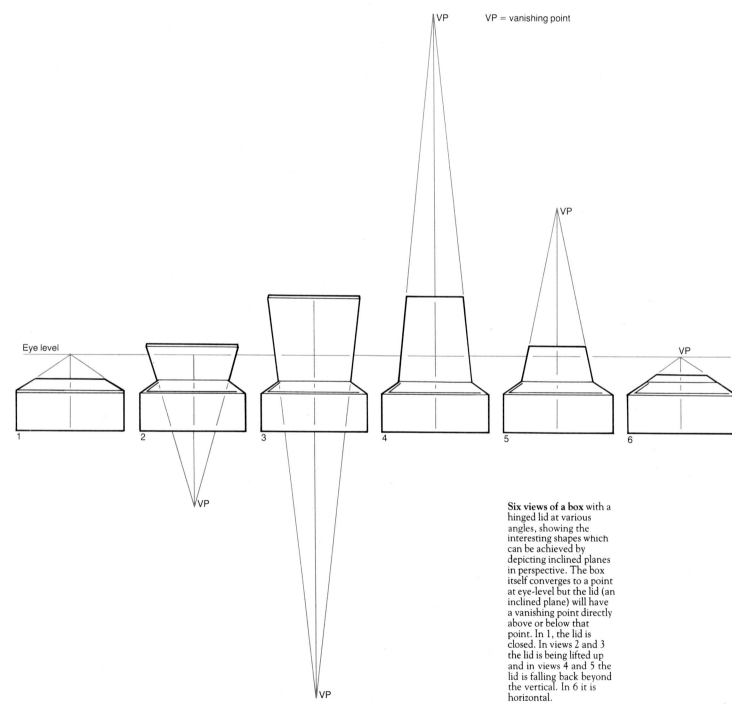

VP

VP = vanishing point

VP

VP

Eye level

VP

1 2 3 4 5 6

VP

VP

Six views of a box with a hinged lid at various angles, showing the interesting shapes which can be achieved by depicting inclined planes in perspective. The box itself converges to a point at eye-level but the lid (an inclined plane) will have a vanishing point directly above or below that point. In 1, the lid is closed. In views 2 and 3 the lid is being lifted up and in views 4 and 5 the lid is falling back beyond the vertical. In 6 it is horizontal.

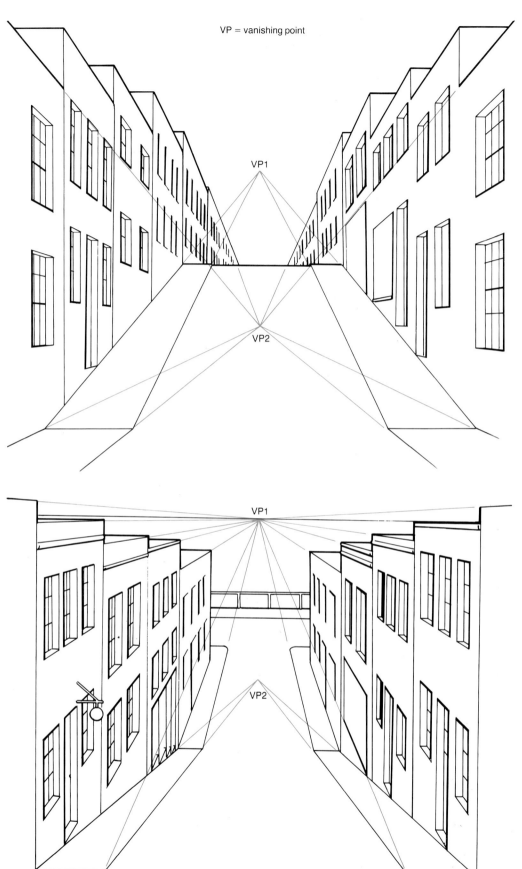

VP = vanishing point

VP1

VP2

VP1

VP2

The side-view shown at the top of the opposite page is here drawn in perspective. The spectator at the foot of the rise cannot see beyond the brow of the hill. This limits the depth of the composition but where the eye stops the imagination continues, making it a successful proposition.

The view down the hill is constructed in the same way except with the vanishing point of the inclined plane below the vanishing point of the architecture. Here the view is uninterrupted. In fact the eye might be tempted to rush down the hill and out of the picture. The barrier across the end prevents this from happening.

PERSPECTIVE AND THE FIGURE

Combine careful observation and the application of the rules of perspective to achieve a sense of diminution and scale often vainly sought in figure-drawing.

When interpreting the figure, whether posed or in action, not only should cognizance be given to the general features and details of anatomy, but there are other factors which should also be brought into account and important among these is perspective. In figure poses, for obvious reasons, distance from one part of the body to another is of necessity limited; the maximum travel from a point in the closest foreground to that at the greatest distance from the eye is unlikely to be more than the distance between outstretched hands above the head and the feet — about 7½ feet. Nevertheless, when drawing a figure, the rules of perspective must be employed to

suggest depth, solidity and balance. At its simplest, this merely involves the relationships between the angle of the feet, the hips and the shoulders plus their relationship to those angles of the top of the head. The important thing is to treat the figure as just another solid existing in space, to be interpreted according to the established conventions of making pictures.

It is always important to draw a firm platform for the feet of a standing figure or, in the case of a seated model, for the thighs and buttocks. One method is to draw an enclosed platform, on the floor plane — as though the figure were standing on a smaller dais. This

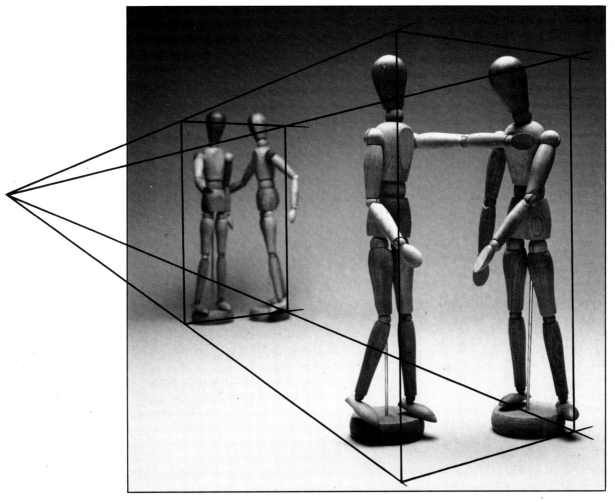

The two pairs of figures in this arrangement, as the perspective lines indicate, can be set in space through the use of linear perspective. Measurements do not have to be exact, but to give an illusion of recession in the picture space, vanishing points can be located and the figures placed accordingly in the right scale, so that the distance between the foreground and background figures is explained through perspective.

In the single figures shown to the left and above, the need for an assessment of the perspective of the figure drawing can be seen. To set the figure on a solid base, it is often helpful to sketch in a platform on which the model can stand, or sit, to which the angles of the body can be related. The angles through the shoulders, hips and feet demonstrate the effects of perspective. The eye-level of the artist will coincide roughly with the eyes of the standing model.

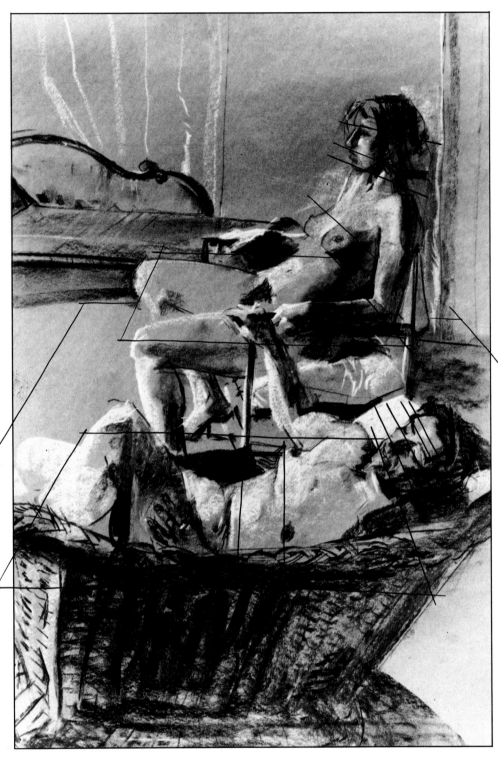

When more than one
figure is involved, again it
is useful to establish the
floor plane. This helps to
stop figures appearing as
though they are on hills
or standing in holes and
enables them to stand or
sit on the same plane as
their fellows. Many figure
artists make elaborate
ground plans, as did
Leonardo, drawing in eye-
levels, vanishing points
and other structural lines
necessary for the

depiction of space, only
to obliterate them later in
the process of developing
the sketch into a
painting.

can be an aid to drawing the figure, for to be able to relate the points of the form to an edge in space makes it is easier to establish the three-dimensional nature of the figure.

Now, from the angle set by drawing an imaginary line between the soles of the feet (assuming them to be well poised) one can begin to set up the perspective of the pose.

The eye-level of a figure drawing will not generally vary very much as we tend to meet most people at our own eye-level. Lines will converge from above and below, so that the shoulders will most likely be slightly below, whereas the top of the head will be slightly above eye-level. The feet, knees and hips, however, will be well below and the angle of them, relative to the other features, will therefore differ as a result. In cases of more extreme movement, when for instance the legs are placed wide apart, the perspective construction will be more marked, but in all interpretations of the figure such descriptions of space must be located.

In portraiture, another, very interesting, use of perspective can be employed. Because all the features of the face are set on a semicircular plane, the lines as they converge must allow for it. The mouth lies on a further semicircular form, proud of the main facial structure, so careful observation is essential.

When several figures are involved in a composition, or in association with other features, the use of perspective is important. The joy of relating foreground details with distant form is to be experienced and exploited — it brings visual excitement and originality to a theme. An eye in full foreground can be the same size on the picture plane as a full figure in the distance. Many great painters have used extremes of scale to express depth and to enhance the rhythmic composition, so that the eye may read swirls and convolutions on the picture surface, going on to penetrate into middle and deeper distances. Frans Hals' group portraits are fine examples of this technique.

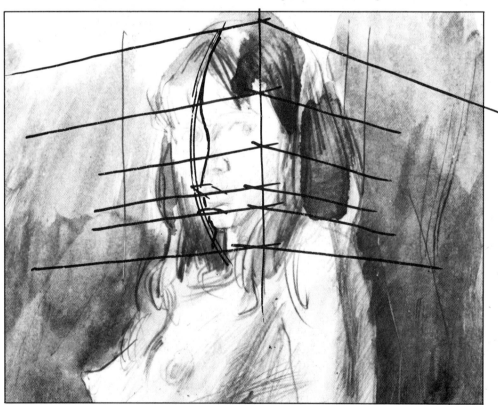

The features of the face are symmetrical so when the face is seen at an angle, a line drawn through the eyes, base of the nose, mouth and chin should all recede to a vanishing point far in the distance. Careful observation is needed when drawing a portrait because the effect of diminution can greatly alter the character of a person. For instance, in the drawing above, the far eye will appear very slightly narrower, allowing for the effects of foreshortening.

161

3 COMP

OSITION

INTRODUCTION

The size, format and allocation of space in a composition are as important, in many ways, as the execution of the work.

An essential part of all work in the visual arts is the preparatory planning — the organizing, scheming, pondering and, finally, the decision-making involved in composition. A glance at Eisenstein's visual notes for *Battleship Potemkin*, or the violations leading to the paintings of Walter Richard Sickert, or even the detailed technical drawings of Isambard Kingdom Brunel for his bridges or transatlantic steamers, all show how necessary such care and forethought is.

Study the preparatory sketches for a finely wrought and highly finished work and you will find it difficult to believe how the various elements have been manipulated before the perfect solution is reached. These investigations of alternatives, note-making and the taking of the 'pulse' of the work are comparable to a poet's notebook or a musician's improvisations.

Composing a picture is rather like putting furniture into an empty room or arranging tulips in a vase. The placing of every element is important and a successful result depends on a mixture of judgment — learnt from observation and experience, tempered by relevant theory — and intuition. With such arrangements we tend to observe that the result is pleasing from one position, only to find that it is not satisfactory when the viewpoint is changed. So, we end up testing our reaction from all directions and then making adjustments — moving the bed or chair or

stool a few feet, or cutting a few tulip stems to create more variety, taking a picture to another wall, or turning the vase to receive the light from a different angle. Hopefully, the result is a good composition — one that satisfies the eye, where each part of it takes its place alongside the other parts with a logic or ease or even inevitability.

What is reassuring to the artist is that a body of theory has evolved that acts as an aid to composition. There are many types of composition to choose from so the artist must learn to select that most suited to the needs of the subject matter. Sometimes an idea will demand that the overall emotional response to the finished work should be of calmness and dignity, as evoked by the façade of a classical building. But there are some subjects which call for an entirely satisfying asymmetry or apparent imbalance in the composition. Yet other themes might call for a strong suggestion of energy or movement and this too calls for the artist to consider how best to express such qualities.

The compositional rules introduced in this section, which have been carefully refined over centuries, are the culmination of experiment, theory and deep concern, but they are also fallible. So, it is worth remembering that invention is the essence of good art and that the aim of every artist is to develop an individual approach to art which acknowledges the system but is not a slave to it.

'Thumbnail' sketches (right and opposite page) can feel out the possibilities for a composition. Several variations can be rapidly drawn, experimenting with different shapes and sizes. The least expected is often the best solution, but it is only through trial and error that ideas suggest themselves.

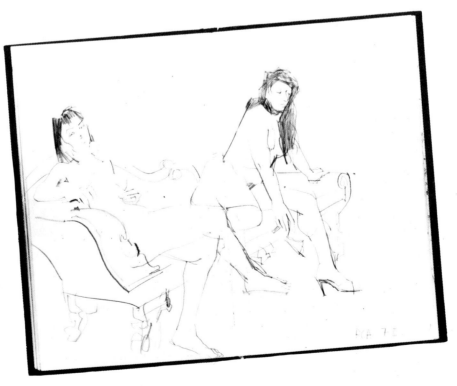

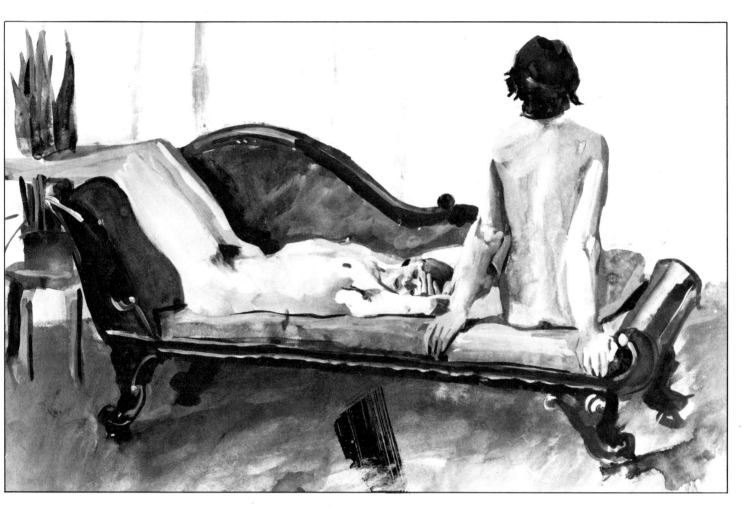

Above, the composition has been developed one stage on from the rapid sketch-book notes. Several different drawings have been combined to take the basic sketch-book material further. From this stage, there might be another set of more resolved works, before embarking on a larger and more ambitious painting.

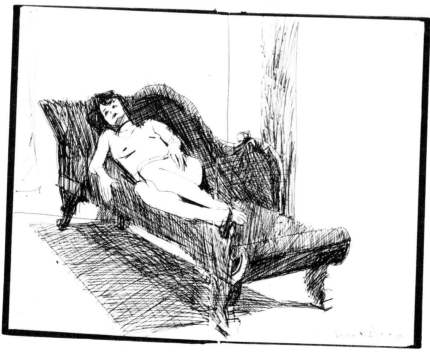

PICTURE SIZE AND SHAPE

The effect of size is perhaps obvious, but shape is just as crucial — it can influence mood and character in a picture dramatically.

After deciding on the subject matter, one of the first problems to tackle is the shape and size of the support, be it canvas, paper, wood, copper or glass. Does the project in hand suggest a rectangle — the commonest picture shape — and, if so, what kind of rectangle? Or would the work be better suited square, round or oval in form? And, there is no reason to be restricted to these. In recent times, complicated multiform supports have been constructed and used effectively. So the criteria need to be examined and the theory consulted to establish which to choose.

Size

The size of the picture is usually clearly dictated by the subject matter but some artists find themselves attracted to a large or small format and stick to it whatever the theme. Versatility is important, and, in order to service the knowledge and experience, much disciplined work is needed.

The French Impressionist Degas was well able to vary the size of his compositions. Indeed, in reproduction, the pictures often assumed to be large ones are in reality small, because, contained within the small size, will be all the fine effect and rich detail of a descriptive ballet episode or racetrack event. When working to fulfil a commission, artists often find they paint in materials or on a size quite contrary to the day before.

Shape — rectangle

The shape of the support is also dictated, to some extent, by the subject matter. It is common practice, however, to call the horizontal rectangle 'landscape' and the vertical 'portrait', regardless of the type of painting made . Certainly, a figure portrait from head down to the hands, hips or feet is more easily accommodated on the vertical rectangle, just as the landscape rectangle more naturally accepts the breadth of the middle distance and horizon. But, within these two broad generalizations, interesting variations occur. For

David Hockney (b. 1939), for his pen and ink drawing, above, of *Nick and Henry*, has chosen a horizontal rectangle and has related his composition to the shape of the support. These compositional relationships, together with those of the subject matter, help promote a feeling of inevitability about the design.

This rapidly made pen-and-ink wash sketch of Dedham, right, was made by John Constable (1776-1837). The landscape shapes and his fascination with the sky suggested the vertical rectangle, rather than the horizontal 'landscape', but he has relied on his instincts for compositional structure. The eye is led through a pattern of tonal extremes to the church tower.

The rhythmic linear interplay of this roundel by Ingres (1780-1867), *The Turkish Bath*, is by no means simple. The design intrigues us in both its carefully contrived subject matter and its composition. The foreground figures spread out like a bunch of flowers, leading the eye up and into the composition. Several strong verticals balance the predominant curves which reflect the shape of the support.

instance, a landscape featuring an overpowering, heavy sky demands a rectangle closer in shape to a square. The same is true for a portrait featuring an illustrative background which would suit the squarer shape or even a horizontal rectangle.

It would appear, therefore, that the shape can affect the character of the picture. We react to the visual arts not simply through our eyes but we engage our emotions and other faculties — if only by association. Color is an obvious way in which the artist can inspire a specific reaction: Picasso's 'Blue Period' paintings compared with Van Gogh's *Sunflowers* make the point. So, it has been found that if a composition is to inspire calm and stability, then a horizontal rectangle will promote this feeling. The composition would then reflect the shape chosen and emphasize the emotion through strong horizontal lines, echoing and reiterating this restfulness.

When the design is to be full of energy and movement, leading the eye across rhythmic even convoluted lines, then a squarer shape will probably suit the subject matter better. And, if the picture is to suggest dignity and aspiration, then perhaps a taller-shaped rec-

tangle should be chosen. I say 'probably' and 'perhaps' because, although these suggestions have been tested and proven by time, as in all art theory, no rule should act as a strait-jacket, but rather as a guideline.

Circle and oval
When working within a circular support (or roundel), it seems that the composition will inevitably have a liquidity of line, an underlying surface movement, sympathetic to the outer form. Not a common form in recent times, perhaps it is due for reassessment. Similarly, an oval shape can aid the composition. It is not chance that dictated the use of the oval for portraits, particularly miniatures. The human face is roughly oval in shape and therefore inevitably suits an oval frame.

Multiform
If the roundel shape is unfashionable, multiform supports are in vogue. These can be a combination of geometrical shapes, a square superimposed by a triangle, or the result of artistic whim. The result can be very effective if the lines of the composition reflect the shape or vice versa.

DEVELOPMENT OF COMPOSITION

A planned structure lends a feeling of stability and unity to a design whilst allowing the artist freedom to vent his creativity.

We have chosen the shape and size of the support to suit the subject matter, now the work on the composition must begin.

Golden Section

As we saw in the section on anatomy, theories on proportion have been propounded since classical times. It was thought that, by following mathematical formulae, true beauty could be ensured in a work of art. These formulae were not only applied to the human figure, but also to the composition itself, so, a rule concerning the proportional division of the picture surface was evolved.

This Golden Section, or Golden Mean, was formulated in Vitruvius' *De Architectura*, written in the first century BC. He stated that the harmonious relationship between unequal parts of a whole was achieved if the smaller was in the same proportion to the larger as the larger was to the whole.

It is interesting to sit down and mathematically construct a composition with dominant compositional lines highlighting the Golden Section. This can be done with a construction using Vitruvian geometry, but it is fascinating to discover that one's eye will intuitively find the Golden Mean.

Beach at Trouville by Claude Monet (1840-1926) is a good example of a well-constructed design with a feeling of inevitability. It is not surprising to find, therefore, that the major compositional lines fall close to the Golden Sections. But, from what we know of Monet's methods, it is unlikely that he used mathematical means to locate the proportional divisions. Through a combination of training, and an instinctive visual sensitivity, he has achieved a happy balance, while retaining the vigor so characteristic of his work.

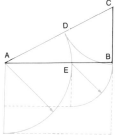

To construct a rectangle in the proportions of the Golden Section, divide the line AB into two sections of equal length. From B draw an arc from the midpoint of AB to C at right angles to AB. Draw in CB and CA. Then from C draw an arc with radius CB to cut AC at D. From A draw an arc with radius AD to cut AB at E. In proportion EB is to AE as AE is to AB. A rectangle can now be drawn.

From his notebooks, we know that Leonardo da Vinci (1452-1519) believed that a composition needed a solid geometric underpinning to give it strength and unity. In this detail of the *Virgin of the Rocks*, the triangular base is immediately obvious. Closer scrutiny reveals countless other carefully contrived lines and curves, leading the eye from the Virgin, to St John, to the Christ child, to the angel, and then back into the grottoes of the landscape. The heads all rest on the circumference of a circle and there are strong verticals hinted at by the configuration of the rocks in the background, continued in the figures, for example, down through the Virgin's left hand, through the vertical fold of her sleeve, to the Christ child's head and arm.

Geometric composition

So many of the most exciting pictures on the walls of galleries or churches are constructed in such a way as to lead the eye on a journey of lyrical convolutions, through and across the surface. What is often not realized is that these compositions have a basic geometric 'scaffold' underlying the work — sometimes, based simply on the triangle but often of a more complex nature — devised with great care to promote a feeling of stability. A geometric foundation to a composition is visible to the observer through compositional lines. These lines are formed, not only with gestures made by figures, but by the angle of a figure, the shape of buildings, trees or other elements of the composition, each contributing to a compositional line or part of a line. Out of this order can readily spring rhythm where composition lines, apparently unrelated, can be traced from one energetic movement to another, taking the eye on to other, often counter, rhythms.

In such compositions, care must be taken not to lead the eye too violently off the edge of the picture or even towards the edge so that the viewer's attention is precipitated off the picture surface. Rather, the eye should be enticed back into the composition, via a circuitous route perhaps, but back to complete the viewing of the work. It is interesting to investigate and analyse the geometry behind such compositions.

First, we could take the simplest geometric structure — an equilateral triangle set symmetrically within a rectangle. Examples of such a composition abound, particularly in Renaissance paintings of the Madonna and Child. In its simplest form, the apex of the triangle sits in the center of the top edge of the support. The main features of the work are then contained within the two diagonal sides, the bottom of the support forming the base line of the equilateral triangle. This construction gives the painting a strong sense of calm and dignity, one which incites no argument but gives a classical balance and unity, without excitement but with satisfaction. But, it is also rather limiting and predictable and, even when the triangle changes its character and takes a more Gothic (pointed) form, the same results apply.

This basic 'scaffold' was often enlivened, therefore, by introducing other rhythmic

The sketch above shows how symmetry gives a solid base to a composition and also demonstrates how the eye can be invited into and around a picture, through compositional lines based on geometric shapes. In the West, we tend to read a picture as we do a book — from left to right. An introduction into the picture space can be affected, therefore, by a diagonal gesture or line, from the left-hand side up into the picture. The sketches on the left show how more complicated geometric compositions can be contrived.

By writing 'Johannes de Eyck fuit hic 1434' above the mirror in this painting of Giovanni Arnolfini and his wife, Van Eyck (c. 1390-1441), it is thought, was acting as a witness to their marriage. The portrait is symmetrically composed either side of the bisecting vertical through the candelabra, mirror, the clasped hands, to the right paw of the dog. But within that simple symmetry are a multitude of subtle variations which bring visual pleasure. The strong verticals and horizontals are softened by the curve of the linked arms, echoed in the curve of the candelabra above and the curve accented by Arnolfini's right foot, the dog's paws and a fold in Miss Cenami's dress. There is tonal variation between the darker Arnolfini, against a light background, and lighter Cenami against a dark background.

lines within the lines of the triangle. Alternatively, asymmetry can be employed by moving the apex of the triangle to one side or the other, dividing the rectangle of the support in a more interesting way. This means there is still an ordered underlying structure, but it affects the mood of the composition in a more dynamic way. More interesting use of the triangle as the skeleton of the picture can be made, for example, by using two or more interrelated triangles — side by side, overlapping, or integrated. And these triangles are not necessarily sitting solidly on their bases, but sometimes they are inverted or superimposed on other geometric shapes within the picture.

For many subjects such a construction is suitable and no variations or adjustments are called for. But other subjects will demand other solutions.

Painters plying their trade in Italy in the fifteenth century created wonderfully complex skeletons upon which to hang the flesh of their pictures. A fine example is Piero della Francesca, whose compositions bear analysis. From the simplest most obvious primary shapes — squares, rectangles, circles — through ever more complex sub-division, they can be overlaid with a rich mesh of lines, each dependent upon its neighbor, each indispensable to the unity and totality of the work. Indeed, this process of discovering a geometric structure beneath the surface leaves us with a perfectly balanced abstract painting in which the interplay, the intersections and conjunctions combine to create a sense of completeness. In the case of Piero della Francesca, this mathematical structure was an essential part of his art, indeed of his life, but it never dictated a rigid, unfeeling result, rather it served to free him to paint his images with great sensitivity and subdued passion.

It is by examining the paintings of others and experimenting ourselves that we can learn what suits the demands of the subject. All art benefits from intelligent risk and exploration and the sense of satisfaction achieved through balancing the different parts, mathematically, intuitively or by a combination of both, is basic to good picture-making.

Rhythm in composition

Another way to give your composition structure is through rhythm. The eye is led across the picture from one point to another, by

One is always confident in assuming that any painting by Piero della Francesca (c. 1420-92) has a mathematical base as he was gripped by the subject. The strong verticals, here, in his *Baptism of Christ*, are balanced by the compositional lines of a circle centred on the dove, describing the top curve of the frame, round to St John's left arm and the top of Christ's loin cloth. The eye is led into the depths of the landscape by the serpentine stream. But Piero's *Baptism* does not betray this contrived structure; it is a delight in its portrayal of atmosphere, both mental and physical.

curving, curling, twisting lines of the surface pattern. And often not merely across but into the picture too. This form of composition inspires a feeling of movement, urgency or violence. It is more precarious than the solid reliability of the geometric kind, but suits some work very much better.

There are many fine examples of such an approach and the excitement they engender is the essence of much Baroque art. For such picture-making a preparedness to take risks, delete, adjust and correct — not once but perhaps many times — in the early structural stages, is essential. To rely on an emotional response to the needs of the work and discover, through a dialogue with the picture surface, the best solution is a risky business. The rules are not so rigid here but they remain, nevertheless, basic tenets which must not be denied.

To lead the eye from any given point in the picture demands a line of interest and inner strength, not a flaccid and weak one; and any such implied line must interrelate with all the other lines, implied or described on the surface. Such rhythmic lines need not, however, be so full in curve or circular in motion that the picture surface appears to be alive with writhing snakes or like ancient trees in a grove. Better that the lines vary, some being curvilinear and anxious, some slow in movement, others giving contrast by simply being straight. All such lines will marry on the picture surface to bring a rich composition the strength of interdependence and the desired sense of unity and completeness.

The Dutch painter Peter Paul Rubens (1577-1640) favoured this method. In his paintings there is a characteristic sense of sweeping, swirling rhythms. The eye is led from any one point across a complex interplay of circular, ovoid and s-shaped lines until they unite, only to set off again. They are full of movement and energy.

In analysing the work of such painters, it is worth looking at the edges of the picture. Such compositions need room to 'breathe' — to distance the urgent, tumultuous forms from the static edges. Such a design, however, needs the stability of the sides of the support so care should be taken to acknowledge them by reflecting the shape of the support in the composition.

Paul Klee (1879-1940) made the surface of his drawings and paintings pick up rhythms too, but, in contrast to Rubens, in many cases not languid and slow-moving but staccato and urgent in feeling. Indeed, to lead the spectator into the magic world of the picture, and excite an emotional response while doing so, is one of the most satisfactory things in all art language. There is obviously less danger of precipitating the eye off the edge in such compositions, for in each part of the work, not one rhythm, but several major and minor ones might be employed. In such cases, the character of the lines is likely to be straighter, the overall feeling more Gothic; the beat of the drum rather than the melody line of the flute. As in all other systems of picture design, however, care is taken to relate all the elements of the subject matter so that nothing is left out of

This masterpiece of picture-making, *The Death of Sardanapalus*, by Eugène Delacroix (1798-1863), shows how rhythm can give structure to a composition. The rich, writhing surface inspires a feeling of movement. Although there is a scheme of construction somewhere beneath it, the delights of the moving surface disguise it and entice us around and into the picture.

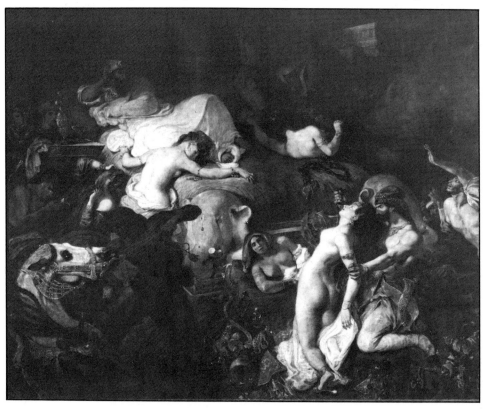

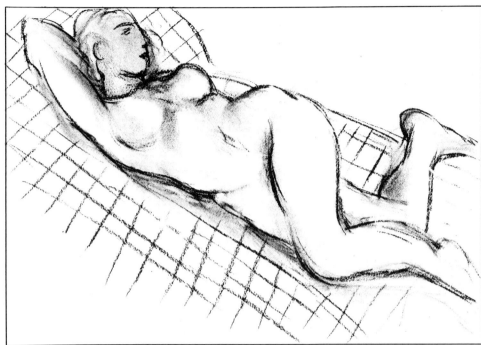

This reclining nude by Henri Matisse (1869-1954) follows the diagonal of the rectangle, but there is little doubt that geometry could not have been further from his mind. Matisse's interest lay in the activation of the picture surface which he does here through the twisting lines of the nude's *contraposto* attitude. The eye is almost discouraged from travelling into the painting and is kept tantalizingly on the surface.

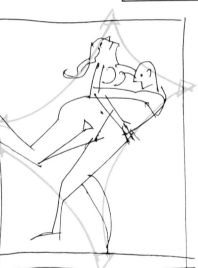

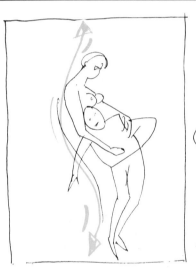

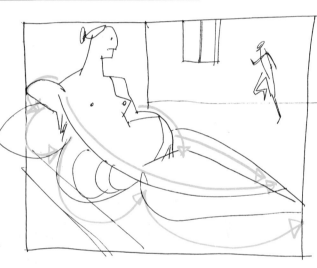

The sketches above, left, center and right, are a few examples of energy being expressed through surface rhythms. They also demonstrate how useful the edges of the support can be to anchor lines and make them easier to locate in the picture space. Above right, shows how the eye follows the natural rhythms of the human form.

The feeling of structured order which pervades so many of the compositions of Paul Klee (1879-1940) is brought about through the instincts of a cultured visual intelligence. Texture plays an important part in his compositions so that the eye is forced to pause and examine before passing on to the next element. The pattern of the interlocking shapes in his painting *Ad Paruassum*, here forms a cohesive composition even integrating with the edges of the support.

the overall structure — unless this is done deliberately for effect.

To combine the several methods discussed, those of geometric understructure, rhythmic lines and staccato marks, within one composition can lead to a satisfactory picture.

Pattern

When color or form is repeated in a painting, this creates a pattern — the design on a shirt or the regular rows of corn stalks in a field, moulding the hillside like punctuated contour lines. Pattern is an ally. It can be used to accentuate a feature, relieve a dull area or bring a contrast of linear grace to a broadly schemed work.

The use of spears in the upper left-hand corner of Paolo Uccello's *Battle of San Romano*, painted in about 1450, is a good example of this device in action. The pattern created by the spears lends visual interest — a chatter of activity — through their positive linear form and the negative shapes formed in between.

Pieter Brueghel the Elder in the sixteenth century unified his bird's-eye view of *Children's Games* by inviting the eye to dance from one red feature to another, across the picture surface and into the depths of the composition.

Tone and color

The aim of a good painting is to contain itself, that is, to make a total unity within the frame.

To this end, the artist must make decisions about each composition and the relationships it contains — of line, of color and of tone. Color and the interrelationships of linear rhythms, as discussed above, are well realizable, and these things are tangible and (with a little practice) can be learnt. The most difficult single problem for so many would-be artists is tone. In its simplest form this means the degree of darkness, the shadows — the negative side of solids — essential in form and achieving realism. But, to the experienced artist, it means much more — perhaps the most difficult aspect of all to grasp and, having comprehended, to master.

Asymmetry and precipitation into an empty space

A very happy balance on the picture plane can be achieved by symmetry. The simplest of compositions, with balanced elements, poised as on a set of scales, brings a dignified and stable feeling. But, such a design is not suitable for all purposes — even a less evenly balanced but geometric-based composition will prove emotionally suitable for some subjects but inappropriate for others. An interesting type of composition with great potential is one which deliberately sets out to employ asymmetry — one in which a natural balance is created by means other than through simple geometry.

Let us assume that the inspiration for a piece of work about to be painted is based on

This emotionally shocking painting of the *Carrying of the Cross* by Hieronymus Bosch (c. 1450-1516) is given structural unity through the pattern created by the heads, which are of a similar size and mostly occupy the same plane in space.

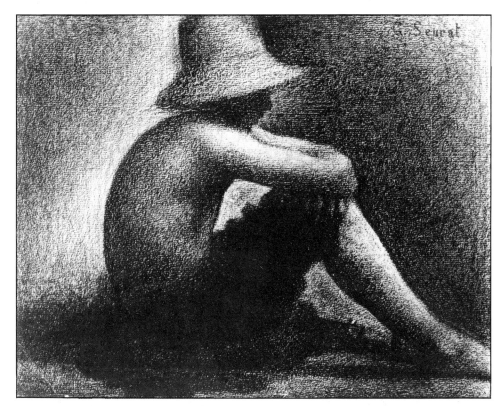

When considering the
unity of a composition,
tonal equality must be
considered, so that the
darkest dark is equal to
the lightest light.
Georges Seurat
(1859-91) evoked the
most subtle tones in his
first large-scale painting,
Bathers, Asnières (below).
In the original, the
structure of the tonal
variation is more obvious
than usual because of
Seurat's pointeliste
technique of building up
the tonal modulations
through minute dots of
color. On the right is a
preliminary sketch for
the figure in the left
background below,
showing Seurat's concern
with tonal values. The
coarse-grained paper
gives this chalk sketch an
interesting texture.

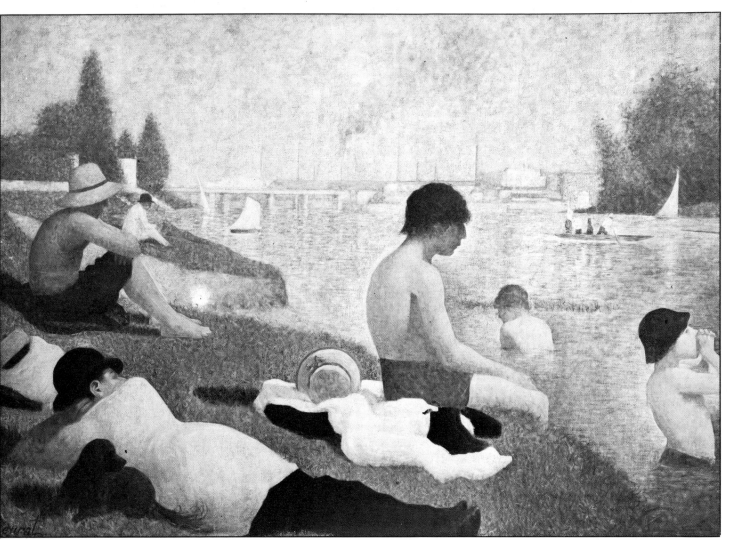

175

Edgar Degas (1834-1917) in his portrait of Diego Martelli was breaking new compositional ground. The portrait is informal; Martelli appears unposed, as though he has been photographed. His stance must have appeared shocking as it breaks traditional rules by facing out to one side with the eyes cast downwards.

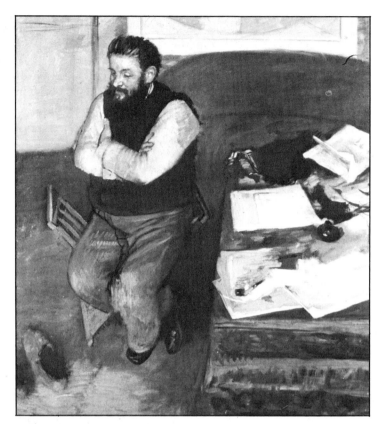

This depiction of the *Three Crosses* by Rembrandt (1606-69), below, suggests a monumental work of vast scale, yet it is of a modest size. This ability to suggest grandeur even with an etching needle takes practice. Here, it is contrived through the low eye-level, the contrasts in shapes between foreground and background. But it is through focus that the eye is inevitably led to the main cross, which is the focal point of the composition.

tension, a sense of urgency or movement. First, the artist might well simply doodle a few ideas on the best ways to reflect the original thought and interpret the theme. From these notes, he could begin analysing possible design structures with the idea of making creative use of empty space.

One artist who quite consciously flew in the face of well-tried canons of design was Edgar Degas (1834-1917). Influenced by photography, he broke what had come to be regarded as the rules of composition — proving, yet again, that the only true rule in art is that a good artist can create his own, if he has primed his mind well with the theory.

Photography was in its infancy in 1861 when Degas was first introduced to the young artists making up the Impressionist group. Unedited snapshots inspired him to abandon traditional symmetry and to separate his characters by a dramatic empty space. Links were made between the elements of the composition, across the void, emotionally — through a cast glance, a gesture or even color. Figures were often cropped by the frame, adding to the drama.

At the racetrack, Degas used these 'snapshot' compositions to transmit a sense of impending movement. The eye is precipitated into a large vacant area on the picture surface, inviting the idea that the horse has only just vacated it or is about to enter it.

Focus in composition

The introduction of photography in the mid-nineteenth century affected other aspects of composition. Camera lenses since then have become much more sophisticated and, what

was once considered the correct focus (that is, on something in the foreground), is now flexible and capable of considerable variation. Quite apart from the deliberate softness of focus practiced by certain fashion photographers, because it tends to bring a feeling of glamour to the subject, there is the use of depth-of-field-focusing. The lens can be altered so that only a certain chosen object is in focus and everything else is slightly blurred. This effect can also be used to advantage by the artist. Photography has been of great influence, but the concept of the single focal-point has been practiced for centuries and is very much part of the artist's equipment.

The Spanish artist Diego Velazquez (1599-1660), in his later works, made interesting use of this single focal point: the central figures in the picture were in full focus, whereas the surrounding details were less well-defined. The Impressionist painters, on the other hand, made great virtue of softening the focus over the whole subject.

It is possible to take the idea of focus further and to exploit its potential for thrilling picture construction. Decide on a point of sharp definition — say towards the center of the picture — and wrestle with the resulting compositional problems. There is softer, more generalized background material as a result of such a decision, but there is also a blurring of the foreground too. Normally, the foreground details are in the tightest focus, with the definition decreasing as the eye travels to the background. So how does the composition organize itself in terms of aerial perspective? Tone is of great help in such a situation, because, although the tightness of

Photography had its effects on later 19th-century art with new 'snapshot' compositions — cropped in unexpected places or viewed from fresh angles — and with focus as a compositional feature. Central single focal points with peripheral softening, generalities of focus, as in soft focus photographs, and very tight focus were all incorporated into compositions. The Impressionists were intrigued by these new discoveries and exploited their potential in their work. In this painting by Claude Monet of *La Gare Saint-Lazare*, there is an overall softening of the focus, emphasizing the atmospheric nature of the subject matter.

focus, the sharpness, is in the middle-ground, logically this area has less tonal contrast than the foreground and the background. This means that, although everything around the focal point is softer in definition, the contrast in tone will be more marked in the foreground.

Rembrandt exploited and popularized this method of composition. Particularly in his portraits, he contrasts a highly focused, richly painted, detailed head with a large, dark, enigmatic surrounding area. The seemingly unbalanced nature of the small bright area with the large dark one is given unity as the eye has no doubt where it is going; the composition has an inevitability about it.

A word of caution is necessary however. Even though the darker areas draw less attention than the focal point, they remain an intrinsic part of the picture and they must not, therefore, become dull or unconsidered.

Portraiture

Portraiture is a very important branch of art. For many centuries, the problems of achieving a likeness have been of concern to artists and the aids devised to give painters better results increasingly ingenious. Although it

would seem that the design of a portrait is a simple matter, this is by no means the case. To begin with, one subject is very different from another, so a major consideration is the character of the sitter. From such considerations should come ideas about size and shape of support, color arrangements and posing. One subject might best be shown full-length — as in the lovely portrait of Aubrey Beardsley by Walter Sickert in the National Portrait Gallery in London; another might be caught in close-up like Brueghel's *Head of a Peasant*. In between these there are many possibilities and variations — half length, three-quarter length and even full length within a well-defined situation, say, a landscape. The subject can be drawn or painted standing, seated or lying down and be seen full-face, half-face or in profile.

Even though a single-figure portrait, full of character and presence, obviously constitutes the main content of that painting, the background must also be carefully considered. With regard to proportion, the subject should not be placed — unless to achieve a particular effect — in the exact center of the composition. This will only split the work into three

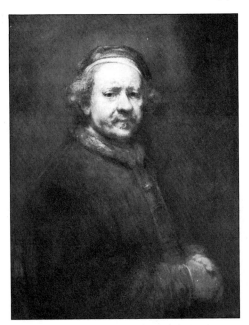

Rembrandt painted a series of self-portraits which are interesting to the artist as masterpieces of portraiture. Here, above, he is seen aged 63. Although the pose is simple, visual interest is created through the turning head and through tonal contrast. Rembrandt's formula was to bathe the head and hands in light, focusing attention on these obviously major aspects. But, it is only by studying these portraits in the original that the vigor

of the darker, supposedly negative, parts of the painting can be appreciated. Rembrandt also shows us how important the inclusion of the upper part of the body is in expressing the character of the sitter.

This portrait, left, by Paul Gaugin (1848-1903), *Girl Holding a Fan*, is a very fine example of the character of the sitter suggesting a pose and therefore a composition. The positioning of the figure on the diagonal, and the head, viewed straight on, is carefully considered. The attendant details are few but each one is essential in adding to our knowledge of the sitter.

The character of the sitter is ably captured by Hans Holbein the Younger (1497/8-1543) in this individual study. Like Rembrandt, the pose is enlivened by turning the head from the main body line, thereby making full use of the expressive nature of her headdress, which has the effect of returning one's attention back into the portrait.

parts and leave an unsatisfactory sense of division. The result will be unsatisfactory because the divisions will be too similar and uninspiring, leaving the eye looking for entertainment and relief. Far better to place the subject in what appears to be a central position that is in fact off-center. By this means, the divisions of the picture will be more acceptably balanced and the visual quality enhanced. The wider part of the background can then be activated by the pose of the subject. When dealing with the human figure, and particularly the portrait, emotional considerations cannot be overlooked. We all identify with other humans and build relationships of several kinds, even with an image in a painting. Thus, movement can be implied by an arm gesture or pointing finger or even with the eyes. The larger area of background is therefore activated and balance in the off-set portrait achieved.

Multi-figure portraiture introduces more complicated problems, associated with the relationships between the individuals in the group. Fortunately, most groups have a natural hierarchy, which can give structure to the portrait, and visual interest can be achieved through the grouping of the figures and the rhythmic interplay of the links as shown in the illustrations on rhythmic composition.

TABLE-TOP COMPOSITION

Experimentation with the positioning of the various elements of a composition can lead to some unexpected results.

One of the traditional areas in which the painter can look for commissions is in narrative pictures — pictures which tell a story, which contain the acting out of an episode, either historical or contemporary. Generally, such paintings involve the arrangement of several elements, each demanding individual attention, but each subject to the overall scheme. Figures, animals, landscape details, interior features, such as furniture, all have to be integrated on the picture surface and on the ground plane. Sometimes movement is involved, adding to the problems posed.

How can the artist evolve the perfect composition when so many permutations and combinations are possible? A useful, and often under-valued, aid is the construction of a 'table-top' composition. This is when the proposed elements of the composition, such as figures, trees, ships or buildings, are roughly modelled and then arranged on a flat surface — usually a table-top. Today it is easy to acquire small three-dimensional objects: toy soldiers, farm animals, model buildings, trees. These should all be, if possible, roughly in the same scale. Plasticine is useful for mak-

ing undulations in the scenery and to model any missing elements.

The method employed is to place the various models on the table-top in some sensible relationship dictated by the subject matter. Then, by changing the elements, viewing angles and lighting effects, combined with one's intuition, aided by the theory learnt, order and balance can be brought to the whole. What is so fascinating is that the eventual composition arrived at is often so remote from one's ideas on the subject at the outset.

At first there is a tendency to isolate each object from its neighbor — separating them in order to affirm the distinctive identity of each. Experience soon shows that regular intervals between objects are less visually interesting, especially if the negatives — or spaces in between — are consistent in size. Change these interstices and immediately you will create more interest.

Experiment on the table-top with the rules we have learnt and see how you can break them and yet still achieve a unified composition. It is a salutary way to free the mind and view the options with ease.

Traditional artists' jointed models have been used in the table-top arrangements on the following pages. These will offer the main structure of the composition around which the more lyrical details can be arranged — physical characteristics, costume or surrounding landscape. Their simplicity also stimulates ideas in a more abstract direction, where the physical form is seen as an outline.

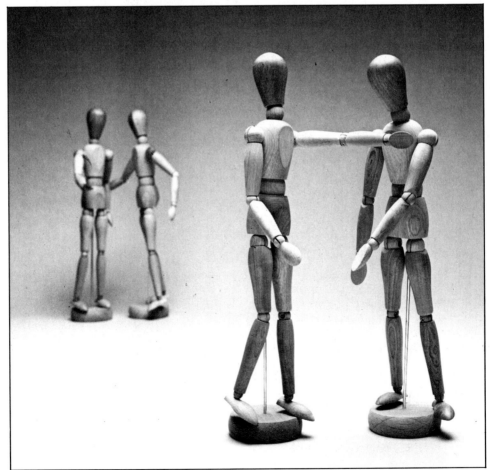

The sketched notes on the opposite page show how the information gleaned from table-top arrangements can be practically used in composition. Here two figures are depicted in a wood. The positioning of the figures resulted from table-top observation, but the composition is given dimension through physical detail, the interest offered by the landscape, with its secondary compositional lines, and through tonal variation.

Placing the single figure within the picture space is a very basic test of compositional ingenuity. Let us start by placing the figure in the center of the picture's surface (right). It is difficult to get excited by such a composition. But, as shown by the sketch below, by changing the view of the pose only slightly and by giving the background an angle of interest, the atmosphere of the composition is fundamentally changed.

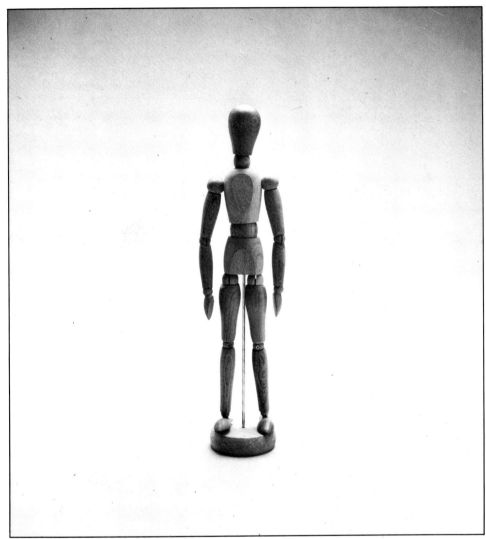

Cropping the figure with the frame makes it easy for the eye to locate the figure in the space. It is a happier use of the abstract elements of positive (the figure) as well as negative (the background) space. Why does this figure look so uncomfortable then? He has been cropped at the knee joint — all joints should be avoided when cropping.

The sketch above shows again how small changes make so much difference. The space is being used and the surface pattern is visually stimulating. The cropping, between knee and thigh joints, does not provoke unease.

Another dimension to explore is the use of the picture's depth. Even though the figure is still centrally and frontally placed, the eye is led from the lower edge of the composition back to the figure, creating interest.

Even moving the figure to one side divides the picture surface in a more satisfying way, allowing for greater potential development.

Cropping this figure (in the correct place) invites the spectator into the picture and on into the left-hand background.

Further cropping of the figure has interesting possibilities. We can see how this tends to lock the pose in a static position — only the right arm in this sketch seems free to move. The abstract shapes created on the surface by this device are visually exciting, making use of the total picture area.

The balance of a composition is of prime importance. This does not imply a necessity for strict symmetry or a balance of like things, it can be achieved through movement, gesture or a cast glance. On the right, the figure has been placed centrally at an angle. On the far right, the pose has been changed to intimate movement. Here, the spectator predicts the continuation of the pose across to the right of the space, thereby creating a balance in what is technically an asymmetrical composition.

According to traditional theories, this would be regarded as an unsuccessful composition. As in the arrangement above right, the eye predicts the forward movement of the figure, but here it finds itself precipitated out of the frame. The resulting feeling of discomfort caused in the spectator can be exploited by the artist as it has been since photography first highlighted the possibilities of such devices.

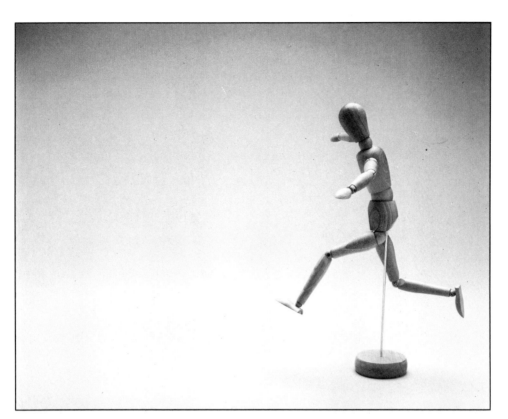

On the left, the figure is leaping into the open picture space, taking the attention of the spectator with him. Again the balance is created by the participating viewer.

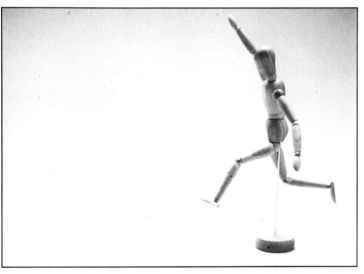

The raised right arm in this arrangement on the left, demonstrates how the picture surface can be further activated. The sketch on the right shows the advantage of such a pose in a composition. The arrows show the direction of the predicted movement.

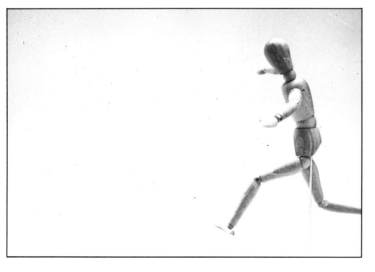

Cropping the leaping figure enables the viewer naturally to enter the picture space through the limb anchored in the surface plane. This phenomenom is well demonstrated on the right where the cropped foot brings the back right foot into the foreground, thereby twisting round the body. It also appears to pin the figure to the frame, somewhat retarding his hasty exit. The attention of the spectator can be returned to the composition through some background rhythm

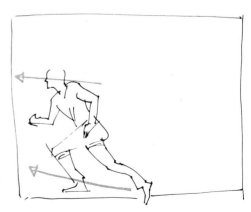

which counters the direction of movement.

Multi-figure composition poses the same range of problems as the single figure, although, for obvious reasons, it is easier to exploit the total picture surface and depth. For most compositions, the arrangement above and right is too regular and predictable.

The tedium of regular visual repetition can be easily relieved through a change of scale (left). The eye which swept from left to right across the surface, above, is now forced to travel back into the picture space as well.

186

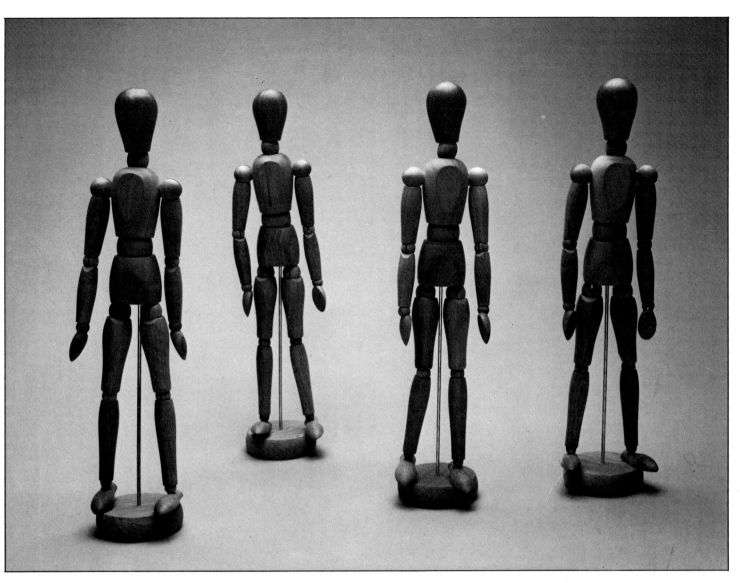

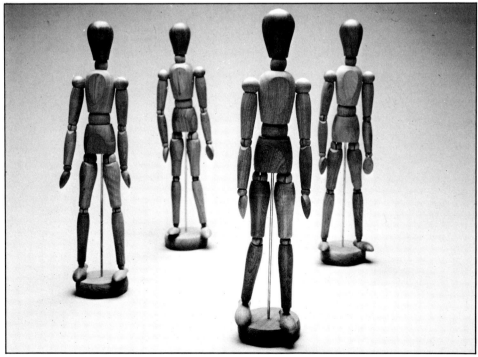

Further visual interest is created here above, through the use of a more extensive ground area. Note how the bases form a pattern on the picture surface but the heads remain on the same line. This is because the eye-level is at head level which brings a sense of calm and stability reminiscent of many 14th- century frescoes and paintings.

The four figures on the left are placed at the corners of a rectangle in the ground plan. The eye tends to stay in the composition for longer as there is no obvious exit.

By dividing up the group of four into two sets of two the emphasis is now on the relationships between the individuals, rather than that of their physical forms. The arrangement on the right takes no account of these feelings.

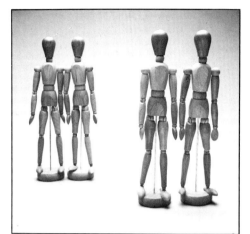

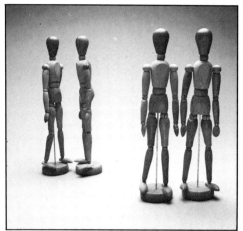

The background couple, here on the left, are communicating, drawing attention to the indifference of the foreground couple. Immediately the observer is forced to make an emotional response rather than just take part in visual gymnastics.

Further visual and emotional interest is created by the interaction of the foreground couple, although the two couples still remain aloof. The silhouette here is enlivened by the variations in angle and gesture.

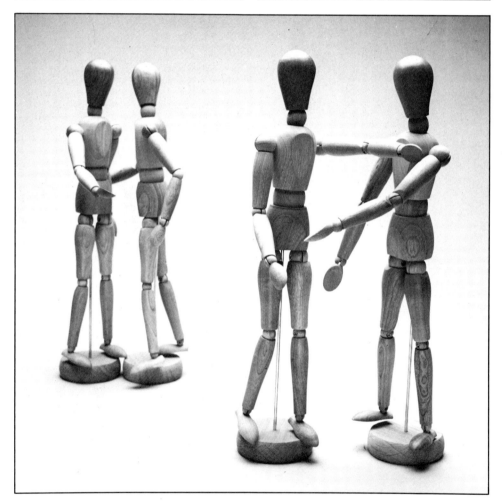

These 'thumbnail' sketches examine the possibilities of gaining greater value from the positive/negative aspects of the arrangement. Such exercises are a valuable adjunct to such table-top experiments, enabling the artist to look quickly at variations on a theme — different angles, spatial relationships, stresses and eye levels.

The two couples below are in similar stances to those are the center page the page opposite, but the background couple have been moved further back. This has the effect of making the foreground couple more important, and therefore their relationship likewise. The observer no longer seeks such a positive link between the two couples, regarding the background pair more as a detail. The lower viewpoint also tends to separate them as the heads are no longer on the same level. Perspective plays a part here: lines drawn through the heads and bases converge to vanishing points.

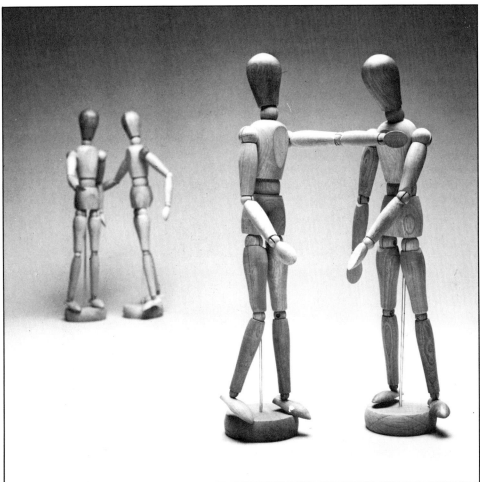

Apparent asymmetry can be employed to add vigor to a composition, achieving a happy unified result. Here we have three figures apparently balancing one. The foreground jogger is more prominently exposed. His implied movement, as discussed above, carries the eye effortlessly to the trio in the background. The sketch above shows how these figures make an interesting overall shape.

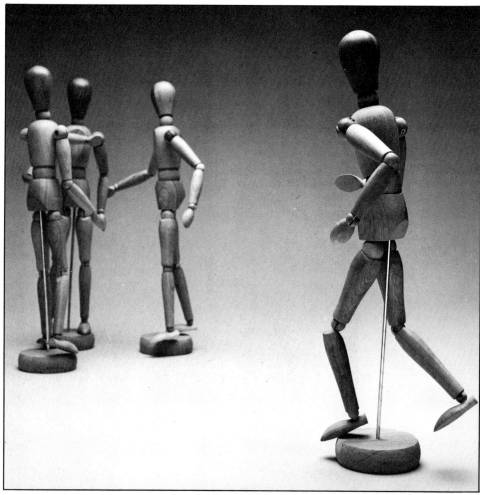

The changes made in the background group, right, strengthen the link with the foreground figure: the attention of the trio is turned towards him making an emotional connection and compositional lines, through the prone figure and the outstretched arm, help to make the visual link. This results in a compositional rhythm.

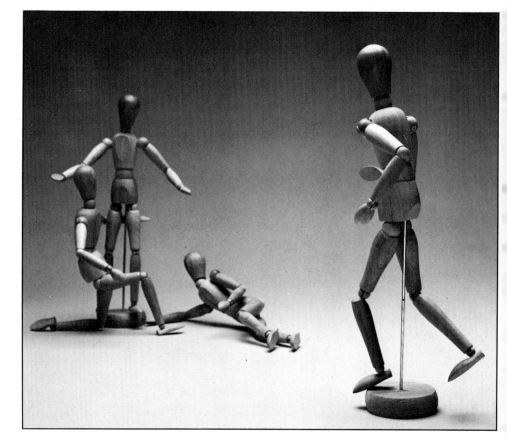

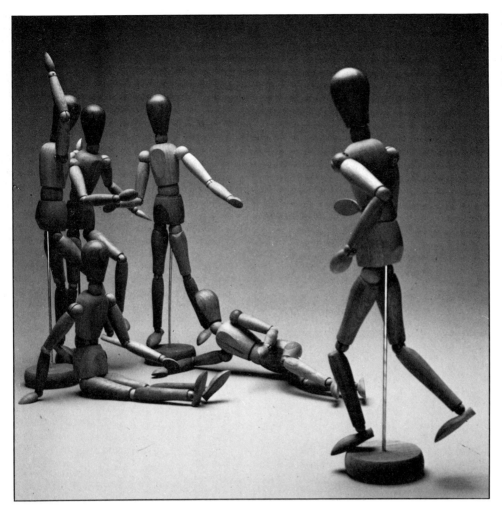

Here the composition is further complicated and the links between the foreground figure and the enlarged background group have been strengthened. The background group now appears positively to greet the runner and a physical link is made through the overlapping limbs.

In this arrangement on the left, the emphasis has been transferred from the foreground to the background, even though the attention of the observer should, logically, be attracted by the variety of gesture and line of the group rather than the uninspiring background figure. This has been achieved through focus: the single figure is in tight focus, compared with the blurred presentation of the group. It is surprising to find that the arrangement above is identical to that on the left except that the eye-level is much lower. The composition as a result is much more dramatic, but the focus ensures attention on the single figure.

A geometric structure to a composition ensures strength and unity, leaving the artist free to vent his inspiration. The dancing figures on the right show how the immediacy of the scene need not be lost through the contrived structure of a simple triangle, which lends a sense of completeness to the composition.

On the surface, there are two triangles here; one inverted below the other, forming a diamond. Further triangles outlined by the limbs are like facets of this diamond. The unity of the ground plan is also considered because the three figures rest on the three points of another triangle.

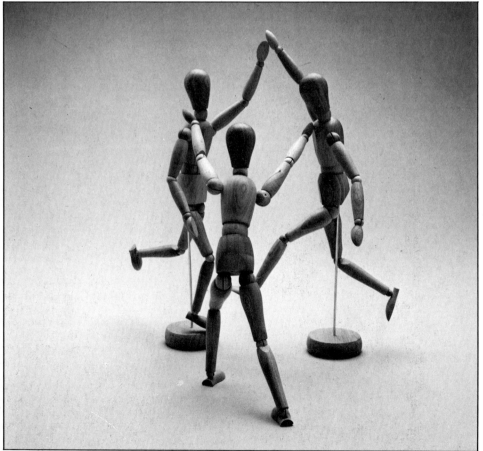

The triangles in this composition, and those implied either side, lend stability to a composition full of tension and movement.

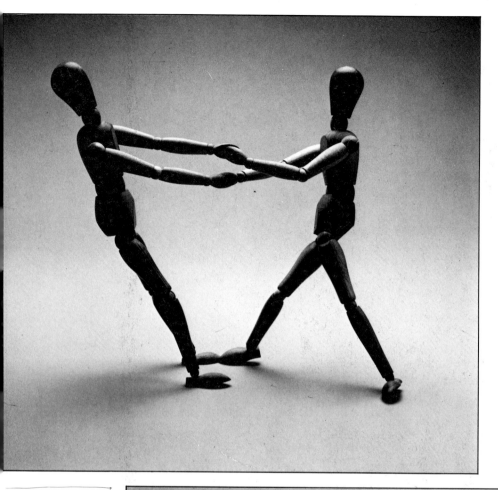

The addition of the two background figures gives depth to the composition, forming a triangle on the ground plan. The combinations are infinite but concentration on such structures must not be allowed to stifle artistic impulse.

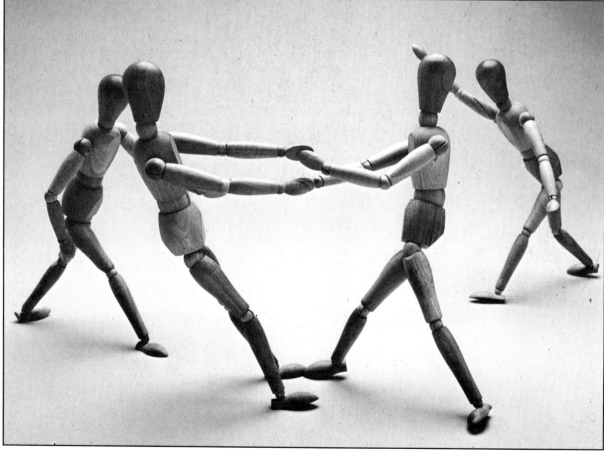

The demands on a composition can vary greatly. One useful geometric skeleton is the circle, particularly effective if used within the square. The high viewpoint of this arrangement demonstrates this point well. The figures are varied in pose, yet there is an inevitable bond between them. The rhythm, though, is all on the surface.

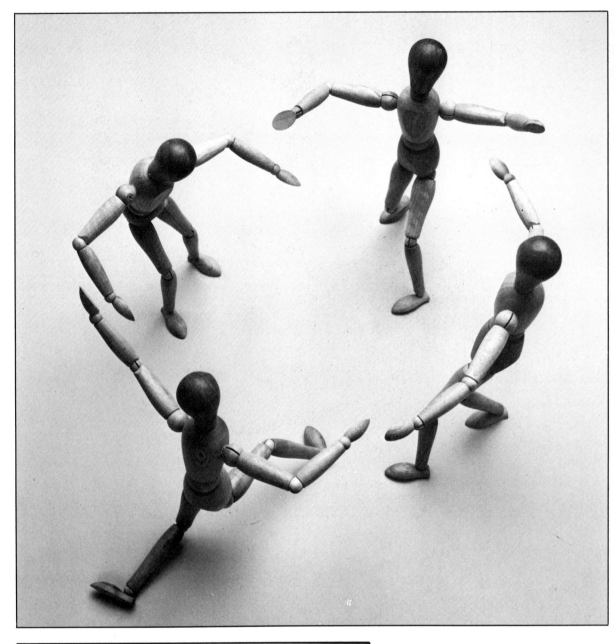

The same circular group when seen from lower down still retains the same feeling of unity because of the implied circle into the depth of the picture, outlined by the heads. This arrangement has more emphasis on the vertical.

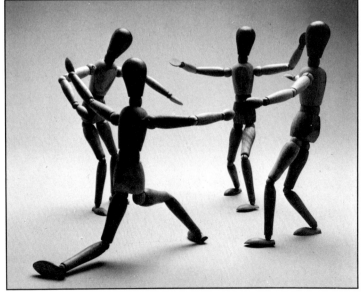

Another view from a high eye-level shows how the same composition from a different station point requires a different shape of support — the vertical rectangle seems more appropriate here. It also demonstrates how many variations can be recorded through the use of a table-top construction.

This 'thumbnail' sketch shows how such a circular-based composition could be used in, for example, the depiction of a picnic scene. The complications caused by the inclusion of the rectangular groundsheet greatly enhance the visual interest.

Lighting can be of great importance in a composition. It is not only the emotional aspect which is affected, shadows can create unusual abstract shapes, adding variation to a composition. The strong lighting from the back, shown above, throws the group into silhouette. The result is dramatic and the interstices, the spaces between the figures, become a significant part of the design.

This is a good example of lighting being used to give a strong sense of movement, not only colored interstices into it. Whenever a group of figures is contained in a shallow field, then the use of chiaroscuro (light and shade) can be harnessed to stimulate interest, to explain subtle variations and to improve the surface legibility of the painting.

196

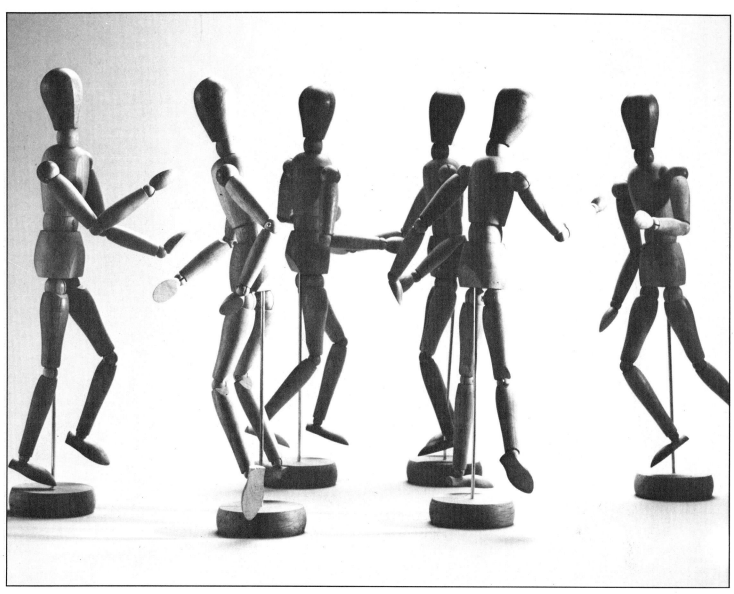

This sketch, right, shows the abstract possibilities of such a figure arrangement. Here the colored interstices demonstrate the possible variety of shapes created by overlapping human forms. The cropping of these figures brings this pattern into the picture plane.

Further compositional options are investigated in such a sketch. The tonal unity helps to emphasize the pattern.

The rich surface pattern created by the strong light in the arrangement above provides a sense of unity and visual excitement. The overall silhouette of the group is strong, and the tonal range of the individuals within the group adds a further dimension.

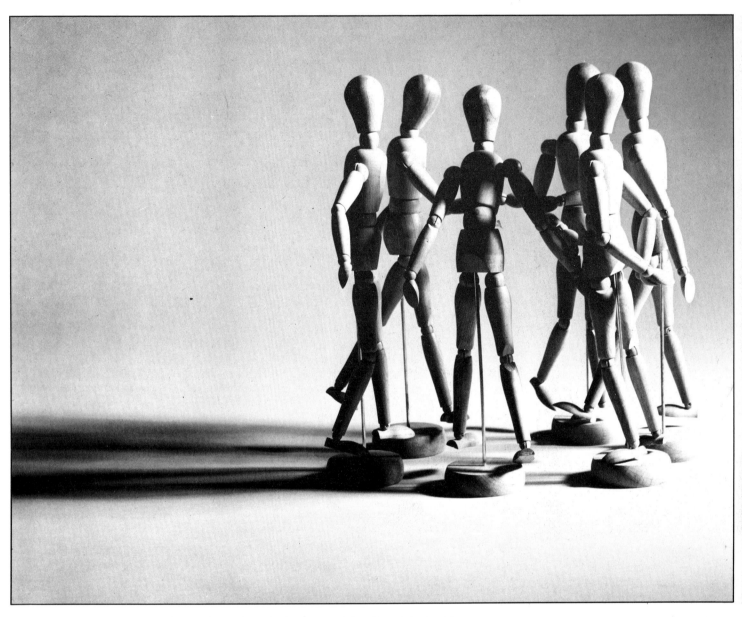

The shadows in the arrangement above become an important element of the composition, by helping to achieve a sense of balance, and by activating the empty space. Shadows can also be used to help define form.

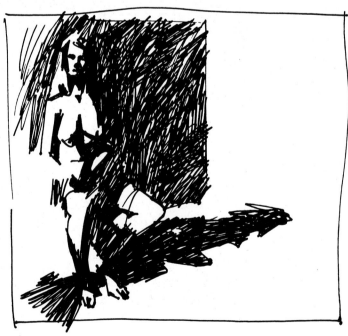

The positive aspects of shadows are being tried out in this sketch on the left. The nude looms out of the shadows in a rather disturbing manner. But the background area of modulated darkness acts as a solid base for the composition.

The arrangements on this page were made with the help of a device often used by artists — a view-finder. This is a thin sheet of white card, with a rectangle cut cleanly out of it. This can be held before the scene at varying distances from the eye, creating countless views. Above, it is possible to see, using this device, how different the composition feels when the shadows are removed. The sense of balance is lost. The same closely linked group, as shown below, offers fascinating possibilities when cropped. The emphasis is now on the internal angles formed by the figures and implied rhythms. It is no longer necessary to establish the group's location within the picture space.

A combination of compositional devices reviewed above is considered here. There is a strong triangular base to the design both on the picture surface and on the ground plane. The light source is interesting too, because the foreground figure is in the shadow whilst the flanking forms are in the light.

Cropping the above composition to produce the arrangement on the left does not, for once, produce a more interesting design. The eye-level of the viewer coincides with head level of the figures so the heads are on the same line. The variation in the positioning of the bases has been cut out.

The eye-level here has been lowered to feet level, making these figures appear menacing and overpowering. This emotional response is increased by the cropping, as seen below. In this case, the visual interest created by the implied triangle through the heads is retained.

Choosing a station point and eye-level Over the next eight pages an arrangement of figures has been viewed from the four sides of the table-top, at two eye-levels — medium and low. The arrangement of figures comprises a main complex group, flanked by two single figures. Here it has been viewed from the front and the 'normal' eye-level chosen does not exploit the interesting aspects of the composition — the urgent discussion in the central group and its effect on the lateral figure.

The same arrangement of figures is viewed here above, from the lower eye-level. The composition, as a result, is more dynamic and dramatic. By cropping it, as shown to the left, an interesting emotional void is created between the group and left-hand single figure. Both positive and negative aspects of the composition are enhanced by the excitement of the uneven head line.

It is difficult to believe
that this is the same
group viewed on the
previous page. Here,
seen from the right. The
seemingly cohesive
central group has
disintegrated, yet the
arrangement has not
been changed. The
emotional relationships
between the various
figures are difficult to
follow but, as the
cropping shows, this view
could be used as the basis
of a purely abstract
composition, where the
negatives are as
important as the
positives.

A change of eye-level, together with a minute lateral change of station point, again radically alters the group. Now the eye travels in from the left, along the linking arm to the central group, through the heads to the gesturing hand of the right-hand figure, which takes you to the figures on the right.

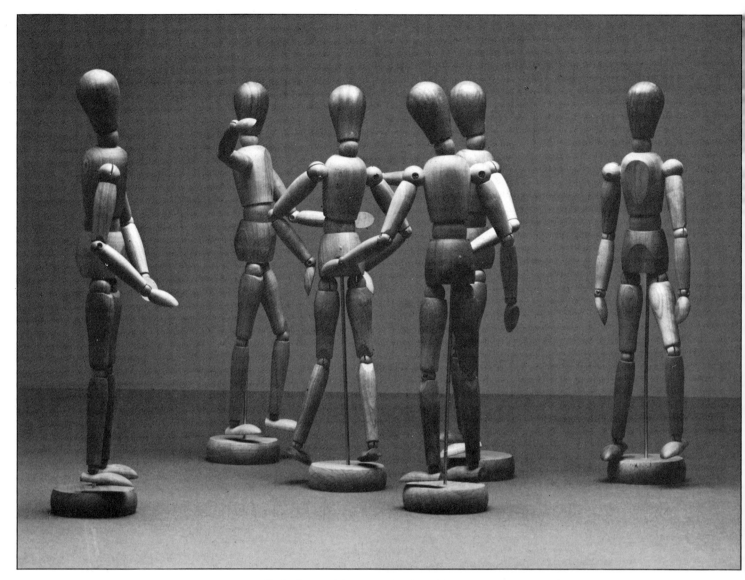

The back-view of the group is similar to the front-view. Again the central group dominates the picture. On the right, you can see how the eye follows the pattern of heads horizontally across the page. The two lateral figures form useful verticals containing the action of the composition and stopping the attention of the observer from leaving the picture.

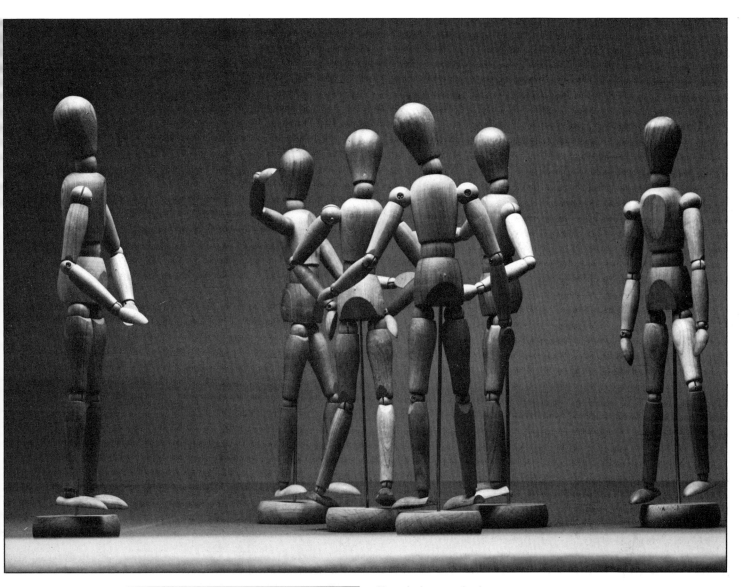

Here, the lower eye-level has a fascinating result. On the opposite page, the gestures of the main group have no geometric base, yet, above, the unity of the central group is achieved through a neat pattern of crossed diagonals. The line on the left again emphasizes how the eye is led across the picture surface by the pattern of the heads, this time in a more visually interesting way.

The final view, from the left, although not very dynamic as a composition shows how back-views lead the observer into the picture space. Hidden faces, however, even implied ones as in these models, make it difficult for the observer to relate to the figures emotionally.

The lower eye-level here again locates a triangular base in the composition. This discovery of a geometric structure in a random arrangement is a useful way of providing the composition with a solid foundation without being tied to a rigid preordained geometric composition. The sketch here shows the ambiguous shapes created by overlapping figures.

Arrangements for a still-life, a landscape or street scene, or even for an abstract study, can be made with the help of three-dimensional shapes. Here, in this sketch, the plan is shown of four monoliths, forming a square on the ground.

The arrangement shown above is viewed here from a low eye-level, inspiring a feeling of drama. The eye is led down a central void, flanked by the overlapping forms, into the distance. The division of the picture surface by these forms is symmetrical but the emotional content makes it an interesting composition.

The eye-level here, for the same arrangement, is still low, but the station point has been changed. The result makes a more visually entertaining composition. Activation of the picture surface has been achieved through the variation in the size and focus of the monoliths, but, more important, their interstices are now irregular. Depth is achieved in the picture space by the perspective of the 'cube' which the monoliths form.

This is the first of a series of arrangements using three-dimensional shapes, which explore and exploit the possible tension and relationships of the various elements of a composition. We start with a simple cube. It is placed centrally, so does not provoke great visual interest.

The addition of a cylinder adds some variation, but no attempt at any relationship between the two shapes has been made, so the emotional content of the composition is sterile. The shapes occupy the same narrow middle-ground strip which makes little use of the picture depth.

Overlapping forms create some unexpected shapes. Here the two additions form a relationship with the objects they are grouped with. The result is more pleasing, although the picture surface has not been exploited.

More use is being made in this arrangement both of the ground plane — by bringing the sphere into the foreground, and by placing the cylinder in the background — and of the picture surface, by giving some height to the cube. There is balance in the relationship of these objects.

Adding new shapes does not necessarily mean an increase in interest. The objects here are all on the same strip in the middle ground of the ground plane and the picture plane.

A small rearrangement will solve the problem and expand on the theme originated above, at the top. Note that in these three arrangements on this page the 'house' has remained in the same position viewed from the same station point. It is the details which alter the visual and emotional content of the composition.

Changes have been made to the height of the objects here. But the basic arrangement is the same as on the opposite page, at the bottom. This has the effect of exploring the diagonals of both the ground and picture planes.

Again, the plan is the same here but the height and bulk of the composition have been transferred back to the cube. Now, the secondary objects are unable to balance the bulk. When such an arrangement is viewed, a feeling of tension is provoked in the spectator — it is not comfortable. This can be exploited by the artist in certain compositions, where the subject matter demands such a reaction.

A return to the limited use of the picture surface and depth highlights the 'dead' area above the objects. Spaces should be lively rather than empty, which is an important aspect of composition.

A cloth is now laid over the geometric shapes, softening the compositional lines and making them more fluid. Tonal variations are now more obvious and the contrast between the texture of the cloth and ball demonstrates another dimension of composition which must not be ignored. Such an arrangement can be used as the starting point for a landscape or a still-life.

The eye is led in from the right by the diagonal formed by the main mass. Here geometric shapes have been added which resemble buildings in a landscape. This alters the scale of the composition. The lines of the cloth (or landscape) soften the harsher silhouettes of the shapes (buildings).

The emphasis has now been transferred to the ground plane objects so that the cloth becomes part of the background and of secondary importance. A landscape in a composition often contains the action or interest of the subject matter, leading the spectator round the composition, acting as a link between often diverse objects.

Another use of the table-top is demonstrated here. It can be useful in organizing a landscape composition as it is so easy to view it from different station points, eye-levels and angles. First a model church is positioned next to a model house. To give some variation to the outline and to exploit the picture surface, the church is then placed on a modelling clay hill. Next, the angle of the church roof and steeple is softened by some foliage, which could also be used to link the two edifices. With such an exercise, why not try another plan? Make the church the center of interest and use the landscape to balance it. The texture of the grass is interesting here. This composition could be used as a setting for a history painting.

GLOSSARY

abduction Of the hand or foot: the extension from a relaxed or normal position.

abstract Representation without apparent form, although elements may be recognizable and a pleasant balance may be achieved. Such a means of expression is generally intended to convey strong emotive force.

acromion process The outer edge of the shoulder blade.

aerial perspective See atmospheric perspective.

angular perspective Perspective of two planes, neither parallel to the picture plane: two-dimensional representation of three-dimensional space involving no more than two planes.

articular fossa Socket or groove of a joint in the body; for example, the socket of a ball-and-socket joint (like the shoulder).

articular process Any joint of the body and the elements of its constitution. The main processes are: hinge joints (like the knee), ball-and-socket joints (like the hip), and rotating joints (like the elbow).

asymmetry In art, not so much a lack of symmetry (an absence of equality in proportions) as a balance in representation achieved by means other than geometrical.

atmospheric perspective Use of the fact that tonal values decrease with recession: as objects recede into the distance there is less contrast apparent between light and shade, and the fact the overall impression is generally that objects become lighter.

Baroque Of the period 1600-1720 or so, and generally tending in art to represent a particular quality that combines the pictorial with the illusory or grand, within formal 'rules'.

calvaria The major, rounded part of the skull that houses the brain. A more usual word is cranium.

carpal bones The eight bones of the wrist, forming a very unusual joint in that for articulation some slide over the top of others.

central perspective See linear perspective.

center line of sight Straight line from the eye to the object focussed upon; the center of the cone of vision.

cervical Of the neck; for artists, generally of the neck above the trunk, describing (for example) the vertebrae between skull and thorax; but for doctors, even more commonly, the neck of the womb.

chiaroscuro Technique emphasizing the use of light and dark (or shade), and often utilizing the resultant contrast in moods within the compostion. Main proponents were Rembrandt and Caravaggio. (The term is Italian for 'light-dark'.)

clavicle One of the two collar bones, thin and rather fragile bones that connect the bones of each should,er joint with the breastbone (sternum). In most people the clavicles are visible in the top of the trunk at the rise of the neck.

coccyx, coccygeal Bone comprising (usually) four vertebrae fused together, corresponding to a rudimentary 'tail'.

color Perceived variations in the wavelengths of light. Natural color (and color from a TV set) is perceived through combinations of wavelengths added to each other. Paints and pigments rely on the absorption of complementary wavelengths on the surface to produce the intended hue; this is essentially a subtractive process whereas natural color, in combinations of light, is an additive process.

cone of vision View out from each eye; the full scope of vision apprehended as a widening beam from the observer's eyes.

contrapposto Providing contrast, antithesis. (The term is Italian for 'set against'.)

cranium Bones of the skull which enclose the brain; the calvaria.

crop To cut away part of a picture; to reduce size not by reducing scale but by 'amputating' part of it; to take a detail from the whole.

depth-of-field focussing Photographic technique in which a moving object is the only element in a picture not to be blurred; the effect is strongly suggestive of great speed at a momentary instant.

digit A finger, thumb or toe.

equilateral triangle Triangle with all its sides of equal length, and thus with all its angles also equal (at 60°).

evertion Capacity for turning, mobility in turning, especially turning off a straight line.

Expressionism Convention in art particularly of the early 20th century

which strives for personal and emotive effect in representation. Major proponents were Marc Chagall, Edvard Munch and Oskar Kokoschka.

extension Causing to straighten (of a muscle); the opposite of flexion. The muscles that cause the limbs and digits to straighten are called extensors.

eye-level In a picture: the level at which the artist is apparently viewing the subject, although not necessarily corresponding to the artist's actual position.

fascia Sheath, generally of fibrous tissue, protecting, separating and/or supporting a muscle, or acting as a layer between the skin and deeper tissues.

femur Large bone of the thigh whereas natural color, in combinations (trochanters and condyles), to which powerful muscles attach, and for protection of the hip and knee joints.

fibula Thinner, but not shorter, of the two bones of the lower leg (the other is the tibia); a protuberance at the lower end forms the outer ankle, protecting the talus, the main carrier of the body's weight, although the fibula itself carries no weight.

flexion Causing to bend (of a muscle); the opposite of extension. The muscles that cause the limbs and digits to bend are called flexors.

geometric perspective See linear perspective.

Golden Section or Golden Mean Mathematical system for calculating proportions in representation based on geometry, thus potentially providing a satisfying overall balance of proportions in the picture.

ground line Line representing the meeting of the picture plane (between artist and subject, corresponding to the surface of the picture) and the ground on which the artist is actually standing.

humerus Large bone of the upper arm; bony projections at top and bottom tubercles and epicondyles have attached muscles.

ilium The major bone of the pelvis, to which the pubis and ischium eventually fuse, and on which the sacrum (the lowest significant part of the spine) 'sits'.

Impressionists Artists of the second half of the 19th century who strove to convey the idea of transitory effects of light in moments of spontaneous discernment, the atmosphere and the impression of the subject even more than outright representation, in a reaction against both the romanticism and the realism of artistic conventions of the time. The term derives from the title of a Monet painting (*Impression, Sunrise*, 1872) that was one of the earliest of the genre. Other major proponents were Renoir, Degas and Cézanne.

infraspinatus Strap-like muscle over the shoulder blade.

interstices Spaces between figures or important elements in a picture.

landscape Of the shape of a picture: rectangular with the longer sides horizontal. Such a shape is considered to impart an air of tranquillity.

linear perspective Also called 'scientific', 'central' or 'geometric' perspective, and what most people think of as just 'perspective'. First formulated (in the West) in the 15th century, it is a process permitting depth in representation, incorporating the use of vanishing points (where parallel lines converge on the horizon), and presents the appearance of three-dimensional reality on a two-dimensional plane.

line of separation Line distinguishing between positive (light, thematic) and negative (dark, background) areas on a composition.

lumbar Of the lower back, particularly of the five vertebrae above the sacrum and below the thoracic vertebrae.

Madonna and Child Representation of the Virgin Mary with the infant Jesus, especially popular as a subject in Renaissance times.

mandible The lower jaw, which hinges at a point very close to the origin of the zygomatic arch, just in front of the ear. It is the only genuinely mobile bone of the head. (At birth, the bones of the cranium are mobile to a small extent to facilitate the passage down the birth canal.)

mannerism Convention in art of forced perspectives in representation, for example, parallel lines converge more rapidly than by ordinary perspective; the overall effect is commonly of foreshortening and false lighting, the result is tension in the beholder.

maxilla The upper jaw, of a piece with the structure that includes the surrounding of the nasal cavity and much of the orbit (the socket of the eyeball).

metacarpal bones The five main bones of the hand: four of the palm, plus the slightly separate one that forms the base of the thumb. Behind are the carpal

bones, forward the phalanges.

monocular Having or using only one eye.

muscle Source of power for body movement. There are three types: skeletal, smooth and cardiac; artists are concerned almost entirely with the skeletal, voluntary muscles — those that can be moved at will. Muscles generally work in pairs, one to flex and another to extend, but all have only the power to contract or relax. Contraction is by electrical stimulation of the striated layering within each muscle.

musculature The shape and quality of the muscles in the body.

negative Of the elements of a picture: the background, or those parts that seem to require less immediate attention, generally the darkest areas. (It is not, therefore, a term implying bad qualities.)

oblique perspective Perspective of three planes involving thus three vanishing points — two on the horizon, and one above or below; two-dimensional representation of three-dimensional space involving more than two planes.

occiput, occipital bone Rounded bone at the very back and lower part of the skull.

one-point perspective Perspective with only one vanishing point on a horizon; two-dimensional representation of three-dimensional space with only one plane showing.

origin of a muscle The relatively static base of a muscle (for example, a bone to which the muscle is attached) towards which by its contraction the muscle may pull a limb or a digit.

orthographic projection Representation by plan, elevation or section, commonly used for exact-scale architectural drawings.

parallel perspective See one-point perspective.

parietal bone Large, rounded bone that is part of the skull, and constitutes protection for the brain over most of the upper top and back part of the head.

phalanx, phalanges The bones of the fingers (including the thumbs) and the toes.

photorealism Representation suggesting a reflection from a transparent and smooth surface, thus confusing reflected images with those seen directly through the surface.

picture plane Imagined plane between artist and subject. In an ordinary photographic picture the picture plane is at right-angles to the ground plane (on which the artist stands), and represented by the pictorial surface.

pointiliste Of a technique in which small dots or extremely fine strokes in pure color impart not only the representation but also the tone and atmosphere. A major proponent was Georges Seurat. Pointilisme is sometimes alternatively known as divisionism (or spelled Pointillism).

portrait Of a picture: representing a likeness of a person or persons; in common usage the term generally describes a picture of a person's head and shoulders, but historically portraits have much more commonly been full-length. Of the shape of a picture: rectangular, with the longer sides vertical; such a shape is considered to impart an active, possibly even disturbing, ambience.

positive Of the elements of a picture: the subject, or those parts that require immediate attention, generally the lightest areas. (The term implies no value judgement.)

pronation In anatomy, making to lie flat, face down, prone or athwart; thus of the bones of the lower arm, for example, turning the hand palm downwards is pronation not just because the hand is then prone but also because the radius then lies across the ulna. The opposite is supination.

radius In anatomy, the slightly larger of the two bones of the lower arm (the other is the ulna); the radius rotates with the hand and is thus sometimes crossed over the ulna (pronation); at its lower end it is always the side of the thumb. In geometry, the distance or line between the point at the center of an arc or circle and the circumference.

rhythm In art, element in composition by which in looking at a picture the eye is led from theme to theme, thus receiving specific impressions or moods intended by the artist; rhythmic lines or curves should thus convey an emotive quality that geometric lines or curves may not have.

roundel Circular framework, canvas or surface for a picture.

sacrum, sacral Bone comprising five vertebrae fused together, that 'sits' upon the bones of the pelvic girdle (specifically the ilium). The sacrum is a major carrier of the weight of the trunk of the body.

sartorius Large, strap-like muscle that extends from the outside of the hip down the inside of the thigh to connect with the strong muscle at the front of the shin. It thus has the length and

strength to be the main source of power to bend the knee.

scale Relative size of subject in a picture in terms of actual size; 1:1 is life-size, 1:2 is half-scale, and so on. Choice of scale in representation can be extremely significant in creating an impression on the beholder.

scapula The shoulder blade, a flat triangular bone which with the humerus constitutes the shoulder joint.

scientific perspective See linear perspective.

silhouette Representation as though by shadow only. The technique was named after a mid-18th century French finance minister (who was notoriously mean and) whose hobby was creating cut-out portraits.

staccato Of a rhythm in a picture: instead of smooth and flowing, consisting of short lines, brief curves or angularities, thus conveying a rather disturbing impression.

station point See viewpoint.

sternum, sterno- The breastbone, a fairly large bone at the front of the chest and in three sections: a rather rounded upper section (the manubrium) that provides the base for the first rib and the collar bone; a long, flattened 'body' to which other ribs attach; and the xiphoid process, a sort of cartilaginous knob at the bottom.

subcutaneous Just under the skin.

superficial Of or on the surface.

supination In anatomy, making to lie flat (supine) and open; the opposite of pronation.

surface plane Apparent surface of a picture; the vertical plane represented by the physical surface.

Surrealists Art movement generated in the 1920s and attempting to introduce creative use of the unconscious mind, hence an enthusiasm for 'dreamlike reality' in which three-dimensional realism is emphasized except that at least part of the subject is unreal (and often reliant on some verbal association). Main proponents have been Louis Aragon, Max Ernst, Paul Klee and Salvador Dali.

tarsal bones The bones within and just below the ankle; the equivalent in the foot of the wrist.

thorax, thoracic The part of the body between the neck and the abdomen; the upper part of the trunk or torso.

three-dimensional Not flat on a surface (two-dimensional) but solid-looking, realistic, having depth and a genuine appearance of distance.

Three-dimensional representation may be achieved in two dimensions through the use of perspective.

three-point perspective See oblique perspective.

tibia The shin bone, larger of the two bones of the lower leg (the other is the fibula); bony protuberances at both ends have attached muscles — the lower inside protuberance (the medial malleolus) is the inner ankle.

tonal equality In art, a condition in which no color or shade is permitted to be lighter or darker, stronger or weaker, or in any way contrasting. Such tonal equality is particularly important in the representation of equi-distant features, for tone changes with distance.

tonal modulation On a picture: the change from one tonal value to another, generally gradual but not necessarily. Tonal modulation may be critically significant in an abstract picture.

trecento The 14th century in Italy (the '300s' of the second millennium).

trompe l'oeil Representation constituting an optical illusion either in simulation (that something is what it isn't) or in dissimulation (that something isn't what it is). The term is French for 'deceives the eye'.

trunk The large, unified part of the body, including both thorax and abdomen but not including the limbs or the neck and skull.

two-dimensional Flat, on a plane surface.

two-point perspective See angular perspective.

ulna The slightly larger of the two bones in the lower arm (the other is the radius).

vanishing point Point at which by perspective parallel lines (appear to) converge on the horizon. Representation of a subject in a single plane requires only a single vanishing point; of one in two planes requires two vanishing points — and so on.

vanishing point of the shadows (VPS) Point at which a perpendicular ray from the sun touches the horizon, corresponding to the location from which all shadows diverge.

viewfinder Small frame used by an artist as a device through which to judge the most appropriate scale and viewpoint in regard to a subject.

viewpoint or station point Point from which the artist is apparently viewing the subject, which, on the completed picture, may bear no relation to the artist's actual location.

INDEX

ACKNOWLEDGEMENTS

Key: (t) top, (b) bottom, (l) left, (r) right, (c) centre.
p. 13: Fotomas Index
p. 15: British Museum, London
p. 30: Staatliche Graphische Sammlung, Munich
p. 110: Scrovegni, Padua (Photo — Scala)
p. 111: Gabinetto dei Designi, Uffizi, Florence (Photc — Scala)
p. 112: Reproduced by Gracious Permission of Her Majesty the Queen
p. 113: British Museum, London
p. 114: Victoria and Albert Museum, London
p. 115 (t): National Gallery, London
p. 115 (b): Biblioteca Marncelliana, Florence (Photo — Scala)
p. 116: Tate Gallery, London
p. 166 (l): By courtesy of the Trustees of the British Museum
p. 166 (r): Victoria and Albert Museum, London
p. 167: Louvre, Paris
p. 168: National Gallery, London
p. 169: National Gallery, London
p. 170 (r): National Gallery, London
p. 171: National Gallery, London
p. 172: Louvre, Paris
p. 173 (t): L'Ecole des Beaux Arts, Paris
p. 173 (b): Collection Felix Klee, Berne
p. 174: Bibliothèque d'Arras (Photo — Giraudon, Paris)
p. 175: National Gallery, London
p. 176 (t): The National Gallery of Scotland, Edinburgh
p. 176 (b): Victoria and Albert Museum, London
p. 177: Musée de Jeu de Paume, Paris (Photo — Hubert Josse)
p. 178 (l): The Greater London Council as Administrative Trustee of the Iveagh Bequest, Kenwood House, London
p. 178 (r): The Bridgeman Art Library
p. 179: Trustees of the British Museum, London

While every effort has been made to acknowledge all copyright holders, we apologize if any omissions have been made.

Artist
Stan Smith

Illustrators
Donald Bason
David Gifford
Stephen Gardiner
David Lawrence
Stan Smith

Photographer
Jon Heseltine

Special thanks to George Rowney & Co Ltd, for providing the lay figures.